COLOUR SOURCE BOOK

Publisher and Creative Director: Nick Wells
Editor: Polly Willis
Picture Research: Gemma Walters and Cat Emslie
Editorial Assistant: Chelsea Edwards
Design: Michael Spender
Production: Chris Herbert, Julie Pallot and Claire Walker

Special thanks to: Phillip Dodd, Geoffrey Meadon, Rosanna Singler and Helen Tovey

FLAME TREE PUBLISHING
Crabtree Hall
Crabtree Lane
Fulham
London SW6 6TY
www.flametreepublishing.com

Flame Tree is part of The Foundry Creative Media Company Limited

Copyright © Flame Tree Publishing

First published 2007

07 09 11 10 08
1 3 5 7 9 10 8 6 4 2

ISBN 978-1-84451-400-7

Printed in China

COLOUR SOURCE BOOK

AUTHORS: ROSALIND ORMISTON AND MICHAEL ROBINSON

FOREWORD: JEREMY LEHRER

FLAME TREE
PUBLISHING

CONTENTS

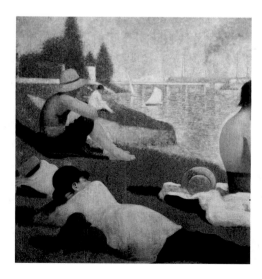

HOW TO USE THIS BOOK

Important Colour Information:

In this book, for each of the colours included we give values for each of the colour spaces: RGB, CMYK, LAB, HSB, Hex, Pantone and Websafe. The block of colour and the colour wheel that we show is only a rough guide to how that colour will appear, and should be used simply as a starting point. Because you are looking at a printed book that uses CMYK technology, the colour that you see uses the CMYK version of the values; the colour may not necessarily look the same in an RGB environment, for example. You should therefore trust the values that are given and ensure that you match the right colour-space values to the right medium (CMYK to print, RGB to websites, etc) to get a true representation of your desired colour.

This book is divided into three sections: **The Theory of Colour**, **The Colours** and **Colour Theorists**.

Each colour featured in **The Colours** section is dealt with on two spreads.

The first spread introduces the colour, with a defintion of it; technical information about how to reproduce what you see on the page; and common colour combinations in order to view how the featured colour combines (or does not combine!) with a variety of other primary, secondary and tertiary colours.

The second spread is designed to provide insight and inspiration into the featured colour. Colours do not exist in isolation; each has developed an unique history and set of associations over the years which are explored here. On this spread, we offer a variety of real-world examples to show how the featured colour is used and can be seen in everyday life: in nature, ceramics, interior design, graphic design, architecture, fashion and textiles, and fine art.

For ease of comparison, we have grouped the colours as follows:

Shades: Black, White, Grey, Slate, Silver
Primary: Red, Blue, Yellow
Secondary: Green, Orange, Violet

Tertiary, arranged as follows:
Red-Orange; Yellow-Orange; Yellow-Green; Blue-Green; Blue-Violet; Red-Violet

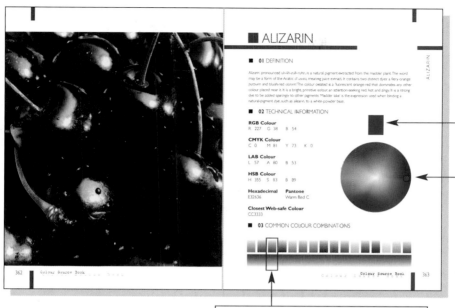

A rough guide to how the colour may appear in print or on screen and an indication of where it is to be found on the colour wheel

Isolate each colour on the top row to see how it combines with the featured colour below it

Colour bars make it easy to identify a specific colour or group of colours when flicking through the book

HOW TO USE THIS BOOK

INTRODUCTION

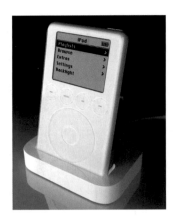

We live in a world of colour. Everything we see is made more impressive through it or remarkable by lack of it. Colour is in the flora and fauna; the sky and sea; in natural foodstuffs and man-made objects. Colour plays a part in your identity. You are perceived by what you wear, be it a business suit, uniform or casual clothes. Your personal possessions such as a car, mobile phone, laptop, MP3 player or just the pen you are writing with, are, to a certain extent, chosen by colour.

When humankind first walked on earth they *viewed* colour as we do today; it is only through Sir Isaac Newton's discovery, that colour originates in light, that we *understand* how it is created. As Newton discovered, white light is made up of six different colours of the spectrum, namely magenta, red, yellow, green, cyan and blue. Every opaque object we view is generally seen as a result of white light illuminating it. If the object is white it will reflect all the light and absorb none; if it is black will absorb all of the light and reflect none. An object will reflect only the red part of the spectrum and absorb the green and blue light if the object is red, while a magenta-coloured object will reflect red and blue light and absorb the green. This is how colour is seen.

The eye has three receptors, called 'cones' which perceive colour when stimulated by light-waves; one receives blue through a short wavelength; the second, slightly longer wavelength, produces green and the third one, red, is the most sensitive and produces the longest wavelength. To understand this 'vision' of colour, a methodology has been created and 'additive synthesis' and 'subtractive synthesis' are the expressions used to differentiate between colour created by light and colour created by pigments. Colour formed through light is an additive synthesis; a subtractive synthesis refers to chromatic pigment for painting.

The *Colour Source Book* explores colour theory from ancient Eygpt to the present day. The theory behind the colour wheel, complementary colours, RGB, CMYK, HEX terminology and web colours are explained. Ninety-two colours are outlined by definition, history and culture. Specific examples of the natural world and architecture, fine art and textiles, ceramics and graphics are given to each colour, to explore its diversity of use. The comprehensive bibliography will guide you to further exploration.

FOREWORD

Hanging on the wall next to me as I write this is a reproduction of Vasily Kandinsky's *Farbstudie Quadrate Mit Konzentrischen Ringen (Colour Study of Squares with Concentric Rings)*. The 1913 painting shows a grid of twelve unique combinations of circular shapes and hues. Kandinsky created this and other compositions as part of his ongoing investigations into colour's metaphorical and metaphysical meanings; artists, designers, scientists, psychologists, nationalists, marketers and anthropologists both before and after him have undertaken similar explorations, considering the significance of colour as it relates to their area of expertise, passion or communicative purpose.

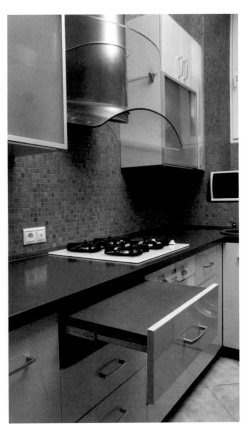

In addition to its visceral effect on our state of mind, colour embodies a narrative of history and meaning, relating to the value of a colour and its role within a culture: we might recognize green as the emblem of Irish Catholics, but it is also, interestingly enough, the colour of Mohammed. Red dye was highly valued by the Aztecs because their method of making it necessitated one million female cochineal beetles for a single pound.

In contemporary art and design, Pedro Almodóvar's set decorator must make careful consideration of the colours – in the form of curtains, furniture, carpets – that would be most fitting for the director's storylines and lush celluloid palette. And designers for major companies wonder what particular shade will be the most effective in embodying a client's ethos. It goes without saying that in the age of the brand, colour can help build customer loyalty. The telecommunications company Orange has its eponymous hue, which carries associations of happiness, enjoyment and sociability. For its logo, beauty products' firm Nivea uses blue, bearing connotations of cleanliness and good health.

Every colour, every Pantone chip, every CMYK combination, is a word in a vocabulary. Just as reading the classic books helps us to become more literate and better able to appreciate literature, and, if we are so inclined, to compose it, so we can gain a similar benefit from understanding the history of colour more deeply and making practical investigations into the application of it. Certainly Kandinsky, from his studies, developed a more profound appreciation for the subtleties and symbolism of different compositions. He described yellow as having an 'irresponsible appeal' and white as 'a great silence'.

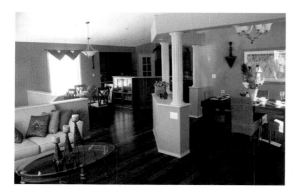

This book will allow you to articulate better the legacy and associations of a particular colour, and it offers a guide for practical, pragmatic and esoteric purposes. You can consider how Titian and, later, J. M. W. Turner employed vermilion. If a designer, you will be certain that your printer will be able to match the precise shade that you have chosen, and you can rest assured that your colour scheme will reproduce well on a computer monitor. But whether or not colour plays a role in your professional pursuits, a fluency in the rich stories of colour and the way it is perceived can be an aid in choosing the best decorative flourishes for your living room or in even more down-to-earth ventures: the fact that deadly fumes from toxic pigments in bright-green wallpaper may have contributed to Napoleon's premature death can make for a marvellous icebreaker (morbid, perhaps, but interesting nonetheless).

Colour defines the palette of everyday life; understanding its traditions heightens our perception of visible light, drawing us into a vast spectrum of ideas, narratives, cultures and memories. Over time, various inks and paints have been made from sources including charcoal, lapis lazuli, cuttlefish and arsenic. Just as we might not recognize these original raw materials, their remnants are still there, still present in the final pigment. Similarly, history and meaning remain embedded in the colour, explaining to us why artisans used blue to paint the crowns on a pharaoh's sarcophagus, or why cerise is associated both with Hollywood glamour and British consumerism.

Jeremy Lehrer 2007

THE THEORY OF
COLOUR

In February 1909 a group of young Italian artists and writers, led by poet and writer
Filippo Tommaso Marinetti and collectively known as the Futurists, published a manifesto
in the French newspaper *Le Figaro*. It defined the importance and difference between seeing
colour and depicting colour: 'How can we still see a human face as pink … The human face
is yellow, it is red, it is green, it is blue, it is violet. The pallor of a woman looking into a
jeweller's window is more iridescent than all the prisms of the jewels that fascinate her.
Our pictorial sensations cannot be expressed in whispers …'.

The Futurist manifesto specifically singles out colour as the most important aspect of life
and reflection of it. On the following pages colour theory is discussed, introducing some
of the many theories put forward, from ancient to modern times, to explain how we see
colour and, the various methods of depicting it. Until Sir Isaac Newton's discovery in 1666
that colour emanates from light many renowned philosophers, scientists and academics
put forward ideas to explain colour and how it is perceived. Following Newton's discovery
the theory of colour was further developed. Through colour analysis the definitive 'Colour
Wheel' was created. The *Colour Source Book* explores the history and theory of colour
and the difference between colour perception and depiction.

COLOUR THEORY

Colour originates in light. This discovery was made by the English physicist Sir Isaac Newton (1642–1727). Through experimentation he discovered that all the colours of the spectrum are present in white light. His theory changed the earlier perceptions of how we 'see' colour.

Since ancient times the challenge has been to understand what colour is and how it is created and visualized. The earliest theories emanated from ancient Eygpt and India. In ancient Greece various viewpoints were debated: one, that colour was a surface substance, which was visible through various natural resources such as water. The mathematician Pythagoras (c. 582-507 BC) linked colour to musical scale and the position of the planets and stars. The philosopher Plato (427–347 BC) in his dialogue *Timaeus* (written c. 360 BC) concluded that the eye transmitted rays of 'vision' toward an object. Aristotle (384–322 BC) related colour to the time of the day; he noticed that colours had contrasts. He defined seven colours, plus black and white.

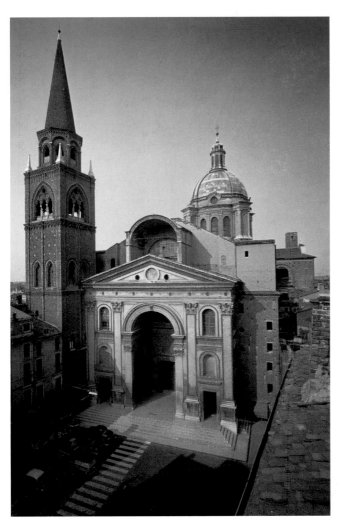

During the Italian Renaissance, particularly in Florence and Rome, theorists aimed to devise a formulaic system. Leon Battista Alberti (1404–72) published his treatise to explain the phenomenon of colour and light in *Della Pittura* (*On Painting*, 1435). Leonardo da Vinci (1452–1519), using his observation of nature, began his theories on colour perspective in 1492. He advanced the idea that air took its colour from humidity and that sky was a reflected colour, with only the appearance of blue.

Church of Sant'Andrea by Alberti, one of the first colour theorists.

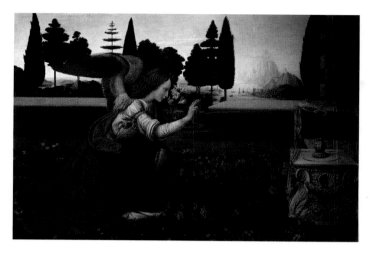

Da Vinci makes striking use of colour against a subdued background in *Annunciation*.

Diverging from previous intellectual theories, Sir Isaac Newton turned to scientific experiment, to understand the colour spectrum (known as the electro-magnetic spectrum). In 1666 his use of a prism revealed that light is not one colour but many. His revelation, that colour was refracted through a prism of light, led him to create a new theory and chart, of colours. German writer Johann Wolfgang von Goethe (1749–1832) disagreed with Newton. He based his theories, published in *Zür Farbenlehre* (*Theory of Colours*, 1810), on the eye perceiving colour, rather than Newton's theory on light as the source.

Newton and Goethe spurred others to follow. The French chemist Michel-Eugène Chevreul (1786–1889), director of the Gobelins factory in Paris, published *De la loi du contraste simultané des couleurs et de l'assortiment des objets colorés* in 1839 (*The Principles of Harmony and the Contrast of Colours*, translated in 1854) to formalize the colour wheel. Taking this forward, American artist Albert Munsell (1858–1918) created a colour tree, based on hue, value and chroma. Johannes Itten (1888–1967), an art teacher at the Bauhaus, theorized that a person's reaction to colour was a spiritual sensation.

Others have followed. The theory of colour will remain a subject in the present tense.

Johannes Itten demonstrates his notion of contrasting colour in *Circles*.

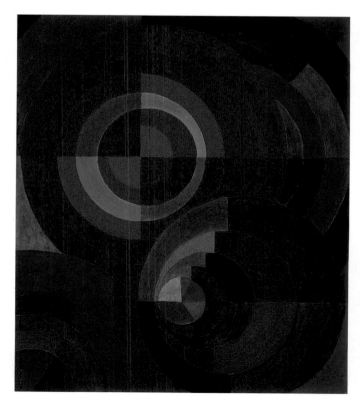

THE COLOUR WHEEL

Various diagrams have been created in the past by philosophers, scientists and artists, to aid colour classification based on perception. Earlier theories have led to the formation of the colour wheel in use today. The aim of the wheel is to illustrate primary and secondary, complementary and tertiary colours; a circle of light-dark and cold-warm contrasts. The 'wheel' is based on six colours in the optical spectrum: violet, blue, green, yellow, orange and red, the same that are visible in a rainbow.

The present-day colour wheel has three primary colours (red, yellow and blue) placed at equidistant points. Secondary colours (green, violet and orange) lie between the two primary colours of which they are comprised. Tertiaries, in order of tonal value, follow the secondary colours around the circle. Complementary colours are those that lie directly opposite each other on the colour wheel. The absorption of certain colours of light by an object and the reflection of others produce colours of different wavelengths. Violet is the shortest wavelength and red is the longest. This determines the colour position on the wheel.

Top: an old RYB (red, yellow, blue) wheel, containing primary and tertiary colours.

Bottom: a modern colour wheel with the addition of secondary colours.

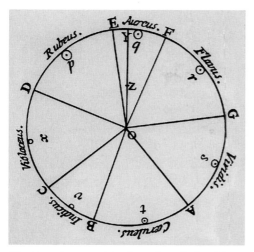

Newton attempted to show the relationships between the colours in his colour circle.

For every colour theory there has been a variation in its visual representation: charts, triangles, spheres, circles, a 'tree' and a 'star'. Isaac Newton recognized a 'circle' of seven colours (c. 1666): indigo, violet, blue, red, orange, yellow and green, but the first attempt to create an ordered system was in 1758, by Tobias Meyer (1723–62) an English scientist. He devised a triangle of primary red, yellow and blue on the angles of the triangle, followed by secondary and tertiary colours within it.

The first colour wheel (1766) is accredited to Moses Harris (1731–85), an English painter who illustrated three pigment primaries in a circle of 18 hues. A major step forward came in 1809, when Philipp Otto Runge (1777–1810) created a colour sphere, although white and black were opposites and red, blue and green were the primary colours. Later, American art-school lecturer Albert Munsell produced a 10-point colour sphere, a numbered 'tree' on which gradations in saturation could be identified.

Each diagram and theory has helped to move the debate and illustrative technique forward. The present-day colour wheel is based on Johannes Itten's 12-point star, which he devised at the Bauhaus in Weimar in 1921. It is an adaptation of Otto Runge's sphere and illustrates gradations of colour and complementary and analogous hues; the basis of the colour wheel in use today.

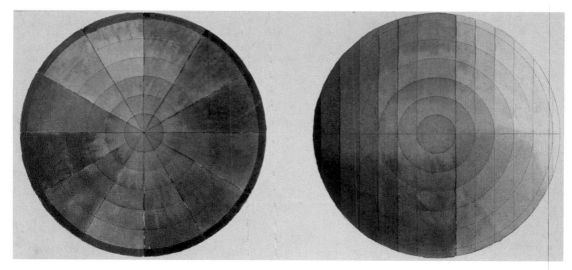

Otto Runge's colour circle gradates colours from pure hues to white in seven steps, from outside to inside.

COMPLEMENTARY COLOURS

The Spanish artist Pablo Picasso (1881–1973) remarked, 'Why do two colours, put one next to the other, sing? Can one really explain this? No.'

Picasso was referring to the extensive experiments in colour juxtaposition in Paris by a number of artists of the previous generation, including Georges Seurat (1859–91) and Paul Signac (1863–1935). His contemporary Henri Matisse (1869–1954) was also interested in this phenomenon, one that was to come to the fore in the Fauvist experiments between 1905 and 1907. Their ideas were to use colour as the form of a painting to create depth, dynamism and vitality with a subject on canvas, using complementary colours.

A complementary pigment or paint colour is one that faces its opposite on the standard colour wheel. The opposite of a primary colour will always be the secondary colour made from the other two primary colours. So in a standard yellow, red, blue colour wheel the respective complementary

Paul Signac's use of blues and oranges, and reds and greens in *Au Temps D'Harmonie* demonstrates his interest in the properties of complementary colours.

When placed together, complementary colours make the other appear brighter.

colours are purple, green and orange. The complementary of red is therefore green and vice versa. Complementary colours can also be extended to the tertiary colours, so for example if red and orange are mixed to make vermilion, then its complementary colour is the combination of blue and green which makes aquamarine. The effect of juxtaposing complementary colours in painting is to 'brighten' and highlight its opposite colour, adding dynamism and stability even in colours with a strong hue.

The CMYK process colours act in a similar way to paint pigment except that the primary colours are cyan, magenta and yellow. The secondary colours are formed the same way as they are in pigment, namely violet, orange and green, being the product of mixing the two other primary colours. However, because the primary colours are different, the complementary colour will be as well, even though it sits opposite on the colour wheel. Yellow and magenta, for example, when mixed produce orange, its complementary colour being cyan.

In the RGB (red, green, blue) model, since the primary colours are different to pigment and process colours, it follows that the secondary, tertiary and ultimately complementary colours will also differ. However, the principle is still the same in that a colour's complementary is on the opposite side of the wheel. The complementary colours of red, green and blue are respectively cyan, magenta and yellow, again being a mix of the other two primary colours. For example, red light and green light added together produce yellow light, its complementary colour being blue light.

When used successfully, complementary colours can enhance a web page or brochure.

welcome

catalogue

services

location

CMYK, RGB AND HEXADECIMAL COLOURS

There are three models used in the creation of and definition of colour, depending on the application. The CMYK model is used in printing, RGB for light creation and hexadecimal for computer and web-design applications.

CMYK is the standard colour process used in printing.

CMYK consists of the three primary colours: **c**yan, **m**agenta and **y**ellow, plus black (**k**ey). It is a subtractive process that adds pigments together in any combination of the three primaries to make another colour. In theory all colours can be made from this process. Although a combination of all three will produce black, in printing this is not usually pure enough and additional black, or key colour, is added. It is usually known as the four-colour process, since the original colours are all 'process' colours. Values for CMYK are expressed as percentage hues of a process colour. For example, the colour cyan is 100 per cent cyan process colour with none of the other three colours, while cinnamon is comprised 16 per cent cyan, 60 per cent magenta, 82 per cent yellow and 51 per cent black.

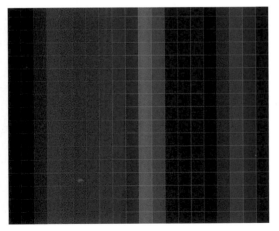

An RGB colour space. RGB colours cannot be reproduced exactly in print as they are a mixture of coloured light.

RGB is used in colour light application where the three primary colours are red, green and blue. Together they make white light, and a total absence of light will create black. In theory all colours can be made from mixing these primary colours, but in reality the range is not as subtle as CMYK process colour. RGB is known as an additive process. Practical applications for this model are stage lighting and television colour reproduction, whether cathode-ray tube or plasma screen. RGB values are specified as a whole number in the range of 0 to 255 for each primary colour. For example white would be expressed as 255, 255, 255 and cerulean blue would be specified as 0 (red), 123 (green), 167 (blue). These values are known as true colour.

A simple chart showing RGB colours (left) and CMYK colours (right) with shades in between.

Hexadecimal is a colour-notation system based on the RGB model, devised specifically for computer use and more particularly in HTML applications for web design. The values are expressed as a six-digit number based on the RGB model but using the range 00 to FF instead of 0 to 255. For example, black is represented as FFFFFF in hexadecimal (0, 0, 0 in RGB) and cerise is shown as DE3163 (222,49,99 in RGB). It is straightforward to convert from RGB to hexadecimal and by using the latter format, over 16 million colours can be more accurately specified in computer and web-design applications.

The RGB/Hex system is used on screens (TV and computer). RGB colours must be converted to CMYK before they can be printed out.

WEB COLOURS

Web colours are those that are used in the design of web pages for use on a computer.

These are comprised of the RGB colours and are shown in their basic format as a 12-colour wheel made up of three primary (red, green and blue), three secondary (yellow, cyan and magenta) and six tertiary colours (orange, chartreuse, aquamarine, azure, violet and fuchsia). Originally most computers were only able to display a maximum of 256 colours and so the industry decided on a standard format use of only 216 colours.

Successful web pages may only use two or three carefully selected colours.

This allowed for certain colours to be used as standard browser colours, for example for menus. These 216 were known as the 'web-safe' colours. Although today it is now possible to recreate over 16 million colours on the web, in reality 147 are used with any regularity and, of those, 16 are used most consistently (black, white, grey, silver, red, maroon, purple, fuchsia, green, lime, olive, yellow, blue, navy, teal and aqua.)

Web designers may be carried away with the variety and choice of colours that are at their disposal, but in reality they use a fairly consistent palette and follow some golden rules. Web pages are, after all, designed to convey information in a clear format using

Many web pages use a minimum of colours for maximum impact.

A bright background and eye-catching use of contrasting colour is simple and effective.

harmonious colours. Not surprisingly then there is usually a base colour (which is often a corporate colour), an analogous second colour (usually for the text) and a third colour used for highlighting. For example, a base and analogous colour scheme may well be in the range yellow, orange and red. The third colour may well be a complementary of orange, being the middle colour of the range, which would be blue. However, designers are also likely to use what is known as a triad of colours, that is three equidistant colours on the colour wheel, for example, aquamarine, violet and orange. There are certain combinations to avoid since the text is hard to read, for example red on either blue or green.

Other considerations are the hue (intensity), saturation (vibrancy) and value (brightness) of colours that control the eye's reception of the colour and how it contrasts with the juxtaposed colour. Thus yellow, a warm colour that advances toward the viewer, works well against a blue background that is a cooler recessionary colour. Paradoxically, it is not always complementary colours that offer the highest contrast. Most web pages do not require high levels of contrast to make an impact, usually considering other factors, such as the psychology of certain colours.

A combination of red, navy and white is clear and authoritative.

THE
COLOURS

The following pages illustrate 92 colours on the colour wheel: primary, secondary and tertiary.

Each colour is spread over four pages. **The first two-page spread** includes a large illustration of the colour and a definition of it. This includes technical information on RGB, CMYK, LAB, HSB, HEX and Web-Safe colours. Common colour combinations are illustrated.

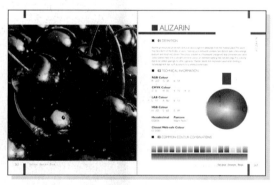

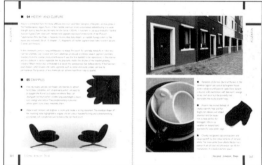

The second two-page spread gives the history and culture of the colour with illustrated examples from the world of architecture and fine art, interior design and graphics, ceramics and textiles and the natural world. In this format each colour can be explored through its diversity of origin and its link to ancient methods of accruing pigments with which to decorate ceramics, glass, wall frescoes or oil paintings. Modern synthetic-pigment replacements are discussed.

The symbolism of individual colours is considered in the light of ancient and present-day depictions and how and where colour is used in interior design. Useful direction is given for room settings and how to use accent colours in furnishings and textiles. These are just a few of the informative facts and discussion points raised in the colour-wheel range of 92 colours.

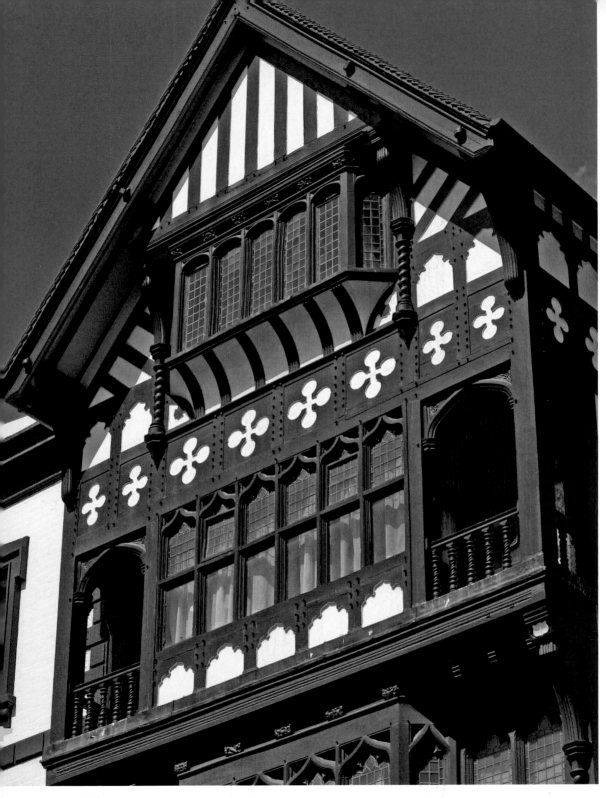

Colour Source Book

■ BLACK

■ 01 DEFINITION

Black is all colours, totally absorbed. It communicates absolute clarity, with no fine nuances and works particularly well with white. It is the colour of evil and disaster and yet black is frequently worn for official functions and in the world of business. Black is essentially an absence of light, since no wavelengths are reflected and it can, therefore, be menacing; many people are afraid of the dark.

■ 02 TECHNICAL INFORMATION

RGB Colour
R 0 G 0 B 0

CMYK Colour
C 76 M 71 Y 65 K 81

LAB Colour
L 0 A 0 B 0

HSB Colour
H 0 S 0 B 0

Hexadecimal **Pantone**
000000 Process Black C

Closest Web-Safe Colour
000000

■ 03 Common Colour Combinations

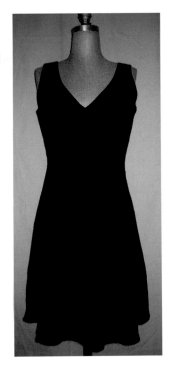

■ 04 HISTORY AND CULTURE

Being a non-colour, black only 'happens' when an object is absorbing all the coloured wavelengths. Many of the Impressionist painters were in agreement with this idea when they claimed that there was no black in nature and stopped using black pigment in favour of blue, yellow and red. This may be true, but a picture does not seem real until lowlights or shadows are included. Charcoal was probably man's earliest pigment as it was available anywhere there had been a fire, as was manganese dioxide. Analysis of prehistoric cave paintings proves this is the case. Ink was well-established in both Egypt and China 4,000 years ago and was probably introduced into Europe by Arabs in medieval times.

Black paint has variously been made of soot, galls, peach stones, vine twigs, bones and ivory. In Western culture, black often represents death and it is traditional to wear black clothes as a sign of mourning. It is also seen as glamorous and sophisticated, promoting the idea of efficiency and security.

■ 05 EXAMPLES

■ Coco Chanel (1883–1971) introduced the world to the little black dress in 1926 and it since has become the epitome of timeless fashion and remains the height of chic, knowing no boundaries of society, style or size.

■ Black, white and silver were the defining shades of the Art-Deco era. Designer Jean Dunand (1877–1942) showed this Smoking Room at the Paris Exhibition in 1925, with black and silver lacquered panels lining the walls and fabrics inspired by African and Abstract art.

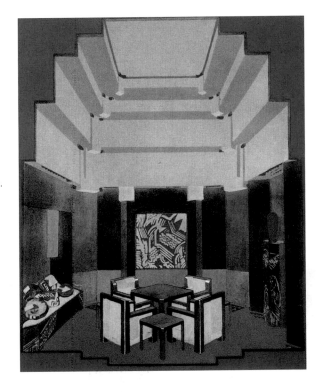

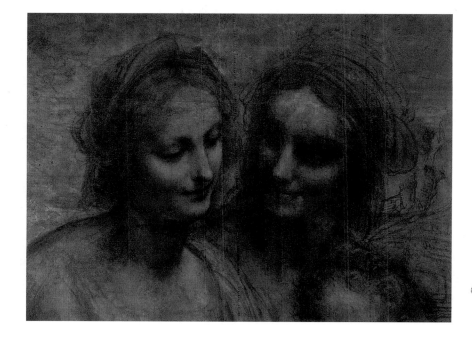

■ Leonardo Da Vinci's (1452–1519) exquisite cartoon, *Virgin and Child with St Anne and St John the Baptist* (1506/08) was drawn with black and white chalk and charcoal: all soft, simple materials to smooth in the highlights of the Christ Child's shoulder and the tenderness of a mother's face.

■ Black has always been the ultimate in rock-star chic. Guitar manufacturer Fender have combined classic style with new and innovative designs to create the Aerodyne Stratocaster, made of black rosewood as the ultimate rock-star guitar.

■ In recent times Japanese design has been associated with 'Zen' minimalism, yet this has been an historical exception rather than the rule. Ceramics certainly do not come much more luxurious than this ornate ewer and basin in black and gold made by an unknown craftsman at some point in the seventeenth century.

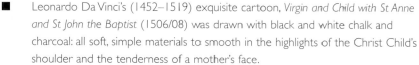

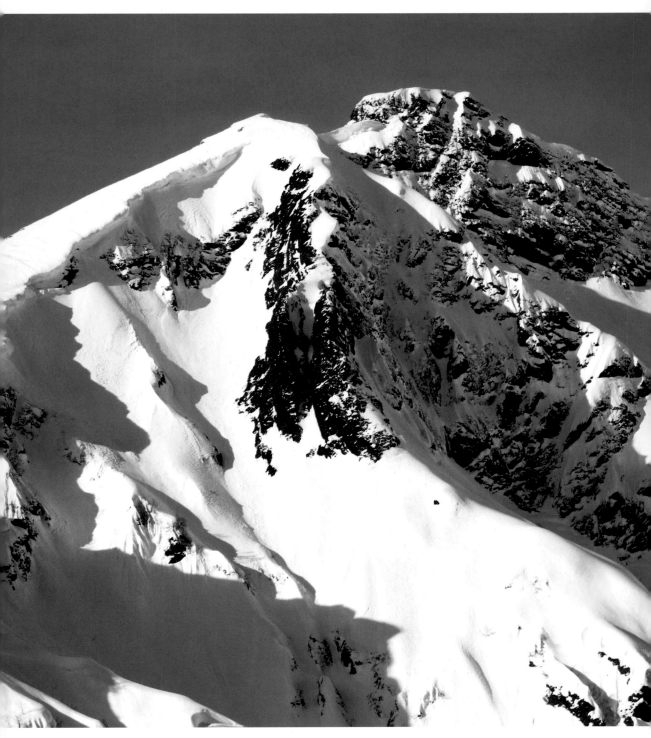

□ WHITE

■ 01 DEFINITION

The artist Vasily Kandinsky (1866–1944) referred to white as 'a great silence that shrouds its life from our understanding … not a dead silence but one pregnant with possibilities'. Kandinsky saw it as pure untainted nothingness that was the world before the birth of anything. Today we still think of white as that 'pure nothingness', using it as a foundation for painting, drawing and writing our 'possibilities'.

■ 02 TECHNICAL INFORMATION

RGB Colour
R 255 G 255 B 255

CMYK Colour
C 0 M 0 Y 0 K 0

LAB Colour
L 100 A 0 B 0

HSB Colour
H 0 S 0 B 100

Hexadecimal **Pantone**
FFFFFF Cool Gray 1 C

Closest Web-Safe Colour
FFFFFF

■ 03 COMMON COLOUR COMBINATIONS

■ **04** HISTORY AND CULTURE

White has to be the starting point for all explorations of colour theory in the arts. Since painting – and for many centuries thereafter – the white pigment in paint was lead carbonate, the product being referred to as either lead white or flake white. During the late nineteenth century it became apparent that the lead was causing fatalities due to its toxicity. Although it is still recognized that lead white provided the most stable and tough permanence of any white paint, zinc white and titanium white have, during the last hundred years, gradually replaced it.

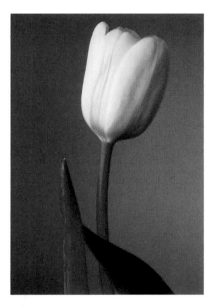

The Impressionists created a climate of change in the use of white and black paint, stating simply that these two colours did not exist in nature. In watercolour painting it is often the white paper ground that is allowed to show through instead of using white paint, but occasionally artists use Chinese white or body-colour to emphasize certain white characteristics in a work. In sculpture too, up until the twentieth century, most works were in white, reflecting Johann Winckelmann's notions of the 'ideal' human form from classical times. During the twentieth century, the epoch of Modernism, white came to symbolize the disposal of cluttered Victorianism, with its often, garish dark colours and the promise of a new beginning.

■ **05** EXAMPLES

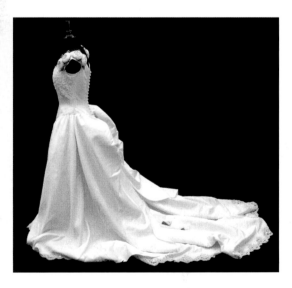

■ During the late sixteenth century the tulip, originally from Asia Minor, was introduced to the Dutch. By the 1630s 'Tulipmania' had hit Holland with huge prices being demanded for more and more exotic hybrids of the bulb. The simplicity of the white variety shown here is as delicate as any white flower, however common the species.

■ With few exceptions, most women in the Western world choose to be married in a white wedding dress, originally a symbol of their purity and chastity. This tradition began with the wedding of Queen Victoria and Prince Albert in 1840, in which she took the then-unusual step of wearing white, which until that time has usually been reserved as the colour of mourning!

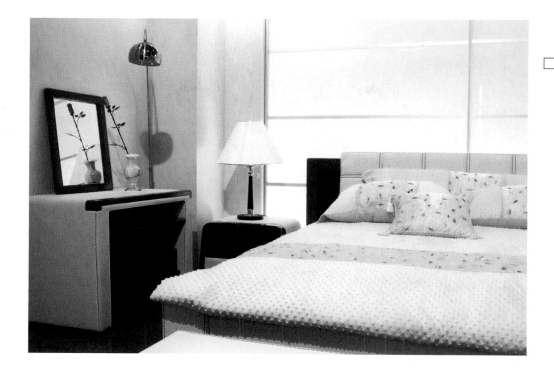

■ The cool (rather than cold) fresh look of this bedroom has been created using a predominance of white. However, the starkness has been tempered with the use of texture, in this case wood, stainless steel and a woven duvet cover. It works as a scheme because the reddish wood, which resembles iron oxide, relates to the steel through the natural world. The white provides the necessary backdrop and the unity within the scheme.

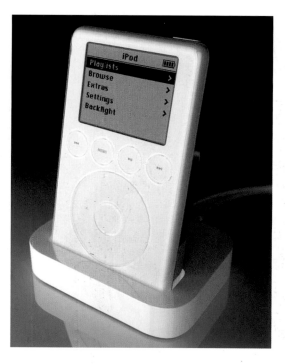

■ As with their previous products, Apple wanted to market a fashionable product that appealed to their existing market of art- and design-based users. Their products, also manufactured in white, became successful, but nothing could have prepared them for the overnight and runaway success of their iPod MP3 player, which has become the first iconic 'must-have' of the twenty-first century.

GREY

■ 01 DEFINITION

Grey is defined as the dulling of white. It is created in pigment by adding black and in light by adding equal amounts of light's primary colours red, green and blue. Grey is also produced when two complementary colours are mixed, for example yellow and violet. Grey therefore has no complement, since it is its own complement. Grey has neither positive nor negative connotations as a colour.

■ 02 TECHNICAL INFORMATION

RGB Colour
R 128 G 128 B 128

CMYK Colour
C 50 M 42 Y 38 K 2

LAB Colour
L 54 A 0 B 0

HSB Colour
H 0 S 0 B 50

Hexadecimal **Pantone**
808080 Cool Gray 9C

Closest Web-Safe Colour
999999

■ 03 COMMON COLOUR COMBINATIONS

■ **04** HISTORY AND CULTURE

Clearly the various shades of grey have always been in evidence in nature. The specific use of grey can be traced to twelfth-century stained glass in monasteries when certain holy orders forbade the use of colour. This style of monochromatic painting in shades of grey came to be known as *grisaille*. Monochrome figure painting can be traced to the Italian frescos of Giotto in the early fourteenth century at the Arena Chapel in Padua, intended to recreate the look of stone. This idea served as an inspiration to other artists of the period who often painted allegories with statues of figures, perhaps saints, painted in monochrome, while contemporary figures were painted in polychrome.

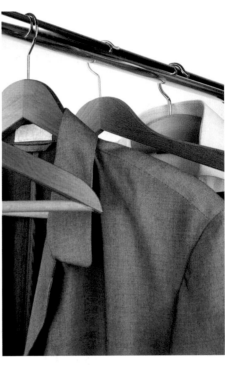

The boom in book illustration during the nineteenth century, which used photography and photogravure, saw the use of *grisaille* techniques for preliminary studies, being a more accurate method of determining grey tones. The twentieth century too has seen the use of *grisaille* and not simply to highlight a particular mood, the most startling example being Pablo Picasso's (1881–1973) *Guernica* (1936).

■ **05** EXAMPLES

■　Although the 'grey suit' came to signify the dull Whitehall mandarins during the 1980s and 1990s it has maintained its position as

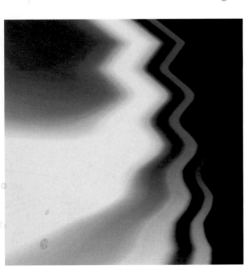

the favoured choice of most business people, professionals and bridegrooms. In a recent poll, the grey suit worn by Cary Grant in the film *North by Northwest* (1959) was voted the 'most legendary in the history of American cinema'.

■　This exciting pattern perfectly illustrates the versatility of monochromatic design, as there are fewer rules to be obeyed in their combinations, since black and white are each other's complements and grey has none. Following the colourful exuberances of the *fin de siècle*, the Modernist epoch saw simpler, cleaner graphics using monochrome, a theme that was exploited again in the 1960s and continues to be reinvented.

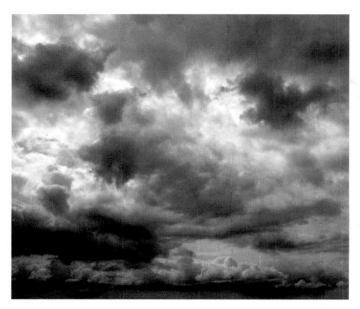

■ Probably our earliest childhood recollections of grey are naturally occurring rainclouds, which also seem to tinge everything around us with a grey hue. The English painter John Constable (1776–1837) made many detailed sketches in oil of cloud formations, which he used to great effect in his finished paintings, demonstrating the effect of 'grey light' on the landscape.

■ Even with this relatively limited palette, Adolf Friedrich (1824–89) has succeeded in creating a wonderful atmosphere of the impending storm and the flight of the travellers seeking shelter before it breaks in his *Horses Drawing Carts up a Hill* (1856). This technique, known as chiaroscuro, literally 'bright-dark', was used extensively from the sixteenth century to create effects of shadow.

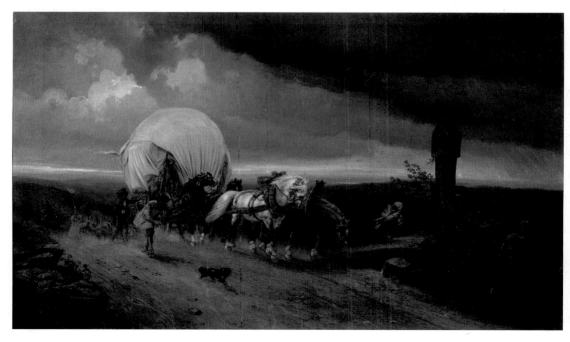

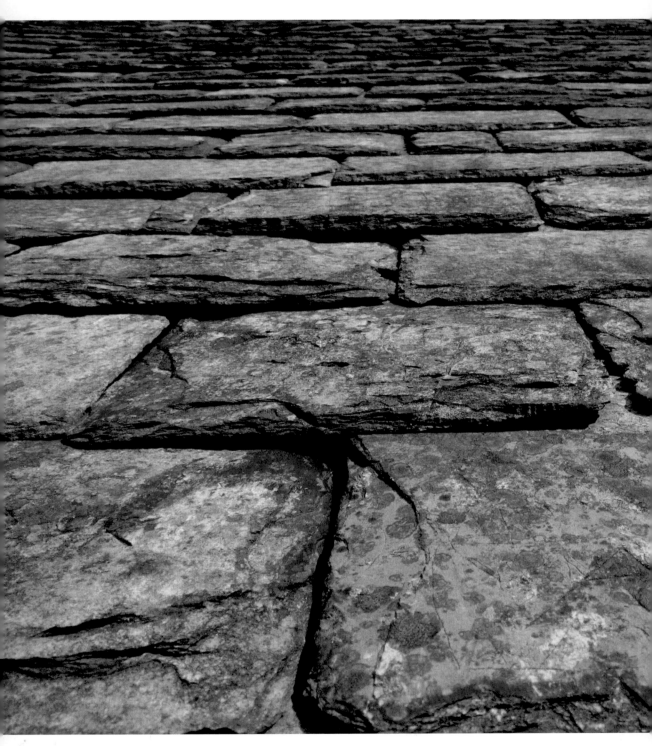

Colour Source Book

SLATE

■ 01 DEFINITION

Slate (aluminium silicate and carbon) takes its name and colour from the rock mineral. Depending on light reflection it can reveal cool hues of greyish blue to dark-greyish purple. It is a colour of medium intensity. Slate pigment was introduced in 1705. Payne's Grey Daler-Rowney, a composite pigment, is the nearest hue to slate. It is permanent with opaque to semi-opaque coverage. The colour suggests discreet sophistication, hardwearing fabrics, business-like attitude and longevity.

■ 02 TECHNICAL INFORMATION

RGB Colour
R 112 G 128 B 56

CMYK Colour
C 61 M 37 Y 25 K 4

LAB Colour
L 53 A -6 B -12

HSB Colour
H 210 S 22 B 56

Hexadecimal **Pantone**
708090DIC 2384s

Closest Web-safe Colour
669999

■ 03 COMMON COLOUR COMBINATIONS

■ **04** HISTORY AND CULTURE

Many colloquial expressions include the word 'slate' but they are not related to the colour, more to the use of the stone. Slate is a fine crystalline rock, derived from clay and silt sediments. The natural colour of the rock, which can range from mid-grey to purplish dark grey, gives the colour its name and value. Slate is used mainly for roof tiles.

Slate-grey colour is associated with Confederate Army uniforms during the American Civil War, 1861–65, (north versus south). The grey was in contrast to the opposing Union army of the North who wore deep-blue jackets and sky-blue trousers. In *Harper's Weekly* (17 August 1861) a sketch was published showing at least 26 different varieties of Confederate uniform. It highlighted the looser formation of the renegade army, in its initial stages of battle. The uniform colour was dark- to mid-grey jackets or trousers, which united the army by colour if not by style.

Slate grey remains a colour that is always 'in fashion'. Miucca Prada (b. 1950), the renowned Italian clothes designer, uses understated shades of grey to tone with soft whites and perennial black as a basis for many of her collections.

■ **05** EXAMPLES

■ The slate-grey metal door hinge evokes the Arts and Crafts ideology of late nineteenth-century Britain, in which ideally all building materials were sourced in local quarries and woods. The heavy oak doors would be dressed with metal hinges and held together by handmade rivets in a style reminiscent of twelfth-century medieval England.

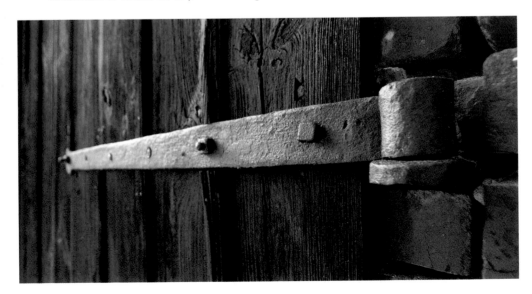

■ The greying tones of the natural world reveal the rich variety that exists in the monochrome spectrum. An overcast sky clouds the sunrise. Shafts of white light break through on a grey day.

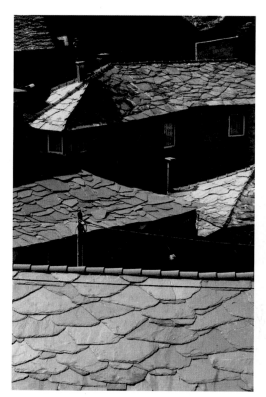

■ Handmade slates in varying sizes accentuate the non-organic but natural quality of the roof materials. In some cities and regions of countries, strict guidelines ensure that rooftops retain the original style of the buildings of the area. Local materials such as slate or terracotta are used and local craftsmen are employed to maintain the architectural history of the buildings and the area.

■ Business suits in monochromatic shades of grey could prove a dull wardrobe but textured patterns and striped fabrics enhance the varying shades of slate grey. The addition of a brightly coloured tie, worn with a pale cotton shirt would enhance the chromatic effect.

■ Computer monitors can be monochrome, grayscale or colour. This monochrome graphic uses variant tones of dark-light-dark shades of slate grey on a white background.

SILVER

■ 01 DEFINITION

Silver is a naturally occurring noble metal found in various parts of the world and extracted from mines. As a colour it is a metallic version of grey that is not easy to replicate since silver has a lustre that can vary according to the light source acting on it. Silver exudes a genderless classiness when used in graphic design or packaging, particularly when juxtaposed with a deep red or blue.

■ 02 TECHNICAL INFORMATION

RGB Colour
R 192 G 192 B 192

CMYK Colour
C 22 M 16 Y 14 K 0

LAB Colour
L 78 A 0 B 0

HSB Colour
H 0 S 0 B 75

Hexadecimal **Pantone**
C0C0C0 Cool Gray 4C

Closest Web-safe Colour
CCCCCC

■ 03 COMMON COLOUR COMBINATIONS

■ **04** HISTORY AND CULTURE

In ancient cultures silver was rarer than gold and therefore used on only the most expensive items of jewellery. It was particularly valued for its lustre when highly polished. It was also used for most of the world's earliest coinage, its use having disappeared from today's coins, which although silver coloured are in fact made from base metals such as nickel. The heyday for the use of silverware was in the Neoclassical period of the eighteenth century, taken to excess by the then Prince Regent (later George IV). Similarly at Versailles, silver furniture was made for the royal palace.

Until the twentieth century, artists who wanted to use silver colour in their work either used silver leaf and burnished it to a lustre or used grey to resemble silver. Today it is possible to buy silver (and gold) particles suspended in a medium allowing it to be applied as ink. When dry, with the medium evaporated, the particles shimmer. Winsor and Newton have also developed a silver oil colour that is made from aluminium flake.

■ **05** EXAMPLES

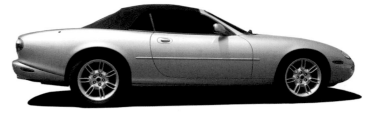

■ The colour silver now accounts for nearly one third of all manufactured cars in Europe, Japan and North America. Clearly there are differences in the colour's rendition depending on the shape of the vehicle and the colour and finish of the paint (for instance, pearlized or metallic). The graphic designer's job is to highlight these features when promoting his particular car to a market such as sports or luxury.

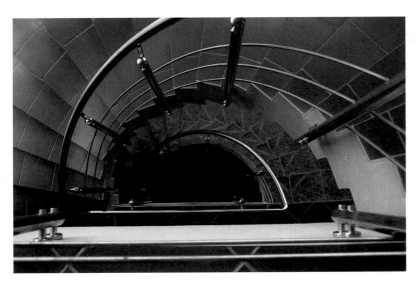

■ In this innovative piece of design the shape of the staircase becomes the dominant feature, which detracts from the functional but repetitive viridian tile colour. The peach colour serves gently to warm the scheme. The polished-chrome handrail and banister are reminiscent of Erich Mendelsohn's (1887–1953) architecture of the 1930s and provide a Modernist feel to the design.

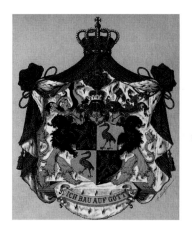

■ Although silver is one of only two metal colours used in heraldry, it is normally represented by grey, as in this case. The colour silver expresses nobility, peace and serenity and because it withstands fire is associated with the qualities of purity and chastity. The emblem here is religious and translates as 'I build on God'.

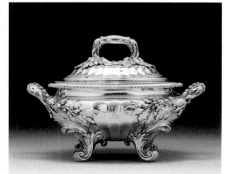

■ Although this Rococo-designed tureen may seem decoratively excessive, silver was used extensively for food in the eighteenth century because of its practical as well as decorative properties. Silver retains heat and is sterile and hygienic.

■ Jean-Baptiste-Siméon Chardin (1699–1779) was an eighteenth-century French artist who copied the Dutch tradition for still-life painting and then surpassed it with his staggering realism. There are few artists indeed who can replicate silver in a painting with such conviction. His subjects are usually humble and everyday, such as here in *The Silver Goblet* (c. 1728).

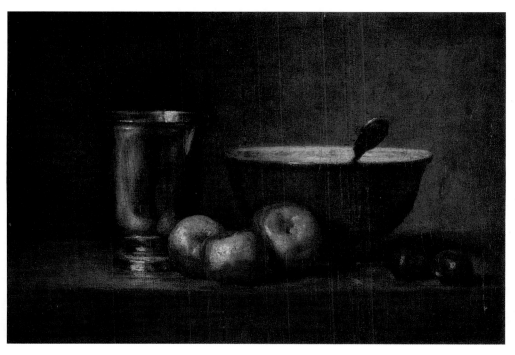

 # RED

■ 01 DEFINITION

Being the longest wavelength, red is a powerful colour. Although not technically the most visible, it has the property of appearing to be nearer than it is and therefore it grabs our attention first. One of the three primary colours, pure red is the simplest colour, with no subtlety. It is stimulating and lively and is the colour of fire and blood. As well as being friendly it can be perceived as demanding and aggressive.

■ 02 TECHNICAL INFORMATION

RGB Colour
R 255 G 0 B 0

CMYK Colour
C 0 M 99 Y 100 K 0

LAB Colour
L 63 A 90 B 78

HSB Colour
H 0 S 100 B 100

Hexadecimal **Pantone**
FF0000 172C

Closest Web-safe Colour
FF0000

■ 03 COMMON COLOUR COMBINATIONS

■ **04** HISTORY AND CULTURE

Cave paintings dating from around 18,000 to 10,000 BC are our first-recorded evidence of the use of the colour red. Prehistoric artists used an iron oxide called hematite or red ochre. The ancient Egyptians developed red paint from pigments they found in the soil and the Aztecs can be credited with the discovery of a red dye made from the cochineal beetle. Just 0.5 kg (1 lb) of water-soluble extract required one million female beetles: no wonder then that to the Aztecs the dye was more valuable than gold. The Spaniards introduced this colour to Europe in the 1500s and it was not until the nineteenth century that synthetic red pigment was available.

Red is traditionally viewed as the vigorous colour of health. Red wool was applied to relieve sprains in Scotland and to prevent fevers in Macedonia. The ruby was worn in China to promote long life. Red is the colour on the shields of heroes and famous achievers, such as Hannibal. In Eastern cultures it is a sacred colour used on festive occasions. Red is the colour of passion and the zest for life. It promotes an image of activity and motivation and is used on signs such as 'Stop' and 'Emergency'.

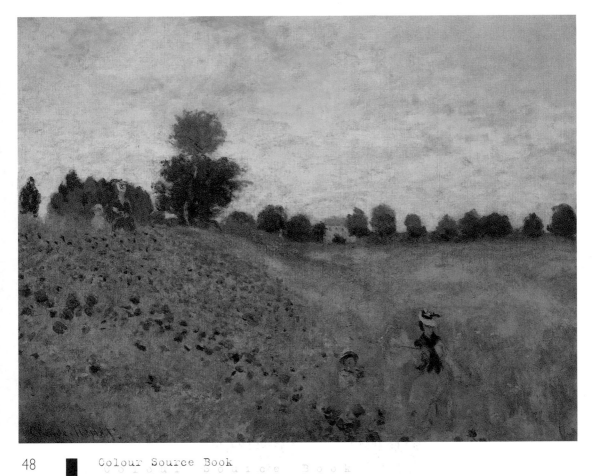

05 EXAMPLES

Claude Monet's (1840–1926) *Wild Poppies near Argenteuil* (1873, shown left) sees the artist experimenting with the visualization of pure colour within the landscape. He uses complementary colours, such as the red of his poppies and the green of the fields, blues and oranges and yellows, to create the vividness so associated with the Impressionist landscapes.

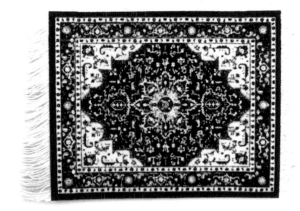

Persia was renowned throughout the world for its rugs and carpets (shown above). The carpets of Haris, made near Tabriz, the capital of Azerbaijan, are heavy and thick and known for their durability. The colour of their background is usually red or madder obtained from roots of herbs grown in nearby regions.

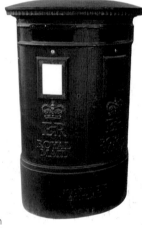

Green was chosen as the standard colour for the first British post (or pillar) boxes in early Victorian times, but people kept bumping into them so between 1874 and 1884 they were repainted in bright red silicate enamel. This was also the colour for telephone kiosks in 1924, although designer Giles Gilbert Scott (1880–1960) wanted them to be silver.

Red is the colour most often used to signify danger as it catches people's attention. Commonly found on road signs, it indicates drivers and pedestrians to stop, and to warn of potential hazards. Red is also the colour of brake lights and the 'stop' signal on traffic lights.

The red of Coca-Cola denotes power and high efficiency. Use of red is less frequent than blue due to red's obtrusiveness. Red is also the favourite colour of children.

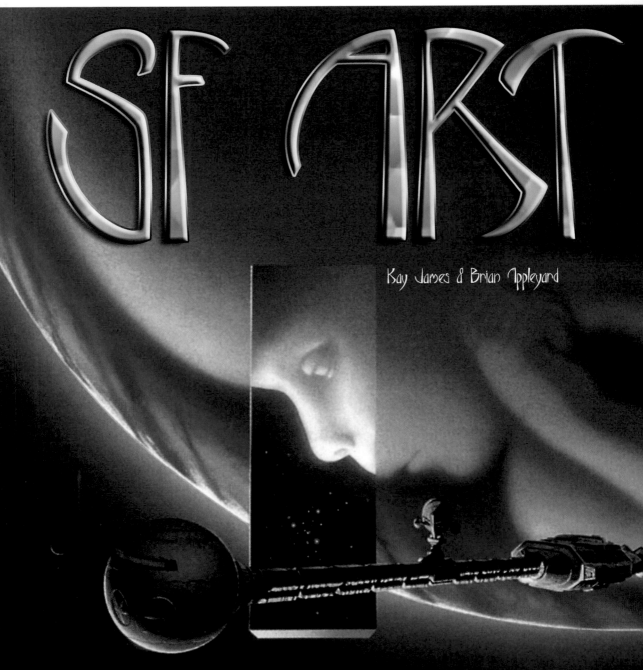

SF ART

Kay James & Brian Appleyard

Methods and Inspirations of the Greatest Science Fiction Artists

BLUE

■ 01 DEFINITION

Towards the end of the colour spectrum, blue is the colour of sky and water. The colour blue has a calming effect (UN soldiers wear blue helmets) and suggests cleanliness and freshness in household products such as detergents. Blue is also associated with fidelity: blue flowers such as violets symbolize faithfulness and in England brides traditionally wear 'something blue'.

■ 02 TECHNICAL INFORMATION

RGB Colour
R 0 G 0 B 255

CMYK Colour
C 87 M 66 Y 0 K 0

LAB Colour
L 30 A 69 B -114

HSB Colour
H 240 S 100 B 100

Hexadecimal **Pantone**
0000FF 2735C

Closest Web-safe Colour
0000FF

■ 03 COMMON COLOUR COMBINATIONS

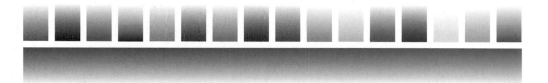

■ **04** HISTORY AND CULTURE

Discovered by the Ancient Egyptians 5,000 years ago, blue frit (or Egyptian blue) was the first synthetic pigment. Blue was an important colour in ancient Egyptian culture, symbolizing life (water) and the divine (the sky). As a divine colour, it was used to paint eyes, hair and crowns on statues of the pharaohs and on sarcophagi. At around the same time, ordinary Egyptians' adobe houses were painted with mineral pigments, including blue-copper sediment.

Ultramarine, first discovered in Afghanistan in the sixth century, was extracted from the semi-precious stone lapis lazuli. As the extraction process was complicated and labour-intensive, it was extremely costly. In medieval Europe ultramarine was highly prized by painters and reserved to paint the most revered subjects, such as the robes of the Madonna and Christ. In Renaissance times, it was more expensive than gold and far more stable than its poor relative, azurite. Vegetable dyes such as woad were also used in medieval times, mainly for dyeing cloth. Prussian blue, first produced by accident in 1704, was the first modern artificially manufactured colour. The pigment was available to artists by 1724 and has been used ever since. Cobalt blue was discovered in 1802 and provided artists with another source of pure blue colour.

■ **05** EXAMPLES

■ The Ishtar Gate was built in about 586 BC and was one of the main entries to the city of Babylon, capital of the Babylonian Empire. It was decorated with glazed brick reliefs, as seen here. The first plain tile glazes were blue and were made from copper.

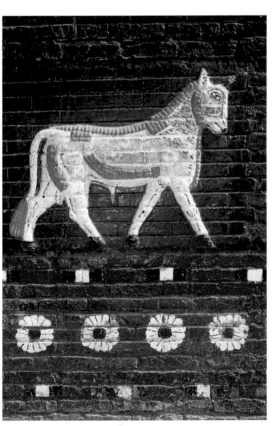

■ In Ancient Egypt, hippopotami were often modelled in blue frit or blue-glazed faience, because blue was considered a 'divine' colour. For this reason the River Nile was always coloured blue in grave paintings and the hippo was a popular symbol for this live-giving force. Blue frit was a synthetic pigment made by firing silica, copper and an alkali together.

■ The colour blue has long been used by companies for their logos, including German company Nivea. Blue is popular in Germany: with its positive connotations and evocation of cleanliness and good health it is the perfect colour to use for the packaging of Nivea's products.

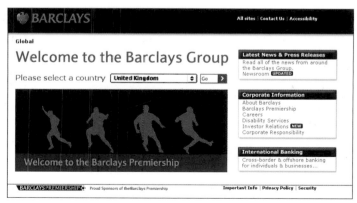

■ Blue eyes have an allure and charm beyond any other colour: in films, it is the blue-eyed, blonde-haired bombshell who gets her man. This book cover fuses a human eye with cartoon elements and special effects to produce an arresting, eye-catching image.

■ As a colour, blue is well known for its associations with security and authority. For this reason, it is chosen by many banks as their corporate colour to project an image of fiscal responsibility. Barclays Bank, for example, has made heavy use of different shades of blue in their website, imbuing the site with a feeling of security.

■ YELLOW

■ 01 DEFINITION

The yellow wavelength is relatively long, and so the yellow, one of the three primary colours, is the strongest colour psychologically. It is the colour of confidence and optimism, of corn, sunshine and gold, and is believed to strengthen analytical and precision behaviour. Too much of it, or the wrong tone in relation to the other tones in a colour scheme, can cause self-esteem to plummet, giving rise to fear and anxiety.

■ 02 TECHNICAL INFORMATION

RGB Colour
R 255 G 246 B 0

CMYK Colour
C 3 M 0 Y 99 K 0

LAB Colour
L 94 A -8 B 95

HSB Colour
H 58 S 100 B 100

Hexadecimal **Pantone**
FFF600 3955C

Closest Web-safe Colour
FFFF00

■ 03 COMMON COLOUR COMBINATIONS

■ 04 HISTORY AND CULTURE

Yellow pigments were used in the wall paintings in the cave of Lascaux 17,000 years ago. Yellow ochre was used by ancient Egyptians to depict skin tones or for painting backgrounds in their wall paintings. In ancient Egypt, Assyria and China, a poisonous yellow pigment derived from arsenic, orpiment, was used for paintings, walls and illuminated manuscripts. Indian yellow, used by Vincent Van Gogh (1890–1978) in his *Sunflowers* (1888) paintings, is believed to come from the urine of cows that had been fed mango leaves. Other more modern yellow pigments, such as Naples yellow and Chrome yellow, are derived from minerals, but poisonous too.

Yellow is a sign of pulsating life, but is also the colour of bile. In animal life, especially when mixed with black, it is a warning against being stung or bitten. In Asia, yellow is the colour of power: Chinese emperors were the only ones allowed to wear saffron-dyed robes. Yellow is the wedding colour for people in Egypt, Russia, the Orient and in some of the Balkan countries. As well as being a life-giving colour, it can signify illness and decline. A sallow complexion signifies illness and the yellow of leaves in autumn show that they are dying.

■ 05 EXAMPLES

■ The 1960s was when the era of hippies, free love, peace and flower power was in full swing. Flowers, in line with the ethnic look, were one of the key fashion trends and appeared on every possible garment including men's trousers, such as the yellow ones here, which have been teamed with complementary blue animal shapes and a blue background.

■ Yellow was Vincent Van Gogh's favourite colour: he preferred yellow ochre at the beginning of his career, adding the newly discovered pigments cadmium yellow and chrome yellow later on. He transformed the light in his landscapes into pure colour and used yellow in context with its complementary colour, blue, to great effect in *Wheat fields With Crows* (1890).

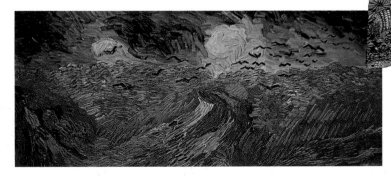

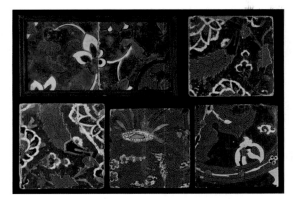

■ This group of tiles was produced in seventeenth-century Persia using the *cuerda seca* technique in which different coloured glazes are used on the same tile, separated by thin lines of grease. The principal colours used were blue, yellow, turquoise, pink, aborigine and green and the tiles are generally square.

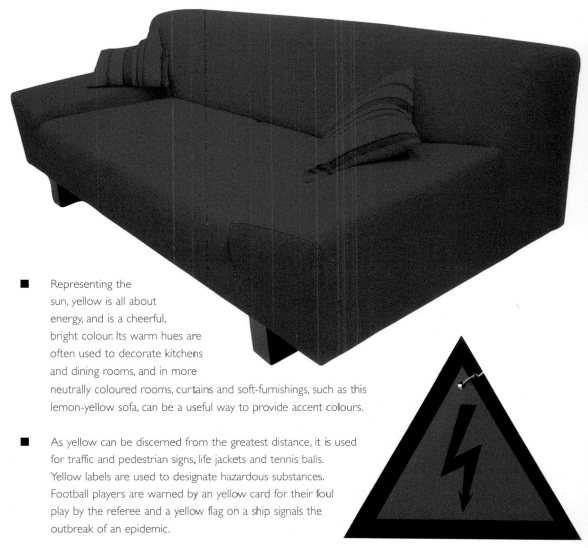

■ Representing the sun, yellow is all about energy, and is a cheerful, bright colour. Its warm hues are often used to decorate kitchens and dining rooms, and in more neutrally coloured rooms, curtains and soft-furnishings, such as this lemon-yellow sofa, can be a useful way to provide accent colours.

■ As yellow can be discerned from the greatest distance, it is used for traffic and pedestrian signs, life jackets and tennis balls. Yellow labels are used to designate hazardous substances. Football players are warned by an yellow card for their foul play by the referee and a yellow flag on a ship signals the outbreak of an epidemic.

■ GREEN

■ 01 DEFINITION

Green is in the centre of the colour spectrum and is the colour of balance, life, plants and spring. When the world around contains plenty of green, this indicates the presence of water and little danger of famine, so it is reassuring on a primitive level. Negatively it can indicate stagnation and, if incorrectly used in a colour scheme, will be perceived as being too bland.

■ 02 TECHNICAL INFORMATION

RGB Colour
R 0 G 255 B 0

CMYK Colour
C 50 M 0 Y 67 K 0

LAB Colour
L 83 A -128 B 87

HSB Colour
H 120 S 100 B 100

Hexadecimal **Pantone**
00FF00 354C

Closest Web-safe Colour
00FF00

■ 03 COMMON COLOUR COMBINATIONS

■ **04** HISTORY AND CULTURE

Although the green pigment chlorophyll has existed since the dawn of life four billion years ago, as a colour green was barely used during the Stone Age. Neolithic cave paintings do not contain any depictions of plants even if green earth pigments were available at that time. New gods entered the picture with the emergence of farming and green seemed to come to prominence in painitings. In medieval times it was the colour of love; in Christianity, conversely, it also represented demons and poisonous serpents.

Discovery of the pigment emerald in 1800 perpetuated green's association with poison. Emerald was prepared from verdigris and copper arsenite, resulting in one of the deadliest poisons ever used in painting. Napoleon Bonaparte's favourite colour was green and deadly fumes from his bright-green wallpaper may have led to his premature death. Green is the colour of the prophet Mohammed, and many Arabic countries have included green in their national flags as it symbolizes the unity of all Arabic nations. Establishment of the Green Party in Germany in 1980 brought this colour into politics. Green is the national colour of Irish Catholics as opposed to orange, the colour of the Protestant Orangemen who conquered Ireland led by William of Orange.

■ **05** EXAMPLES

■ This wallpaper design dates from the 1880s and was produced by William Morris (1834–96) during the Arts and Crafts movement. The muted greens that he used are typical of the whole ethos of the movement which was to bring back the idea of the artisan craftsman. Artefacts from this time were largely handmade and used natural vegetable dyes rather than the chemical ones that were all the rage at the time, resulting in the harmonious combination of colours here.

■ Kandinsky's picture *Improvisation 7* (1910) demonstrates the restful effect of the colour green. He believed that pictures painted

in shades of green were passive and tended to be wearisome; this contrasts with the active warmth of yellow or the active coolness of blue. Green is the colour of summer, the period when nature is resting from the storms of winter and the productive energy of spring.

■ In the 1990s the environment emerged as a concern among the wider population of the Western world and the colour green came to stand for organic, environmentally friendly

products: even lead-free petrol has been given green pumps at petrol stations. In people's minds, green symbolizes nature and the natural world. This is the international recycling symbol, with the arrows indicating the cyclical motion of materials being reprocessed.

■ The late 1960s and early 1970s saw an explosion of interest in natural colours for the home, particularly when combined with neutral beige. The contrast of the green walls with rest of the room is a particularly good example of this colour combination in action.

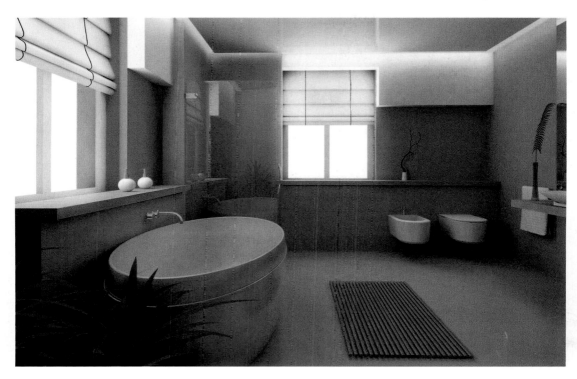

■ ORANGE

■ 01 DEFINITION

Since it is a combination of red and yellow, orange is stimulating and reaction to it is a combination of the physical and the emotional. It focuses the mind on issues of physical comfort: food, warmth, shelter and sensuality. It is a fun colour. Too much orange suggests frivolity and a lack of serious intellectual values.

■ 02 TECHNICAL INFORMATION

RGB Colour
R 255 G 127 B 0

CMYK Colour
C 0 M 62 Y 100 K 0

LAB Colour
L 73 A 57 B 85

HSB Colour
H 30 S 100 B 100

Hexadecimal **Pantone**
FF7F00 1505C

Closest Web-safe Colour
FF6600

■ 03 COMMON COLOUR COMBINATIONS

■ **04** HISTORY AND CULTURE

Such is the intensity of vermilion, it is rarely found in nature. During the period of the Roman Empire, Vermilion pigment was processed from cinnabar, a naturally occurring mineral that was mined in Spain. Cinnabar colour can vary between the brilliance of vermilion and the darker blood red. During the medieval period, vermilion, which was also known as minium, was extracted using a dry process invented in China about 2,000 BC (hence China red) and used in illuminated manuscripts because of its brilliance. By the seventeenth century most of the vermilion used in Europe was processed in Amsterdam.

During the Renaissance, Venetian artists such as Paolo Veronese (c. 1528–88) and Titian (c. 1488/90–1576) used vermilion in their painting, the latter's *The Entombment* (c. 1570) serving as a prime example. The colour was also used extensively in Venetian laquerwork during the seventeenth century. The English artist J. M. W. Turner (1775–1851) used vermilion in his expressive and experimental watercolours from the 1820s on. It was also favoured by some of the Fauvists in the early years of the twentieth century using colour to express form, as in Maurice de Vlaminck's (1876–1958) *Portrait of Derain* (1905).

■ **05** EXAMPLES

■ Silk weaving was developed in China at least 5,000 years ago. The fabric required a fine dye and so for vermilion, as in this example, cochineal was used. Cochineal is a parasitic insect, whose shell gives a range of red dyes that are waterfast. Due to the scarcity of the insects the dye produced was expensive and reserved for only the finest materials.

■ This painting by portrait artist David Cobley (b. 1954) is called *Red Glow* in which he uses vermilion to great striking effect. His paintings are imbued with either a blue or red background and, according to him, his studies of the human form are observations on solitude and longing. The red is highly emotive and suggests sexiness, passion and compassion.

■ Signage is an important aspect of a graphic designer's work. The colour of the sign is important, as is the typography. In this example the background colour is vermilion, a colour that moves towards the viewer as a warning. The white is a contrast due to its cool nature, thus making it easy to read.

■ This striking vermilion door is based on the doors of the Ming dynasty (1368 to 1644) palace in Beijing known as the Forbidden City. The Chinese flag is a gold motif on a red background and in this door there is a similar colour combination, emphasizing its regal and important status.

■ The Japanese quince is native to that part of the world and is rarely grown in Northern Europe. The flowers are usually vermilion in colour and the fruit is inedible when raw but can be cooked for use in preserves.

CHESTNUT

■ 01 DEFINITION

As the name suggests, chestnut is a warm red-brown colour akin to the fruit of the chestnut tree, or *Castanea* a genus of tree from the beech family. The horse chestnut is not related but is so-called because of the similarity of colour in the nuts. Chestnut as a colour is imbued with a sense of warmth making it an ideal hair colourant. The colour is also frequently used as a dye in cosmetics.

■ 02 TECHNICAL INFORMATION

RGB Colour
R 205 G 92 B 92

CMYK Colour
C 15 M 77 Y 60 K 2

LAB Colour
L 59 A 56 B 30

HSB Colour
H 0 S 55 B 80

Hexadecimal **Pantone**
CD5C5C 7416C

Closest Web-safe Colour
CC6666

■ 03 COMMON COLOUR COMBINATIONS

■ **04** HISTORY AND CULTURE

The colour is derived from naturally occurring iron oxides present in the soil and therefore as old as time itself. The coloured earth is mined and washed leaving deposits of red-stained clay. It is mined in different parts of the world and has a different texture and hue depending on location. In the case of chestnut, the large quantities of this soil in India have determined its name as Indian red, a painting pigment used for watercolour and water-based dyeing. As such it is an extremely permanent colour with a high degree of opacity. Because of these qualities, Indian red is also used as a pigment colour for egg-tempera painting. Today the red oxide is made synthetically.

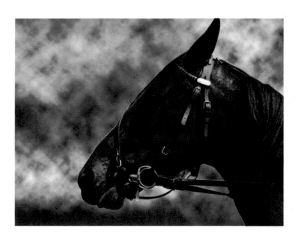

Chestnut hair colourant is today one of the most popular colours for women. It is made synthetically using a variety of chemicals, or is made from organic materials such as henna leaves mixed with naturally occurring staining materials, for instance herbal tea.

■ **05** EXAMPLES

■ The modern horse as we know it (*Equus Caballus*) originated in Europe and Asia and was imported by the Spanish into the Americas, after their conquests. A chestnut horse is not a variety or subspecies of the animal but is referred to as such by its reddish-brown-coloured coat. The chestnut is also the name of a part of the horse's leg behind its fetlock.

■ This species, prolific in the United Kingdom, is not related to the chestnut tree, but shares its name because of the similarity in the colour of its respective fruits. In autumn the green spiky shells of the fruit fall to the ground and are broken open to reveal the horse chestnut itself, colloquially referred to as a 'conker'. They cannot be eaten but are used instead to play the traditional game of conkers. In America the horse chestnut is referred to as the buckeye.

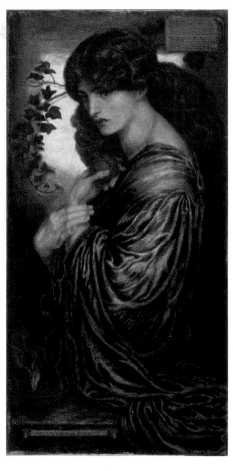

■ This warm chestnut fabric is likely to have graced a large number of sofas and chairs at the end of the nineteenth century, It is typical of many Arts and Crafts designs responding to a demand for warm, colourful and practical fabrics to be used in soft furnishing.

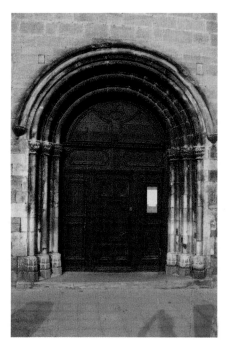

■ *Proserpine* (1882) by Dante Gabriel Rosetti (1828–82) is one of the best-known Pre-Raphelite images from the nineteenth century. This group of artists portrayed women in the role of mythical or legendary figures, usually with chestnut-coloured hair. Proserpine was the Roman goddess of Spring.

■ The magnificent sturdiness of this panelled church door, fashioned from oak and stained dark chestnut brown, has been elaborately carved to be both practical and decorative. Doors such as this are a common sight on churches and cathedrals throughout Western Europe, and are usually constructed of local materials, such as oak, which over time takes on a warm, rich hue.

Colour Source Book
Colour Source Book

BURNT UMBER

■ 01 DEFINITION

Burnt and raw umber are two colours from the same base pigment, an iron oxide that also contains manganese dioxide, with burnt umber being roasted in an open hearth to create a deep warm brown. It is a permanent colour that is also transparent when used as a watercolour and an oil paint. From the late sixteenth century the colour was used extensively in landscape painting to create warmth.

■ 02 TECHNICAL INFORMATION

RGB Colour
R 138 G 51 B 36

CMYK Colour
C 11 M 85 Y 91 K 22

LAB Colour
L 38 A 46 B 38

HSB Colour
H 9 S 74 B 54

Hexadecimal **Pantone**
8A3324 484C

Closest Web-safe Colour
993333

■ 03 COMMON COLOUR COMBINATIONS

■ 04 HISTORY AND CULTURE

Before the sixteenth century umber was hardly used in Western painting, the obvious exceptions being the Lascaux and Altamira cave paintings from the Palaeolithic period. One exception was fresco painting in which colours were specially selected for their ability to withstand the alkaline properties of the lime in the walls. Umber was one of the resilient pigments. From the late sixteenth century when Caravaggio (1571–1610) was espousing the effects of chiaroscuro, his palette was essentially limited to earth-colours including umber. Paintings from this time also show that umber was a popular colour for interiors, particularly for wall decoration.

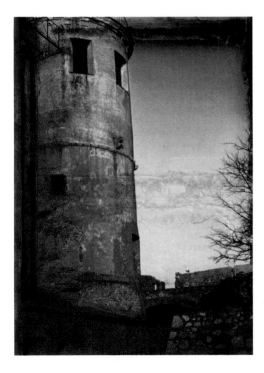

In the eighteenth century, umber was used as a tint in priming oil canvases, while in the nineteenth-century John Clayton and Alfred Bell succeeded in developing burnt umber and other colours not used before in medieval times, for stained-glass design to meet the demands of the then-fashionable Gothic-revival interiors. One of their finest works was the restoration of the enormous west window at King's College, Cambridge.

■ 05 EXAMPLES

■ This photograph of an old French prison fortress adequately demonstrates the colour difference between the raw umber of the circular wall and the burnt umber of the foreground wall. Although this photograph was taken on a sunny day, the pale-blue sky betrays the temperature, perhaps empathetic to the bleakness of the ancient prison.

■ The Grand Canyon is over 270 miles (434 km) long and in places over 1 mile (1.6 km) deep. The Colorado River cuts a swathe through it leaving silt deposits. As the photograph indicates, the sediments are multi coloured and composed of limestone, sandstone and siltstone dating from the Permian period (250 million years ago). Much of the siltstone was oxidized in this period producing red rock formations.

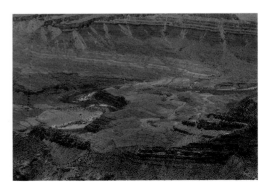

■ Simplicity and symmetry were the keynotes to classical Italian design, prior to the Baroque period of the seventeenth century. The arched windows are reminiscent of earlier Roman architecture. During the Renaissance, the most important churches would have their façade clad in marble but the side walls were often left the natural colour of the stone.

■ The seventeenth-century Dutch artist Meindert Hobbema (1638–1709) was much admired by the English painter John Constable, both of whom stayed faithful to landscape painting. Hobbema was one of the first to imbue his landscapes with the warmer earth colours, seldom seen before his epoch.

■ This colour combination is well suited to cooler and cloudier climates normally found in the Northern hemisphere where light can often appear 'grey'. This is due to the clouds filtering out much of the red end of the spectrum, these colours helping to redress the balance.

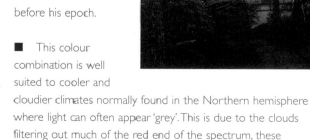

◼ BISTRE

◼ 01 DEFINITION

Bistre is a French word for a warm brown transparent pigment that is made from the soot produced by a wood fire. The colour is most often to be found in seventeenth- and eighteenth-century fine-art prints, commonly, and erroneously, referred to as sepia prints. Bistre's transparency makes it an ideal medium as ink, or watercolour wash, the tone of colour depending on the type of wood that is being burnt. Generally the colour has a warm yellow undertone.

◼ 02 TECHNICAL INFORMATION

RGB Colour
R 61 G 43 B 31

CMYK Colour
C 45 M 71 Y 81 K 57

LAB Colour
L 19 A 11 B 15

HSB Colour
H 24 S 49 B 24

Hexadecimal Pantone
3D2B1F Black 4C

Closest Web-safe Colour
333333

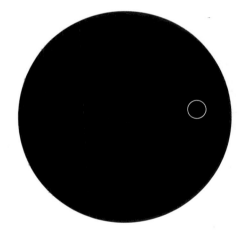

◼ 03 COMMON COLOUR COMBINATIONS

■ BROWN

■ 01 DEFINITION

The colour brown suggests natural materials such as earth and wood and luxury ingredients like coffee and chocolate. It is a secure colour offering warmth and comfort. Brown is a colour of low intensity and is barely perceptible unless surrounded by a brighter contrasting colour such as red or orange.

■ 02 TECHNICAL INFORMATION

RGB Colour
R 150 G 75 B 0

CMYK Colour
C 7 M 69 Y 98 K 21

LAB Colour
L 44 A 39 B 57

HSB Colour
H 30, S 100 B 59

Hexadecimal Pantone
964B00 471C

Closest Web-safe Colour
993300

■ 03 COMMON COLOUR COMBINATIONS

■ CINNAMON

■ 01 DEFINITION

This colour takes its name from the dried bark of the cinnamon tree (*Cinnamomum verum*), which is grown in Sri Lanka, the word meaning 'sweet wood'. It is yellow-brown in colour and often conjures up the associated aromatic sweet smell of the spice. It can be used when warm mid-browns are required.

■ 02 TECHNICAL INFORMATION

RGB Colour
R 123 G 63 B 0

CMYK Colour
C 12 M 69 Y 96 K 32

LAB Colour
L 36 A 32 B 50

HSB Colour
H 31 S 100 B 48

Hexadecimal **Pantone**
7B3F00 1535C

Closest Web-safe Colour
663300

■ 03 COMMON COLOUR COMBINATIONS

■ 04 HISTORY AND CULTURE

Cinnamon is mentioned in the Bible as an expensive spice ranked as an equal with myrrh and aloe, befitting a king. It was introduced into the Western world in the medieval period through Venice, a port for the spice trade. The Portuguese conquered Ceylon (now Sri Lanka) in the late fifteenth century and traded cinnamon as a valuable commodity. The British eventually took control of Ceylon at the end of the eighteenth century, by which time cinnamon trees were also being cultivated elsewhere.

Cinnamon, a brown that contains yellow pigment, is a valuable colour in design because of its warmth and vitality. It is often used in design logos for professional bodies such as solicitors who in the past would have used black, but who now require a more modern image without losing the gravitas of their profession.

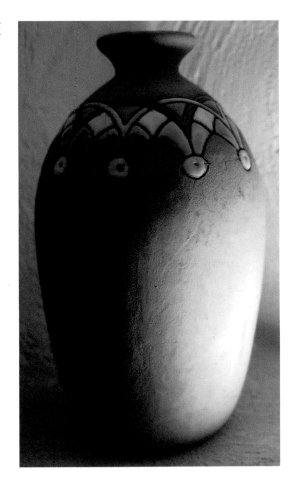

■ 05 EXAMPLES

This elegant pitcher demonstrates the use of a delicate slipware motif on an otherwise ordinary cinnamon-coloured clay vessel. The slip uses the two almost complementary colours of yellow and blue, the darker brown band at the top contains the design and binds it to the pot.

■ Abstracted geometric patterning on textiles was popular in the so-called Art-Deco period of the 1920s, a time when Modernism was making its mark on the Continent. It was also a time known as the 'jazz age' when bright colours and geometry were fashionable. In this case the background cinnamon colour acts as a stabilizing device to the exuberant yellow-on-black motif.

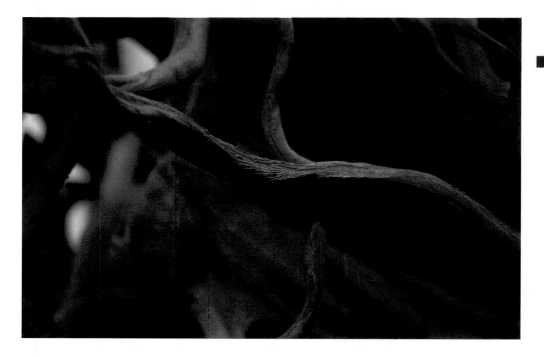

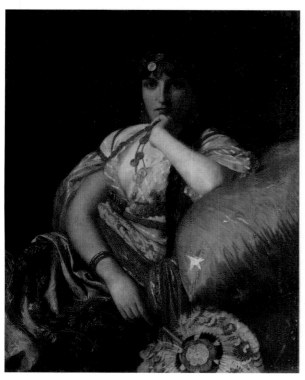

■ These tree branches have been dried and treated to preserve them from rotting. Presented as a sculptural form they take on a new life to be viewed in a gallery or museum space. They will be admired for their texture, abstract forms and perhaps above all for their colour, with the warm cinnamon tones that suggest an Eastern exoticism.

■ *An Oriental Beauty* (1878), painted by Giovanni Costa (1826–1903), is typical of a large number of paintings of this period by many different artists depicting Western notions of the Orient. The scenes were usually the interiors of harems, using cinnamon and other warm earth colours to create the right atmosphere.

Colour Source Book

SEPIA

■ 01 DEFINITION

When we think of the term sepia it generally brings to mind the colouring of Victorian photographs. However, this colour, or more accurately sepia-tone, is the result of fading over time and bears little resemblance to the colour of sepia that is an extract from the ink sacs of the cuttlefish. This has a much deeper brown-grey hue. Today, sepia is produced synthetically due to conservation issues.

■ 02 TECHNICAL INFORMATION

RGB Colour
R 112 G 66 B 20

CMYK Colour
C 17 M 64 Y 94 K 38

LAB Colour
L 35 A 25 B 43

HSB Colour
H 30 S 82 B 44

Hexadecimal **Pantone**
704214 731C

Closest Web-safe Colour
663300

■ 03 COMMON COLOUR COMBINATIONS

■ **04** HISTORY AND CULTURE

Sepia was used as a pigment for writing ink in ancient and medieval times. Artists such as Francisco Goya (1746–1828) used the pigment in sepia-wash drawings in the late eighteenth and early nineteenth centuries. The word *sepia* is Greek and means cuttlefish, from which the pigment is obtained. The pigment produced is a fine powder, making it ideal as both a watercolour and ink medium with a high permanence and some transparency. A number of artists, particularly watercolourists during the eighteenth and nineteenth centuries, including John Varley (1778–1842), used sepia in their work both as a specific colour and as a diluted wash.

During the nineteenth century sepia was used to make ink, which provided a warmer colour than the more traditional black Indian ink. Later in the century, sepia was added to the printing stage of silver-nitrate photographs in order to extend the life expectancy of the picture by converting the less stable nitrate into a sulphide. Today sepia is made synthetically from carbon black and iron oxide, giving a permanent and opaque colour in watercolour and oil as well as proving a useful permanent dye for textiles.

■ **05** EXAMPLES

■ Brown and blue always work well together and usually suggest a hot climate. Blue is essentially found in a Mediterranean sky and in lapis lazuli from India and Afghanistan. The ochre colours suggest arid climates such as the desert or savannah regions of the world. The sepia of the outer tiles holds together and warms the whole design.

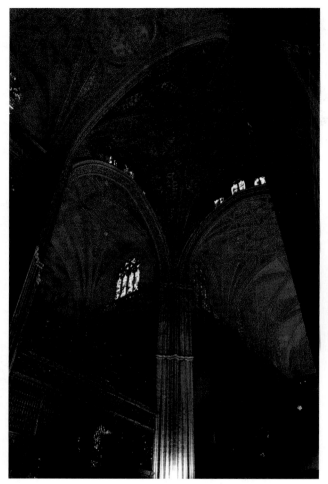

■ This beautiful cathedral in Seville, Spain, is one of the largest Gothic cathedrals in the world, its roof soaring a massive 42 m (138 ft) high. The juxtaposition of the gilded fan vaulting, which has been lit to emphasize its lustre, with the unlit sepia tones of the pillars and arches, is captured wonderfully in this photograph.

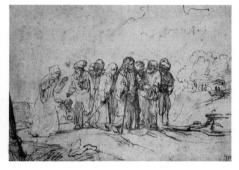

■ Most people are familiar with Rembrandt's oil paintings, but less well known are these beautifully executed drawings in sepia ink and wash. He was a superb draughtsman with the ability to

capture every glance and gesture, the distress on the Canaanite woman clearly evident in this picture, *Christ and the Canaanite Woman* (c. 1650)

■ The tones of the first sepia photographs were produced as a result of the adding of cuttlefish sepia to the photograph (originally much darker) and its subsequent fading over time. Today, these effects can be easily reproduced and the photographs digitally enhanced on a computer to recreate the original picture, as here.

COPPER

■ 01 DEFINITION

Copper, as the name suggests, takes its colour reference from the metal, a yellowish-red brown base metal that reflects mostly red and orange light, while most of the blue is absorbed. In the subtractive-pigment process the yellow is dominant in this colour with magenta and black added, but with no cyan at all. As with all colours that are defined by their similarity to a metal, copper as a colour does not contain the reflectivity or lustre of the original.

■ 02 TECHNICAL INFORMATION

RGB Colour
R 184 G 115 B 51

CMYK Colour
C 4 M 50 Y 92 K 8

LAB Colour
L 58 A 32 B 54

HSB Colour
H 29 S 72 B 72

Hexadecimal **Pantone**
B87333 7412C

Closest Web-safe Colour
CC6633

■ 03 COMMON COLOUR COMBINATIONS

■ **04** HISTORY AND CULTURE

The metal copper has been mined since ancient times, its Latin name *Cuprus* or *Cyprium* assigned to it by the Romans during their occupation of Cyprus, a significant resource for its mining. Copper was and continues to be used for making cooking vessels due to its efficient heat conduction. Copper has played a significant role in the history of art. As a major component of bronze it has and remains instrumental in the making of sculpture.

During the fifteenth century, Leonardo da Vinci began to use copper panels as a ground for oil paintings. Then in the eighteenth and nineteenth centuries copper was used for engraving plates to print reproductions of art works and for book illustrations. In compound form copper was important for colour-pigment making; copper acetate for *verdigris*, copper carbonate for malachite and azurite and copper arsenite for emerald green. A lustred copper colour can now be reproduced using metal particles and is used in spray paint, water-based ink and other mediums. Winsor and Newton have also introduced a copper paint for oil painting that resembles the lustre well.

■ **05** EXAMPLES

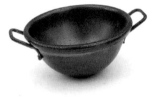 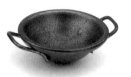 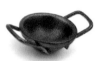

■ Copper has always been used for cooking utensils, once man realized its extraordinary properties for conducting heat and being easy to clean. As well as its practicality, shiny copper pots are also aesthetically pleasing making them an ideal product for kitchen display. Great care is taken in designing copper pots to suit modern kitchens.

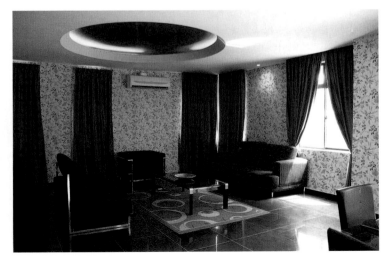

■ This room set is typical of many from the 1970s, which often used autumnal and rustic colours, in contrast to the exuberant colours of the 1960s. The brilliant orange sofa and the flame red on the inside of the ceiling's oculus offset the rather neutral and bland colour scheme, including the copper-coloured curtains.

- The lustre of the original metal is captured better on screen than on paper or canvas. It also provides a perfect background, as in this example, for the red and yellow logo, an analogous harmony.

- The fast shutter speed used when taking this photograph creates a waterfall in a state of suspension, revealing the red iron oxide present in the rock's strata. This pigment has given the rock its overall copper-like hue.

- Unlike Western civilizations, copper was used for cladding doors in Asia Minor and ancient Egypt. Although made of wood, this Islamic door has the appearance of copper, a trick of the light due to the strong sun and the contrasting pale limestone surrounding it.

Colour Source Book

■ CARROT

■ 01 DEFINITION

On the CMYK colour scale, carrot is made almost entirely from a 2 to 1 mixture of yellow and red, resembling the vegetable in its raw state. A darker version called carrot orange is also made and this resembles carrots in their cooked state. This is an inexact science due to the variation of carrot colours, from yellow-cream to a dark reddish brown. The colour now accepted as carrot is based on the vegetable that was developed in Holland during the seventeenth century.

■ 02 TECHNICAL INFORMATION

RGB Colour
R 237 G 145 B 33

CMYK Colour
C 4 M 50 Y 100 K 0

LAB Colour
L 73 A 57 B 85

HSB Colour
H 30 S 100 B 100

Hexadecimal **Pantone**
ED9121 1505C

Closest Web-safe Colour
FF9933

■ 03 COMMON COLOUR COMBINATIONS

■ 04 HISTORY AND CULTURE

Carrots are one of the most widely eaten vegetables in the world and most people from across a range of cultures are able to identify the Dutch carrot as the definitive colour. From the seventeenth to the nineteenth centuries, the carrot figured in a large number of Dutch still-life paintings. As 'carrot' is not defined specifically as a studio colour it would have been mixed using red and yellow. Variations of carrot and carrot orange appear also in a number of paintings by Vincent Van Gogh and by other Post-Impressionists, most notably Georges Seurat (1859–91) in *Sunday Afternoon on the Island of La Grande Jatte* (1884–85), where it is used extensively as a costume colour.

Carrot, although not specifically defined as a colour at that time, appears to have been used in Arts and Crafts textiles, as one of a range of autumnal colours favoured in the second half of the nineteenth century. Because of its visual appeal, carrot is used today on its own in many colour textile applications, from shirts to towels, sail-cloths to soft furnishings.

■ 05 EXAMPLES

Penguin Group

■ This iconic design of the twentieth century was the masterpiece of the German-born designer Jan Tschichold (1902–74) who was committed to the ideals of the Bauhaus, namely simplified and practical graphics and typography. These were applied to the Penguin range of books in the 1940s.

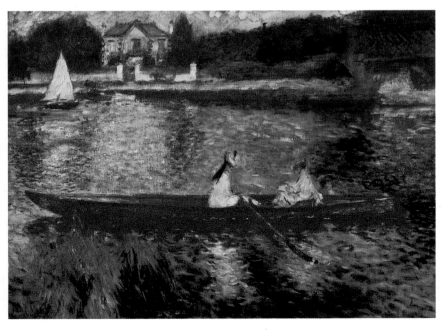

■ Pierre-Auguste Renoir's (1841–1919) picture *Boating on the Seine*, c.1879, was painted in 1879 at a time when Parisians were beginning to take advantage of the new railways and travel to the suburbs. The boat is painted in orange and yellow chromes and vermilion, the carrot-coloured top edges are highlighted by their juxtaposition with the water.

This brightly coloured teapot is a modern-day version of the eighteenth and nineteenth century teapots and warmers, usually made in silver. A small methylated spirit burner was placed underneath the teapot to keep it warm.

Playful and colourful are two adjectives that describe this doorway. The extreme use of the carrot colour in the porch is balanced on its outer edges with the use of purple, its complementary, to prevent its 'escape'. The close complementary green contains the colour by providing some relief from its excess.

The carrot is one of the simplest and yet most versatile foods. It can be eaten raw as in a salad or dip, cooked as a vegetable in stews, used as an ingredient in carrot cake and pulped for use as a health drink. It has also been used as a food colourant.

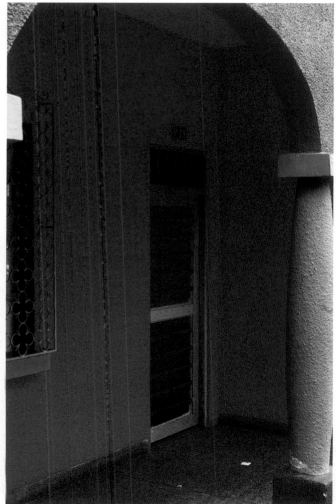

Colour Source Book

■ CHOCOLATE

■ 01 DEFINITION

The word chocolate is from the Aztec word *xocolatl* meaning bitter. The colour has less yellow and black than the colour brown and resembles milk rather than plain chocolate. The craving for chocolate is about taste and texture but perhaps above all the colour, since brown is seen as a supportive colour, something that one can depend on in times of stress.

■ 02 TECHNICAL INFORMATION

RGB Colour
R 210 G 105 B 30

CMYK Colour
C 14 M 69 Y 100 K 2

LAB Colour
L 61 A 50 B 68

HSB Colour
H 25 S 86 B 82

Hexadecimal **Pantone**
D2691E 158C

Closest Web-safe Colour
CC6633

■ 03 COMMON COLOUR COMBINATIONS

■ **04** HISTORY AND CULTURE

The earliest recordings of the word are from about 600 BC when the Aztecs were drinking *xocoatl*, a spicy and bitter drink made from cocoa beans. Today most of the beans that make chocolate are grown in West Africa. Chocolate became an edible commodity in 1759 when Joseph Fry opened his factory in the UK to manufacture chocolate bars. Such was the demand that John Cadbury opened his factory in the 1820s. Today the world spends an incredible £7 billion on chocolate products annually.

Chocolate, the colour, was originally used to describe the raw cacao seed, now referred to as dark brown, but today it is used to describe the colour of milk chocolate. It has rarely been used as a solid wall colour in interior-design schemes, but was one of the most used colours in pattered textiles, carpets and sometimes wall coverings. The combination of chocolate and black in packaging and graphic design suggests masculinity and durability.

■ **05** EXAMPLES

■ One of the largest of antelopes and possibly the most beautiful is the bongo, a native species of West Africa. Its chocolate-coloured fur features a number of white stripes making it easily discernable, except in the forest, when it helps as camouflage.

■ The chocolate-coloured shadows cast on this church wall at sunset contrast wonderfully with the brighter yellow ochre illuminated by the setting sun. They contrast not only in colour, but in colour temperature indicating to the viewer the cooler climate of the night air about to descend. This transition is underpinned by the white arches, that are now passive and no longer reflect the yellow hue.

■ This unusually dark chocolate wall provides a rich and interesting patterned background to the sterility of the white bath, supplying the necessary warmth to the scheme. Unlike most wall coverings, the design is not formal and does not have an obvious repeating pattern.

■ The imaginative ceramic floor-tile design uses only two predominant colours, chocolate and terracotta, to create this elaborate scheme. Although the design can be found today in many Northern European and North American homes, such designs were originally to be found only in places such as Asia Minor and the Indian sub-continent.

RUSSET

■ 01 DEFINITION

Russet has a similar red-yellow mix to that of ochre, but contains more black, making it a mid-tone brown colour. Unlike many browns it is a distinctive colour, similar to the brown denoting the Bakerloo line on London's underground railway. Russet also denotes a particular kind of country clothing and an apple or pear of this colour.

■ 02 TECHNICAL INFORMATION

RGB Colour
R 128 G 70 B 27

CMYK Colour
C 14 M 69 Y 94 K 29

LAB Colour
L 39 A 31 B 44

HSB Colour
H 26 S 79 B 50

Hexadecimal **Pantone**
80461B 470 C

Closest Web-safe Colour
993333

■ 03 COMMON COLOUR COMBINATIONS

■ **04** HISTORY AND CULTURE

Bologna is an Italian city famous for its two leaning towers in its centre. These towers and surrounding porticos are russet coloured, having been built using a local sandstone of this colour during the thirteenth and fourteenth centuries. Bologna was also a centre for majolica ware in the fifteenth century and much of their slipware contained russet-coloured references. During the 1930s Russet was also given to the name of the army jacket worn by servicemen, also known as the A-2. It was intended to be seal brown but difficulties in the tanning process resulted in the russet colour. By the outbreak of the Second World War, however, the production process had been modified and the revised colour was seal brown. Today replica makers of the jacket produce both the seal brown and russet versions.

Like most of the autumnal colours, russet was popular with the Arts and Crafts designers such as Walter Crane (1845–1915), who produced *Daffodil and Bluebell*, a carpet that he designed in 1896 using only four colours; one of his many designs that was so influential to the Art Nouveau movement, again using russet and other autumnal colours in their designs.

■ **05** EXAMPLES

■ This female mallard belongs to a species of 'dabbling ducks' so-called because of their feeding habit, upending themselves in the water to feed on vegetation rather than diving. They are migratory birds and arrive in large numbers in Northern Europe for the summer. Their plumage colours are variable brown tones: this example proudly showing her russet-coloured breast.

■ This pseudo-Tudor house is typical of a style of domestic architecture in Britain during the 1930s, particularly in suburban

areas such as Kingston-upon-Thames in London. It also suggests elements of the Arts and Crafts vernacular architecture in its use of a stone façade and the russet-coloured roof, a feature that was also popular in American Arts and Crafts architecture.

■ This ceramic mosaic is influenced by the well-known wave motif of the eighteenth-century Japanese artist Katsushika Hokusai. In place of the blue and white of Hokusai, this ceramicist has used predominantly russet with other earth colours on a black background to create a less violent scene than the Japanese original.

■ The russet-coloured pseudo Arts and Crafts table and chairs echo the vernacular homely appearance of its setting, to provide a warm and welcoming ambience to the room. The wall braces opposite the table provide a perfect backdrop for the furniture, emphasized by the brilliant white background. The white wall, pink carpet and the light-coloured bricks provide a balance to an otherwise overpowering russet-coloured scheme.

Colour Source Book

MARIGOLD

■ 01 DEFINITION

Marigold is a tertiary pigment colour, being an equal combination of yellow and orange. It is of course synonymous with the flower of the same name that can vary between a bright yellow through to a burnt orange. As a colour definition it is a strong orange-yellow, similar to the artists' colour cadmium yellow deep or Indian yellow. The flower itself can be used as an organic dye.

■ 02 TECHNICAL INFORMATION

RGB Colour
R 228 G 183 B 57

CMYK Colour
C 0 M 27 Y 100 K 0

LAB Colour
L 79 A 14 B 75

HSB Colour
H 44 S 75 B 89

Hexadecimal **Pantone**
E4B739 7409C

Closest Web-safe Colour
CCCC33

■ 03 COMMON COLOUR COMBINATIONS

■ **04** HISTORY AND CULTURE

There are two main species of marigold, *Calendula* (or pot marigold) and the more familiar *Tagetes* or French marigold. They are both cultivated for domestic garden use and share similar colour ranges of flower. *Calendula* was originally from Asia Minor and transported to South Asia where it is cultivated in huge quantities. They are used for a number of purposes including medicine and as a dye. The flower is used in many Hindu festivals and often worn in garlands. During the festival of Holi, to mark the advent of spring, marigolds are boiled in water to produce a yellow-coloured liquid that is then splashed over people. *Tagetes* are native to South America, being discovered by the Portuguese in the sixteenth century and introduced to Europe.

The name marigold (Mary's gold) was given to the flower as a Christian symbol of the Virgin and is often used in Bible stories. Such is the strength of the marigold colour that it has been used extensively in painting since the late nineteenth century. It can be found, for example, in the form of cadmium yellow in several of the Impressionists' pictures and was also used by Vincent Van Gogh in many of his works.

■ **05** EXAMPLES

■ The species shown here is *Calendula* or pot marigold, the extract of which is used to treat skin complaints, such as eczema and chilblains. It has good anti-inflammatory properties and can also speed up the healing of wounds.

These recycling bins are brightly coloured to help with navigating separate recycle areas. If adopted nationwide, certain colours will become synonymous with certain materials. Bright colour also creates an aesthetically pleasing item that would perhaps otherwise be an eyesore in town centres.

■ There is a sense of dynamism in this work, the yellow has what Kandinsky called 'irresponsible appeal' and advances towards the viewer. On its own it can be overwhelming and hurt the eye, but orange helps to balance the dynamism. Designers call this monochrome harmony, since the colours are essentially from the same hue and are harmonious.

This simple layout uses only two colours, the marigold of the table and chairs, set against the neutral khaki floor tiles. There is a contrast between the two colours simply to delineate their forms. However, the colours are not too contrasting, something that designers refer to as analogous harmony, meaning that the colours are close enough together on the colour wheel to retain a harmony.

Colour Source Book

BRONZE

■ 01 DEFINITION

The colour bronze refers to its similarity to the alloy that is made from copper and tin. Although the colour is predominantly made up of yellow and red, the small amount of cyan gives bronze a very slight hint of green, which cools its overall temperature. Because of its long history, bronze is seen as a colour associated with durability.

■ 02 TECHNICAL INFORMATION

RGB Colour
R 205 G 127 B 50

CMYK Colour
C 1 M 53 Y 93 K 2

LAB Colour
L 64 A 35 B 62

HSB Colour
H 30 S 76 B 80

Hexadecimal **Pantone**
CD7F32 7413C

Closest Web-safe Colour
CC6633

■ 03 COMMON COLOUR COMBINATIONS

■ 04 HISTORY AND CULTURE

The earliest references to the use of bronze are in Iraq (Ur) in about 2,500 BC, although the moulds used were fairly basic and required huge amounts of metal because of wastage. During the Shang Yin dynasty (1700–1100 BC) the cored-casting technique was developed, which was more efficient. The European and British Bronze Age began at the same time and the alloy was used to make weapons and armour as well as vessels. Britain was an ideal location for the manufacture of bronze because of the availability of copper in Wales and tin in Cornwall. Bronze is one of the hardest cast metals and during the modern period bronze has been used extensively for church bells and sculpture. Bronzes, as bronze sculptures are known, date back to ancient Greek and Roman civilizations, a tradition that was

developed during the Renaissance and continues to influence and excite artists today. Many of the world's great artists including Donatello (c. 1386–1466), Auguste Rodin (1840–1917), Alberto Giacometti (1901–66) and Henry Moore (1898–1986) have produced bronze sculpture.

■ 05 EXAMPLES

■ Only one fifth of a desert is covered in sand in the form of 'sand sheets' or 'sand seas', huge areas of undulating dunes resembling frozen waves. Desert sand varies in colour due to the variation in mineral deposits underneath, which can include copper, the main component of bronze.

■ These Indian-influenced tiles use only two colours, bronze and its complementary blue, creating a colour balance that sets up a dynamic. The yellow tone of the bronze advances toward the viewer while the blue recedes creating an additional dimension to the design.

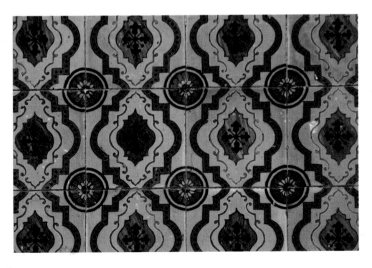

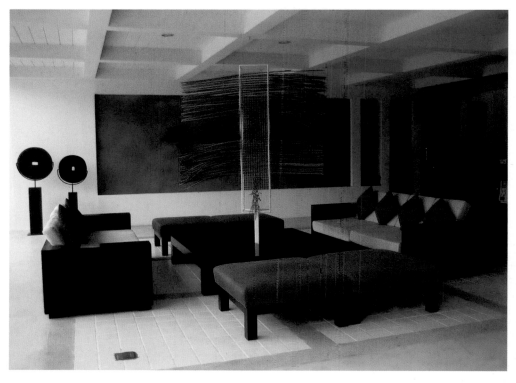

■ This interior is predominantly a colour progression from white to black through grey and it provides a tranquil and harmonious space. The harmony is maintained using square forms on

the floor, furniture shapes and in the coffered ceiling. The variety is provided by the different textures and by the use of the warm, soothing colours of burgundy and bronze.

■ This hot-looking amber-coloured wall and the shadow of the palm tree inform us of its

Mediterranean geography. The open window and the deep shadow on the interior, which has been painted the same colour, emphasize the heat, but the shadow offers the viewer some relief, as it's bronze-coloured, so containing just enough cyan to cool.

■ The crepe-soled desert boot was issued to British officers fighting in the desert during the Second World War. They were and still are bronze-coloured, originally for camouflage. Like many surplus army clothes, desert boots became fashionable apparel in the 1960s for the 'mods'.

■ RUST

■ 01 DEFINITION

As the name, suggests rust resembles the colour of newly oxidized iron. Its 'orangeness' suggests physical comforts such as warmth and food in abundance, while its tendency toward brown adds seriousness and reliability that avoids the frivolous perception of pure orange.

■ 02 TECHNICAL INFORMATION

RGB Colour
R 183 G 65 B 14

CMYK Colour
C 2 M 80 Y 98 K 7

LAB Colour
L 50 A 58 B 62

HSB Colour
H 18 S 92 B 72

Hexadecimal **Pantone**
B7410E 173C

Closest Web-safe Colour
CC3300

■ 03 COMMON COLOUR COMBINATIONS

■ 04 HISTORY AND CULTURE

Oxidized iron or rust powder is not a pigment, but sinopite, an iron-oxide-based pigment is similar in colour and was found in the Mediterranean region and Asia Minor. Sinopite, also known as porphyry, was used by ancient civilizations to make a red paint and in the Pre-Renaissance it was used in a technique called *Sinopie*, a preparatory underdrawing in fresco painting. The Florentine artist Cennino Cennini (c. 1370–1440) described the colour and pigment as 'natural and dry in character'. The pigment was replaced in the High Renaissance by mixing red earth and yellow ochre. An example of the colour at this time can be found in the sixteenth-century paintings of Moretto de Brescia (1498–1554) such as *Portrait of a Man* (c. 1542).

Rust is also a recognized colour in Sri Lanka for textile dyeing where it has been made since twelfth century by mixing black and alum.

■ 05 EXAMPLES

■ With the advent of faster tanning processes and the availability of synthetic alcohol-based dyes, leather has been transformed from an expensive and exclusive commodity to one that has been adapted to the mass market. The beginning of this trend was the 1960s when coloured leather coats became the 'must have' item of mod culture.

■ There are few sights more beautiful than an avenue of trees in early autumn, their leaves hosting all the wonderful colours associated with the season, from yellow through variations of orange and red to brown. What heightens their allure is often the low sun's glow emphasizing the radiance of their colours.

■ This utilitarian rust-coloured cup and saucer is not so very different in colour and style to the unglazed red stoneware made in Staffordshire, England, in the eighteenth century. The glazing of this modern piece adds to its utilitarian appearance and its warm earthy rust colour is emphasized here by its juxtaposition with the 'hotter' burgundy table.

■ For large areas the rust colour is usually more suited to exterior rather than interior decoration, where it can be overpowering. These gates are a prime example, painted to resemble the rust colour of the natural oxidation of iron. The designer has cleverly used a blue-grey to simulate the use of galvanized nails to emphasize this pseudo-corrosion of the gates themselves.

■ One of the fine art uses to which red iron oxide has been put is the manufacture of bole. This red clay-based product is used as a ground on picture frames before the application of gold leaf. The bole enables the leaf to be burnished to a high lustre and is a tradition that has continued since the time of the Renaissance.

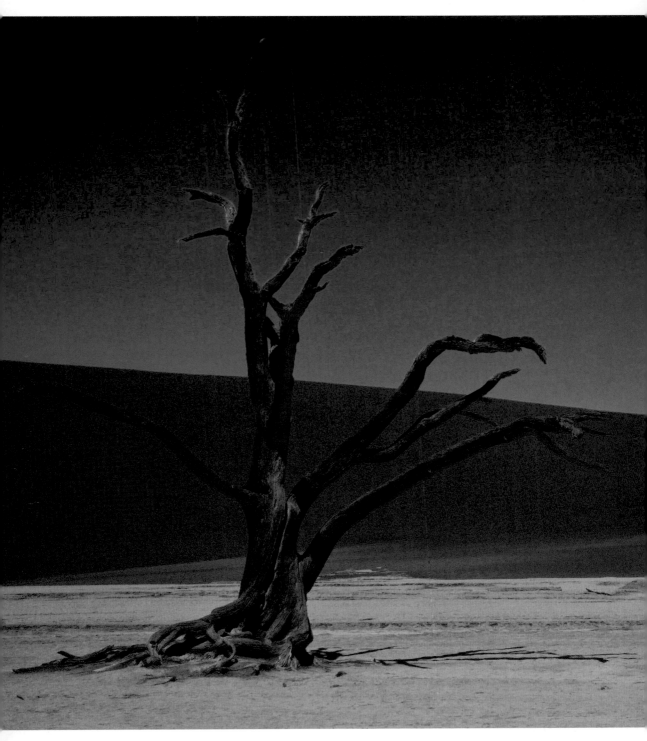

BURNT SIENNA

■ 01 DEFINITION

A 'burnt' version of raw sienna, it has a warm hue and is traditionally used extensively in English landscape painting. Burnt sienna is one of a range of eight 'earth primaries' including sea green and olive, that are essentially variations of brown and green colours, all of which are difficult to mix from traditional primaries and yet figure so much in painting. It has a high transparency as a watercolour and is permanent in all mediums.

■ 02 TECHNICAL INFORMATION

RGB Colour
R 233 G 116 B 81

CMYK Colour
C 0 M 59 Y 63 K 0

LAB Colour
L 67 A 55 B 49

HSB Colour
H 14 S 65 B 91

Hexadecimal **Pantone**
E97451 1645 C

Closest Web-safe Colour
FF6666

■ 03 COMMON COLOUR COMBINATIONS

■ **04** HISTORY AND CULTURE

As an earth colour burnt sienna was suitable for fresco painting from the fourteenth century, but at that time the sienna colours were simply known as varieties of ochre (iron oxides). These continued to be used during the Renaissance. Then from the eighteenth century when many British artists embarked on the so-called grand tour, which would have included Italy, they returned with the pigment that they referred to as *Terra di Siena*. The colour was eagerly adopted by Thomas Gainsborough for his paintings and has continued to be used since then, particularly by landscape painters. It was not known as burnt sienna until the nineteenth century, when records show that considerable amounts of the pigment were imported.

During the latter part of this century the colour figured in Arts and Crafts woven textiles. The mines around Siena no longer produce the raw material as the resource is exhausted. Instead it is mined on the Italian islands of Sicily and Sardinia. It can also be made synthetically.

■ **05** EXAMPLES

■ This Moroccan interior relies on the complementary hues of burnt sienna and azure and uses viridian to hold the design together. The top half of burnt sienna has been applied as a fresco wash and creates a warm and vibrant surface. The lower half is tiled, using a typically Moorish design that contains all three colours to provide a cooler and more subdued surface, one that is continued across the floor.

■ Although the maple leaf is the national emblem of Canada the tree is to be found almost everywhere in the Northern hemisphere. The maple is part of the genus *Acer* and its leaves vary in colour from green through to deep red. This leaf has turned from green to shades of sienna during the autumn season.

■ MUSTARD

■ 01 DEFINITION

Although mustard seed and the resultant paste vary in colour, it is generally accepted that the mustard colour is essentially a pale yellow colour. It is not as bright as mustard paste in a jar, but rather more akin to mustard sauce. It is also a colour often found used in slipware, including English pottery of the seventeenth century.

■ 02 TECHNICAL INFORMATION

RGB Colour
R 255 G 204 B 0

CMYK Colour
C 0 M 18 Y 85 K 1

LAB Colour
L 87 A 14 B 95

HSB Colour
H 48 S 100 B 100

Hexadecimal **Pantone**
FFCC00 116 C

Closest Web-safe Colour
FFCC00

■ 03 COMMON COLOUR COMBINATIONS

■ 04 HISTORY AND CULTURE

Mustard was a favoured colour in Islamic pottery and was often used in slipware vessels from the ninth until the sixteenth century in countries such as Syria and Egypt, and in Spain during the rule of the Ottomans. In England, too, William Taylor made a number of slipware plates in Staffordshire during the reign of Charles II. The colour also appears in the work of the seventeenth-century Dutch artist Aelbert Cuyp (1620–91) who used it as a wash in many of his landscapes.

During the nineteenth century an American artist called Hugh Cornwall Robertson (1845–1908) set up a ceramic works near Boston, making pottery and decorative tiles based on ancient Chinese ceramics that used mustard glazes. His Dedham pottery continued to make ceramics until the Second World War. At the end of the nineteenth century mustard was used frequently by Arts and Crafts designers, particularly C. F. A. Voysey's (1857–1941) woven designs for Alexander Morton and Co.. In the twentieth century, ceramics by Clarice Cliff (1899–1972) often included mustard as a foil colour for the more exuberant reds and yellows of her tableware, for example in the 'Bizarre' range.

■ 05 EXAMPLES

■ This beautiful twelfth-century crypt illustrates the use of Romanesque architecture of the period. At one time this repository would have been dark and dank. Modern lighting technology allows

the viewer to see the two types of stone used in the work with the mustard colour creating a brighter atmosphere and a more optimistic mood for the tourists.

- Turmeric (*Curcuma longa*) is the principle spice ingredient in curry powders and is also used as a colourant for mustard, often as a replacement for the more expensive saffron. Despite its strong colour and use as a food dye, it is not lightfast and therefore inappropriate for use in textiles.

- Today, sets of crockery or dinner services do not have to follow the same pattern or even be the same colour so long as there is harmony. In this set, the designer has used two harmonized colours, burnt orange and mustard, with half of the individual pieces being in one colour and the other half in the other. The crockery is utilitarian and requires no ornament, relying instead on the bright harmonious colours.

- Although quilts have a practical purpose as a bed covering, rather like a duvet, many people use them as decorative wall displays. The founding of a number of 'quilt communities' has enabled the spread of the craft, with many people creating so-called 'art quilts'. This one is clearly influenced by Mark Rothko (1903–70).

Colour Source Book

TANGERINE

■ 01 DEFINITION

As the name suggests, this colour is taken from the fruit of the same name, a slightly paler colour than orange. With one or two exceptions, tangerine was a colour virtually unused until after the Second World War, reaching its zenith in the 1960s amid the cultural revolution that seemed to throw away the rulebook. One earlier exception is the only English professional football club to wear tangerine, Blackpool FC.

■ 02 TECHNICAL INFORMATION

RGB Colour
R 242 G 133 B 0

CMYK Colour
C 0 M 51 Y 77 K 0

LAB Colour
L 71 A 49 B 83

HSB Colour
H 33 S 100 B 95

Hexadecimal **Pantone**
F28500 151C

Closest Web-safe Colour
FF9900

■ 03 COMMON COLOUR COMBINATIONS

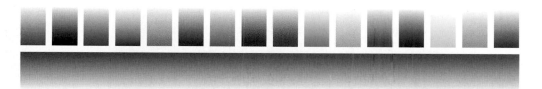

■ **04** HISTORY AND CULTURE

Tangerine became a 'fab' colour during the 1960s, being used in interior design, fashion and graphic design. In fashion, men's suits, casual jackets and shirts were made in tangerine, while for women, coats, skirts and even stockings were made in the colour. Interior design in the 1960s included vibrant colours often juxtaposed, such as tangerine and fuchsia. The mass production of plastics had enabled designers to produce more colourful and exciting products, none more so than Verner Panton's (1926–98) stacking chairs in a variety of colours including tangerine.

In painting, the New York school of artists in the 1950s that included Robert Motherwell (1915–91) and Mark Rothko had started to paint Abstract-Expressionist works using riotous colours, often

juxtaposed with sombre ones. More recently, designers such as Philippe Starck (b. 1949) have been using vivacious colours such as tangerine.

■ **05** EXAMPLES

■ The 'Seasiders' is the nickname given to Blackpool football club, the only league club to play in tangerine colours. They have been in existence since 18,77 and like most clubs have had their highs and lows in that time, with many well-known players such as Stanley Matthews wearing the tangerine shirt.

■ Despite the nasturtium being a native of the warm climate of Central and South America, this small pretty plant can be found in most English gardens, often in patio pots. Apart from providing plenty of colour, the leaves and flowers of the nasturtium can be eaten as a salad in the summer.

■ The first postage stamp was issued in Britain in 1840, but it was not until the late nineteenth century that people began to collect them. By then other countries began issuing stamps and, in the following hundred years or so, many different and colourful designs have been issued. This selection gives an indication of the variety of colours, shapes and designs.

■ This artwork is by Devi the Sri Lankan elephant, one of a series of paintings made to raise funds for 'Elephants in Need'. Devi clearly understands the concept of complementary colours, the cool deep blue receding to the back of the picture plane, contrasting with the advancing warmer tangerine marks that crave the viewer's attention.

■ The use of wool for clothing can be traced back at least to the time of Pliny who was writing about the selective breeding of sheep for the purpose, in the first century AD. Today, wool production is in excess of one million tonnes per annum of which 60 percent goes on clothing. The fibres contain protein, as does silk, and cannot be dyed in the same way as cotton, relying instead on a vast colour range of acid dyes.

Colour Source Book

■ AMBER

■ **01** DEFINITION

A colour that is known by its use as a traffic signal, amber is a deep yellow, similar to tangerine but with a 100 percent yellow hue. There is, however, a difference in the amber colour used for traffic signals, known as UNECE amber, which contains twice the amount of red that standard amber has. Amber is a colour defined by its similarity to the precious stone of the same name.

■ **02** TECHNICAL INFORMATION

RGB Colour
R 255 G 191 B 0

CMYK Colour
C 0 M 25 Y 80 K 0

LAB Colour
L 84 A 22 B 93

HSB Colour
H 45 S 100 B 100

Hexadecimal **Pantone**
FFBF00 810C

Closest Web-safe Colour
FFCC00

■ **03** COMMON COLOUR COMBINATIONS

■ 04 HISTORY AND CULTURE

At least 30 million years old, amber is a fossil resin, admired and used as a gemstone since at least Roman times. It is found around the coastline of the Baltic Sea and from the fifteenth to the seventeenth centuries the Teutonic Knights strictly controlled its removal and transportation. During this period it was only the rulers and aristocracy of Europe that had access to amber, such was its value. A paternoster (or rosary – literally 'Lord's Prayer') made from amber appears in Jan van Eyck's (c. 1395–1441) painting of *The Arnolfini Wedding* (1434). Emperor Leopold of Austria commissioned an amber throne in the seventeenth century. At the beginning of the next century the King of Prussia commissioned an 'Amber Room' for his wife which was subsequently gifted to his then-ally Peter the Great , the Tsar of Russia, for the Catherine palace in St Petersburg.

Amber has continued to be used as a semi-precious stone in the twentieth century for fashionable jewellery and decorative objects. Because of its luminosity the colour amber has as much appeal for decorative and interior-design detail, as does the stone.

■ 05 EXAMPLES

■ To a much lesser extent, amber can now be found in other parts of the world including America and Mexico, although the finest is still known as Prussian amber. Some amber contains fossilized insects or ferns and these are more appealing to some collectors for decorative jewellery.

■ Amber, once the preserve of the Prussians, was made into necklaces and bracelets by them for religious purposes only. Typically a bracelet such as this would have had a crucifix added and made into a rosary.

■ This formidable Norman castle door from the eleventh century is made from oak and contains dozens of hand-made decorative iron studs on its surface. There is also a smaller door inset to allow pedestrians into the castle. The more recent decorative amber frame either replaces the original or has been added to provide a more inviting opening to the premises.

■ This modern parquet floor continues a tradition first begun at the Palace of Versailles in the seventeenth century. Parquet floors are solid timbers laid geometrically often in a lozenge formation using either one type of timber with varying grains or mixing the woods to complement each other. Timbers most used are oak, beech, cherry, pine and, as in this example, the amber colour of maple.

■ The first automatic traffic-light system was installed in Britain in 1927. Since then all countries have adopted the system, but Britain remains one of the few countries to employ the amber signal before displaying the green, as well as prior to the red being displayed.

APRICOT

■ 01 DEFINITION

From the Latin *praecox*, meaning 'early ripener', the apricot fruit is a warm, soft and luscious colour. The derivative colour is slightly paler, but is also gentle and soft, making it very feminine. The colour is therefore used in cosmetics and lingerie.

■ 02 TECHNICAL INFORMATION

RGB Colour
R 251 G 206 B 177

CMYK Colour
C 1 M 21 Y 22 K 0

LAB Colour
L 88 A 19 B 23

HSB Colour
H 24 S 29 B 98

Hexadecimal **Pantone**
FBCEB1 162C

Closest Web-safe Colour
FFCC99

■ 03 COMMON COLOUR COMBINATIONS

■ **04** HISTORY AND CULTURE

Confucius is said to have conducted his teachings below an apricot tree, but the colour we now describe as apricot bears little resemblance to the native fruit of China in the sixth century BC. The colour apricot is somewhat paler than the colour of the fruit and seems to have been invented for purely expedient reasons. The earliest recordings of the colour we know to be apricot are in early Islamic dress during the first millennium. It appears in few paintings prior to the end of the nineteenth century, at which point a number of artists seemed to revel in the femininity of the colour when depicting women. These artists, including Frederic Leighton (1830–96) and Albert Moore (1841–93), depicted an idealized ancient hedonistic world, in which the women were often shown wearing apricot and pale-pink garments.

Apricot continued to be fashionable in both the Edwardian period and the jazz age of the 1920s, and again in the 1950s, particularly in *haute couture*.

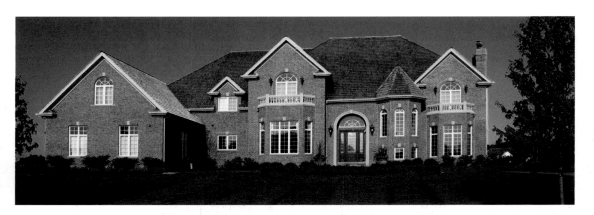

■ **05** EXAMPLES

■ This vernacular architecture is typically English in origin, a style that has the hallmark of C. F. A. Voysey's Arts and Crafts designs. These middle-class 'homestead' style houses were designed as country homes, but were usually set in suburban locations.

■ Since the advent of the department store in the nineteenth century consumers have been able to look and handle goods before purchase. This has prompted manufacturers to design and create more colourful garments and for retailers to devise more appealing ways of merchandising them.

■ Clearly influenced by Kandinsky, this delicate design uses a minimum of line and colour to create its floral abstract form. The delicate use of apricot imbues the design with the softness of nature, such as that found in orchids. Like Kandinsky, the artist uses these forms, not as a reflection of life but as an expression of life itself.

■ The vibrant and vivacious colours of this quilt are reminiscent of the 1960s, when pinks were seen with oranges and chrome sat comfortably with pale blue. However, quilt-making has been around for centuries and was one of the first ways in which colour was explored just for its own sake. Today, people are still exploring the visual excitement of quilt making.

■ The hibiscus is a native shrub of China and Southeast Asia and grows well in warm subtropical climates. It is, however, also grown successfully in southern Britain, particularly the species known as 'Rose of Sharon'. The flowers range in colour from white to pink, yellow and red.

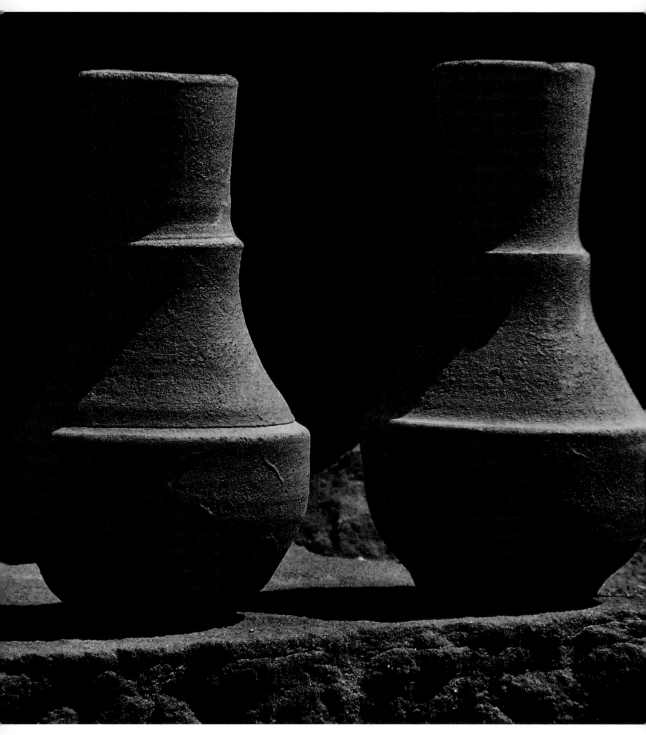

Colour Source Book

TERRACOTTA

■ 01 DEFINITION

Terra cotta is an Italian word that means 'baked earth' and is derived from the ancient tradition of clay sculpture and pottery making. In recent times the uncovering of the terracotta army of warriors in China, made in the third century BC, has brought to the fore this wonderfully warm reddish-brown colour, which has been presented in recent times as a subdued and much paler hue.

■ 02 TECHNICAL INFORMATION

RGB Colour
R 226 G 114 B 91

CMYK Colour
C 0 M 61 Y 58 K 0

LAB Colour
L 66 A 54 B 41

HSB Colour
H 10 S 60 B 89

Hexadecimal **Pantone**
E2725B 7416C

Closest Web-safe Colour
CC6666

■ 03 COMMON COLOUR COMBINATIONS

■ **04** HISTORY AND CULTURE

Terracotta figures and pots are made from red clay and originally would have been left to bake in the hot sun. Consequently, it originated in hot climates such as those found in Asia and southern Europe. Later, the kiln enabled mass production and the introduction of glazes to enhance the works. Most notable of the ancient civilization terracotta figures are the Tanagra figurines made by the Greeks in the fourth century BC. Terracotta continued to be used for sculpture from the early Renaissance because it

was economic and quick to work with, when compared to a modelled bronze or carved-stone piece. The most notable terracotta sculptures of the early modern period are by Donatello (1386–1466). In the nineteenth century, the French sculptor Albert-Ernest Carrier-Belleuse (1824–1887) produced a number of works in terracotta, famously his bust of Honoré Daumier (1808–79) in 1862.

Terracotta was also valued as an architectural commodity for use in ornament and in the late nineteenth century there was a vogue for building in red brick and terracotta. Apart from the pleasing aesthetic, terracotta was also valuable as a fireproof material. There are a number of notable buildings of this period including the Prudential Assurance offices in London and Bradford.

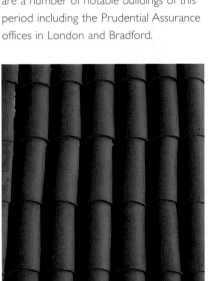

■ **05** EXAMPLES

■ The walls of this huge canyon are made of sandstone that was harder and more resistant to erosion than the rock in the canyon itself. Over thousands of years the sandstone itself has been a victim of wind erosion that has created this wonderful sculptural form.

■ These cleverly designed roof tiles are suitable for a monsoon climate where heavy rain can be a problem. As well as providing deep channels for the fast removal of rainwater, the rounded forms of the tile help to keep the house cool in often searing heat as well.

■ The use of these particular earth colours and the stylized design are clearly based on Egyptian aesthetics. The shape of the eye and the shadow around it are reminiscent of the stylized graphics often found on papyrus scrolls.

■ Solid colours in textiles were little used before the twentieth century in Western culture, preference always being given to pattern. This South American terracotta textile, with a simple pattern influenced by Pre-Columbian culture, demonstrates the folly of such an omission.

■ The terracotta brick and bistre banding of this building's circular design is clearly indebted to Frank Lloyd Wright's (1867–1959) Guggenheim museum in New York, built during 1937 in an austere Modernist style. This modern equivalent relies on texture and colour for its aesthetic.

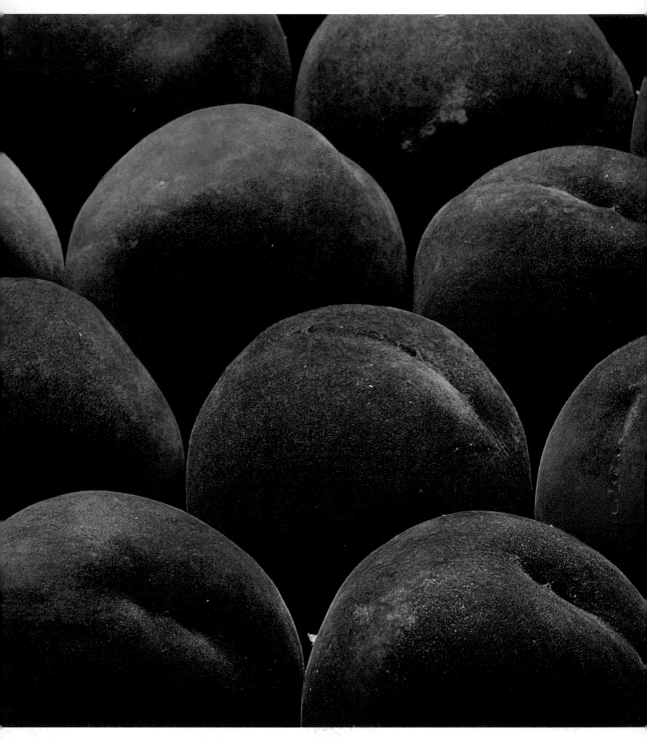

PEACH

■ 01 DEFINITION

This is a pale colour made from one part magenta and three parts yellow with no black and scant cyan content. It is pale, soft pink in colour, similar to the colour of certain varieties of the fruit and to the flesh-coloured tones of a Caucasian person. Peach is a feminine colour and likely to be found in many women's garments and in cosmetics.

■ 02 TECHNICAL INFORMATION

RGB Colour
R 255 G 229 B 180

CMYK Colour
C 1 M 10 Y 27 K 0

LAB Colour
L 93 A 7 B 29

HSB Colour
H 39 S 29 B 100

Hexadecimal **Pantone**
FFE5B4 7507 C

Closest Web-safe Colour
FFCCCC

■ 03 COMMON COLOUR COMBINATIONS

■ **04** HISTORY AND CULTURE

Although not specifically referred to as peach, the colour was used in fresco painting and created using cinnabar (vermilion) with white and a small amount of yellow ochre, for flesh colouring. A similar colour appears in paintings from the fifteenth and sixteenth centuries, particularly for faces in portraits. The colour was often painted over a *terra verte* and white ground and allowed to show through slightly so that it did not appear too pink. These peach-coloured flesh tones continued to be used, but from the seventeenth century cheeks were often 'rouged' with touches of rose madder, signifying a cosmetic custom of the period.

Peach, although used sparingly in previous eras, became one of the 'in' design and fashion colours during the 1920s. The soft pastel shades of this epoch were ideal for the delicate fabrics such as silk and taffeta used on the straight dresses with their uneven hemlines.

■ **05** EXAMPLES

■ The fad for Pop Art began in the late 1950s as a comment on a consumer society, using images from popular culture. Acrylic paints were developed at this time that enabled a flat opaque colour to be rendered without texture, a feature of Pop-Art painting. In a somewhat ironical twist, advertising companies began to use modern equivalent Pop-Art images in the late 1980s and 1990s for promotions, of which this is an example.

■ Portugal has a long history of building towers, from the magnificent eighteenth-century baroque tower of the Clérigos Church in Porto to the more recently completed Vasco de Gama tower in Lisbon. The tower pictured here is more modest and built in the medieval period using *rosa portuguese*, a peach-coloured stone quarried in Portugal and used extensively in much of their architecture.

■ In many ways the peach rose is an ideal colour to send for most occasions. Unlike other colours, which convey certain cultural and social meanings, the peach can be sent to say 'thank you', express a friendship, or just wish someone a 'happy birthday'. They can also be used to express sympathy and consideration.

■ It is unclear when bed linen was first used, but up until the nineteenth century it was made from linen, a rather expensive process and not available to everyone. The advent of the cotton industry in the 1860s changed that and, with other synthetic fabrics that have been developed, have made bed linen accessible to all. This peach-coloured set is indicative of the variety of colours and patterns now commercially available.

■ This coffee-cup set is a mass-produced pseudo stoneware. It is intended to resemble earthenware but is given a vitreous glaze that has not been fired to the highest temperature, producing an opaque but semi-matt finish. The designer has cleverly combined peach and black cups and saucers to be used as interchangeable items.

■ SALMON

■ 01 DEFINITION

Although the flesh colours of salmon can vary depending on their diet, the colour salmon is designated as a pale to medium yellow-pink. One of the most distinctive salmon-coloured items is the *Financial Times*, which has been that colour for over one hundred years. Salmon is a colour that can be found in a number of species of flower including pelargonium, begonias and roses.

■ 02 TECHNICAL INFORMATION

RGB Colour
R 255 G 140 B 105

CMYK Colour
C 0 M 45 Y 43 K 0

LAB Colour
L 75 A 53 B 46

HSB Colour
H 14 S 59 B 100

Hexadecimal **Pantone**
FF8C69 164 C

Closest Web-safe Colour
FF9966

■ 03 COMMON COLOUR COMBINATIONS

■ 04 HISTORY AND CULTURE

Salmon flesh is so coloured because of the astaxanthin present in its body, which comes from its diet of krill and shrimp, both of which contain this pigment. Flamingos have a similar colouring for the same reason. The pigment is used in foodstuffs as a colourant and also provides humans with essential anti-oxidants. It can now be produced synthetically and is often used for farm-reared salmon to enhance their colour before selling. There is little evidence to suggest that the colour was used in painting, but it occurs frequently in textile designs during the Arts and Crafts period. Examples are William Morris's woven-silk design *Kennet* and printed cotton design *Strawberry Thief*. It was a colour also favoured by Alphonse Mucha (1860–1939) in his Art-Nouveau poster and fabric designs at the turn of the century.

The Bloomsbury Group of artists frequently used salmon in their palette for portraits and interiors during the 1920s and 1930s. It was also used a great deal on the painted furniture and other artefacts produced by them in the Omega workshops, and again when they furnished and extensively painted the interior of their Sussex farmhouse at Charleston in East Sussex, England.

■ 05 EXAMPLES

■ This elegant staircase has all the hallmarks of eclectic Post-Modernism, introduced into a fashionable late Regency house. The traditional marble staircase and wrought-iron banister have been restored and repainted and the brass handrail has been left intact. The salmon-coloured patterned carpet is pure late twentieth century, its combination with the harmonious peach paintwork evoking an Art-Deco feel to the whole scheme.

■ As often seen in southern Continental Europe, house walls are painted in a variety of bright colours, which may sometimes seem at odds with the colours used for painting the shutters. Equally it is not uncommon for houses like this to show signs of flaking and faded paint, reducing the whole to pastel shades that do not seem to jar. Thus when hues of colours, even complementary ones, are reduced in saturation they can appear more harmonious.

■ Although the flamingo can vary in colour from pale pink to bright red, it is the deeper hues such as the salmon colour that show it is both healthier and more desirable as a mate than its more insipid counterparts.

■ Despite the generic name of terracotta pottery, many such garden pots are in fact more likely to be this salmon colour. This is due to the variety of clay and the firing process used. The pot needs to be frost-proof (at least in Britain!), which requires a high temperature, and yet also needs to retain some porosity, requiring a slightly lower heat in the kiln. Typically the pot is fired for about three days at a temperature of 1,000 degrees centigrade.

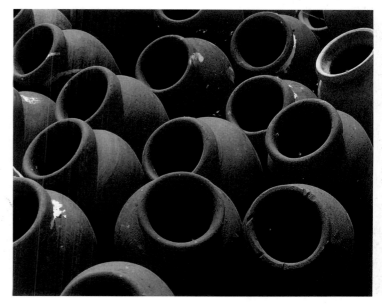

CORAL

■ 01 DEFINITION

The Romans considered coral a suitable talisman for their children. Coral is in fact a small animal (polyp) that lives in the ocean as part of huge colony. It comes in a variety of colours, from white to deep red and even black, depending on its geographical habitat. The colours that we recognize as coral may be either the deeper red of the semi-precious stones or the colour shown here.

■ 02 TECHNICAL INFORMATION

RGB Colour
R 255 G 127 B 80

CMYK Colour,
C 0 M 50 Y 53 K 0

LAB Colour
L 73 A 58 B 58

HSB Colour
H 16 S 69 B 100

Hexadecimal **Pantone**
FF7F50 1645C

Closest Web-safe Colour
FF6666

■ 03 COMMON COLOUR COMBINATIONS

■ **04** HISTORY AND CULTURE

The rare reddish coral (*Corallium rubrum*), which is sometimes referred to as 'fire coral' is found in the shallow waters of the Mediterranean and is used for gemstones and small sculptures. In the fifteenth century Piero della Francesca (1410/20–92) was one of a number of artists who depicted the infant Jesus with coral being worn as an amulet (*Madonna di Senigallia*). Coral has continued to be used for decorative purposes since then, most notably during the Art-Deco period when it was carved into geometric shapes and used in jewellery to define the '*moderne*'.

The pinkish-yellow coral that defines the colour referred to here is found mostly in the Pacific Ocean. Not as rare as the red coral, it is still used in jewellery and as an inlay, although due to conservation considerations synthetically made coral has taken its place on all but the most expensive and exclusive pieces.

■ **05** EXAMPLES

■ Most of the houses along Venice's Grand Canal were at one time palazzos for the rich and famous, each trying to outdo the other with shows of architectural bravura, the most notable being the *Ca d'Oro*, (House of Gold). What strikes the visitor most is the harmony created among these different colours brought together by the city's extraordinary reflective light.

■ Despite its name the goldfish is not gold in colour, but varies from white to deep orange. The fish was introduced to the West in the seventeenth century from China, at a time when goldfish were a more uniform colour. Since then hybrids with other members of the carp family, to which it belongs, have developed.

■ Unusually this scheme has used coral for all of the walls to create a hot colonial feel. The rest of the scheme uses texture and cooler colours to balance the effect. The chairs and table pedestal are pale while the top is in a warmer wood. Without this blending the furniture would offer too much of a stark contrast. The same effect has been used in the Shaker-style sideboard. The texture is provided in the ceramic floor and ethnic blinds.

■ Although graffiti seems to be a twentieth-century phenomenon, its earlier incarnation can be found as far back as the first century AD at Pompeii. It was used then and since for political purposes and protestation and is therefore strictly speaking an act of vandalism. In recent years, however, graffiti has become an art form in itself, with artists creating works in a gallery space.

■ Tea has been drunk in England since the seventeenth century; Thomas Twining opening his first public tearoom in 1706 to cater for this new phenomenon imported from China. The teapot was therefore the ideal vessel for the new and burgeoning Staffordshire pottery makers to manufacture, its complexity creating something of a challenge.

BRASS

■ 01 DEFINITION

Brass is a metal alloy comprised of copper and zinc, varying slightly in colour depending on its composition. Pinchbeck brass resembles gold when it is polished. The pejorative term 'brassy' refers to the imitation of gold as tasteless and flashy. Nevertheless brass has been used successfully for decorative items. The colour brass has none of the lustre of the metal and has a slight green hue to it.

■ 02 TECHNICAL INFORMATION

RGB Colour
R 181 G 166 B 66

CMYK Colour
C 13 M 16 Y 90 K 14

LAB Colour
L 69 A -1 B 58

HSB Colour
H 52 S 64 B 71

Hexadecimal **Pantone**
B5A642 619C

Closest Web-safe Colour
CC9933

■ 03 COMMON COLOUR COMBINATIONS

■ 04 HISTORY AND CULTURE

Although zinc, one of the components of brass, was not purified until the middle of the eighteenth century, brass as an alloy has been manufactured since ancient times using calamine, a zinc compound. One of its earliest uses was for the manufacture of a primitive form of trumpet or bugle by the ancient Egyptians. Coins were made of brass, both in Asia Minor and by the Romans in the first century AD. In the medieval period brass was used extensively in Northern Europe for church metalwork such as reliquaries, lecterns and plaques, and in door handles and candleholders.

The English Industrial Revolution created an opportunity for large-scale brass working and casting, the centre of which was in Birmingham. This coincided with the vogue in the middle of the nineteenth century for Gothic-Revival style in both church and secular building interiors. The first and probably greatest exponent of this was A. W. N. Pugin (1812–52) who designed a great many artefacts in brass and other materials, mainly for ecclesiastical use. He was also responsible for the interior of the Palace of Westminster in London.

■ 05 EXAMPLES

■ These elegant handles are a return to the classicism of ancient Greece and Rome that first became popular as a style in the late eighteenth century. These are modern-day castings in a similar style to Regency Classicism, adapted to include modern lock mechanisms. The white patina is caused by the inclusion of aluminium to increase the hardness of the alloy, but adds to the aged effect, too.

■ This is the ancient temple at Philae situated on the small Egyptian island of the same name on the River Nile. It was built in the third century BC in homage to the goddess Isis, the archetypal wife and mother. It was constructed in syenite, a locally sourced warm-grey stone that has similar properties to granite.

■ This mountain lake is showing signs of depleted water due to the lack of precipitation, most likely seasonal. The resultant exposed rocks reveal that there is a high red-oxide content in the surrounding soil. The brass-coloured appearance of the water's surface is due to the refraction of light altering the reddish colour of the underwater sediment.

■ It is often misunderstood that the Buddha is a god. In fact mortals can become a buddha as well, as it means 'the enlightened'. By reading the teachings (*Dharma*) the student of Buddhism seeks to become 'aware' and overcome his earthly sins of greed, hate and ignorance, in order that they can become truly happy. The brass statue shown here is a replica of the statue of Siddhartha Gautama, the founder of Buddhism.

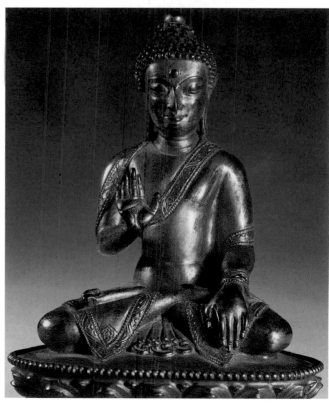

■ OCHRE

■ 01 DEFINITION

Traditionally, ochre was the generic term for all red and yellow earth pigments. Ochres are a mix of sand, clay and iron oxide and represent the most stable pigments, as exemplified in the Lascaux cave drawings. The colour we define today as ochre is yellow-orange and often referred to as yellow ochre, a recognized artist colour. The colour is reminiscent of a glowing summer sun, full of warmth and optimism.

■ 02 TECHNICAL INFORMATION

RGB Colour
R 204 G 119 B 34

CMYK Colour
C 1 M 56 Y 97 K 2

LAB Colour
L 62 A 39 B 67

HSB Colour
H 30 S 83 B 80

Hexadecimal **Pantone**
CC7722 716 C

Closest Web-safe Colour
CC6633

■ 03 COMMON COLOUR COMBINATIONS

■ **04** HISTORY AND CULTURE

Ochre is from the Greek word *okhros* meaning 'yellow' and has been discernable as a colour since pre-historic times. This ochre came from Goethite, a yellow iron oxide found predominantly in France and Spain that was first used in the Palaeolithic period around 40,000 years ago. Despite the addition of more colourful pigments such as red and blue to the ancient Egyptian palette, the interiors of their temples continued to have an ochre foundation. In Byzantine painting of the early Christian period, icons were painted using yellow ochre as a replacement for gold. During the sixteenth century ochre was available in such large quantities that it became viable to purchase the pigment to make house paint, a tradition that continued well into the next century. As a pigment yellow ochre is opaque and it was not until the late eighteenth century, when watercolour was being developed, that changes were made by incorporating tragacanth gum (later replaced by gum arabic) to assist the even dispersion of the colour when used as a wash.

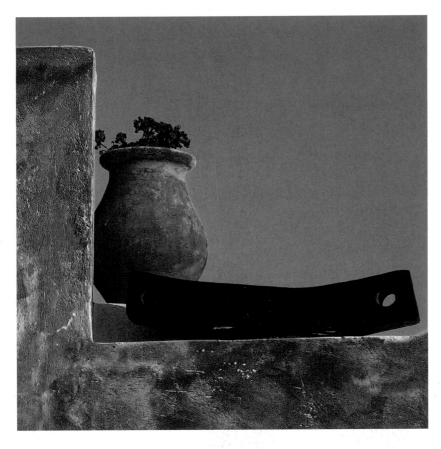

The nineteenth century saw the synthetic production of many colours including yellow ochre, its name changing to Mars yellow. Today, yellow ochre is produced synthetically but its name has returned to yellow ochre.

■ **05** EXAMPLES

■ Roof gardens are not a new phenomenon, having existed in ancient times. They tend to be more popular in Continental Europe, particularly in urban environments where houses are built close together and there is no garden. More importantly they require a flat roof, which precludes most of Northern Europe due to the often heavy precipitation. In this example the ochre pot and wall colour provide a suitable background for the red geraniums.

■ These predominantly ochre abstract forms suggest trees in a hot town square, the white behind emphasizing the bleaching qualities of the sun. The brightness of the yellow makes them appear in the foreground of the picture plane, the hints of blue and red helping to create some depth. The blue and the green also help to cool the abstracted forms.

■ This luxuriant room scheme is inspired by the American Arts and Crafts designers, such as Frank Lloyd Wright, who advocated designs that used local materials and the ethos of 'truth to materials'. In this scheme the sofa with the ochre cushion is similar to the furniture created by Gustav Stickley (1858–1942). The fireplace and surrounding wall suggest the use of local materials to create this vernacular but luxurious 'prairie house'.

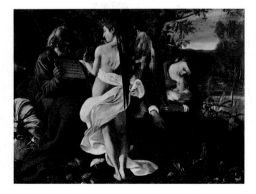

■ Caravaggio painted this private commission (*Rest on the Flight into Egypt*) in c. 1603 when he was at the height of his powers as a religious painter. His theatrical paintings persuade the viewer of the reality of the scene, applying common humanity to his deified characters. Caravaggio was one of the greatest exponents of chiaroscuro using mainly ochre tones.

Colour Source Book

OLD GOLD

■ 01 DEFINITION

Although old gold does not contain any cyan in its constituent parts, it has a slight green tint to it, approximating to the artists' colour green gold. It is similar in colour to straw. The metal green gold is in fact an alloy of gold and silver, the latter being harder than the former and thus providing strength.

■ 02 TECHNICAL INFORMATION

RGB Colour
R 207 G 181 B 59

CMYK Colour
C 5 M 16 Y 93 K 9

LAB Colour
L 76 A 3 B 70

HSB Colour
H 49 S 72 B 81

Hexadecimal **Pantone**
CFB53B 129C

Closest Web-safe Colour
CCCC33

■ 03 COMMON COLOUR COMBINATIONS

■ **04** HISTORY AND CULTURE

Historically people have preferred to wear jewellery that resembles natural gold. Unfortunately gold in its purest form is too soft for most purposes and it has been mixed with other red-yellow metals such as copper to provide the degree of hardness. Omitting the copper from the alloy, and mixing the gold with silver produces green gold. Typically eighteen-carat green gold would contain 25 percent silver. Symbolically silver, the cooler metal, tones down the luxuriant gold to create a less decadent precious metal. As a colour, green gold often appears on 'gold' credit cards and on paper used for letter writing where the lustre of gold would be inappropriate. Green gold is also used on greeting cards for golden anniversaries and other landmark occasions where gold is the celebratory colour.

The colour is often used in graphic design where luxury without decadence is required. Although gold lamé has been used in costume, it tends to be in show business where an impact is required. Old gold, an altogether more subdued colour, may be worn more informally on many different occasions.

■ **05** EXAMPLES

■ As one would expect, cats see well in the dark – in fact up to seven times better than humans. During the day, or in bright light, the iris closes to a slit-like opening as in this image. Cats' eyes can vary in colour between old gold and orange or various shades of green. The exception is Siamese cats, which often have blue eyes.

■ Apart from the neutral colours of the ceiling and floor, this dining room scheme uses only three colours, deep mahogany for the cabinets and furniture, terracotta for the upholstery and a clever use of the old-gold frieze to break up the sharp contrasts. Traditionally the frieze in an interior was the most elaborately decorated part of a scheme, a practice that is continued here.

■ The design on this old-gold brocade depicts both the fleur-de-lys and the chevron, both emblems used in heraldry, the colour signifying its regality. Through history, the fleur-de-lys has been variously used to symbolize the Virgin Mary, the Holy Trinity and the divine right of French kings. It is still used today in the heraldic emblem for Scotland.

■ These red and yellow ochre tiles provide an interesting chequer-board pattern for a roof, almost certainly for a hot, possibly Mediterranean, climate. As with most vernacular architecture in Continental Europe, emphasis is given to the rusticity of the building, as demonstrated by the deckled edges to the tiles and the randomness of the pattern.

■ In the United States the gown colours worn at university graduation ceremonies have been standardized and are defined by the academic subject that the student has studied. For graduates of humanities the attire would be white, for law it is purple and for commerce, accountancy and business it would be old gold, sometimes referred to as 'drab'.

Colour Source Book

KHAKI

■ 01 DEFINITION

Khaki conjures up a picture of military fatigues in monochromes of desert brown and sludgy green but that combination is camouflage green not khaki. Adopted as a fashion item, khaki army jackets are worn in a spirit of defiance rather than compliance with warfare. Khaki shorts symbolize the long shorts worn by Robert Baden-Powell's Boy Scouts. Hikers and bird watchers, nature lovers and ramblers favour the khaki colour, to blend in with the landscape's palette of earthy tones. Khaki can connote heat, durability, long marches, endurance and endeavour; bravery, companionship, duty and military force.

■ 02 TECHNICAL INFORMATION

RGB Colour
R 195 G 176 B 145

CMYK Colour
C 18 M 25 Y 40 K 1

LAB Colour
L 74 A 6 B 20

HSB Colour
H 37 S 26 B 76

Hexadecimal **Pantone**
C3B091 466 C

Closest Web-safe Colour
CC9999

■ 03 COMMON COLOUR COMBINATIONS

■ **04** HISTORY AND CULTURE

The word khaki is adapted from the Hindi/Sanskreet *khak* meaning 'dust-coloured' and refers to a dull brownish-yellow colour rather than materials. Its wider use was to describe British military uniform in India and Afghanistan in the middle of the nineteenth century. In 1848 Brigadier General Sir Harry Burnett Lumsden wanted to disguise the whiteness of British uniforms, for troops to be less noticeable in the earthy, mud-brown landscape. Military fatigues were doused in concoctions of curry spices, coffee, tea and mud to disguise the brilliant white. Following this event the colour was established as soldiers' kit and clothing was issued in the dusty 'khaki' colour. Much later, in 1912, the USA armed forces approved the colour for military apparel when its naval air force kitted out pilots in khaki-coloured jackets. In 1931, the US Navy approved the colour for their submarine crews.

Khaki clothing was popularized when worn by characters in the film *Crocodile Dundee* (1986), set in the Australian outback. Television presenters of wildlife programmes wear it to 'blend' in with the natural landscape. Khaki is a popular fashion colour today. Old military jackets in khaki colour are in constant demand; vintage clothes shops stock originals. Casual fashion shops such The Gap, permanently stock khaki-coloured fatigue trousers, tee-shirts and cropped jackets for men and women.

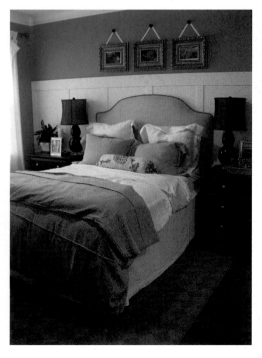

■ **05** EXAMPLES

■ The beach suggests time off and warm sand under bare feet. The natural colours of sand, shingle and crushed seashells are true to the natural brownish-yellow tones of khaki. The board decking in khaki-coloured wood creates a neutral harmony and relaxed mood.

■ Bed linen in khaki is chosen to balance the calming neutral tones of grey-green walls and floor-length pale curtains. Daylight accentuates the whiteboard panels that are a backdrop for the padded headboard, lampshades, pillows and flooring in various khaki hues.

■ Ancient Greek builders used local materials, hewn from nearby quarries. Sandstone was the most common except for prestigious buildings when marble was used. The post and lintel design with columns was formulaic. The sandy-coloured ruins and cobbled road are khaki in tone.

■ The solid milk jug, cups without saucers and large plate in brownish-yellow khaki glaze all have a country-style rustic look: an ideal crockery set for everyday use. The pistachio green backdrop intensifies the khaki colour and visually complements it.

■ This fabric design uses the true khaki colour for background, to highlight the vertical pattern. Dusty, sandy colours work well with other neutrals; alternatively it can be enlivened with shocking pink, sharp bright green or hues of cobalt and cyan.

Colour Source Book

■ TAN

■ 01 DEFINITION

Tan suggests the warm pale brown skin tones associated with a Mediterranean holiday. It suggests a
healthy and luxuriant lifestyle akin to that enjoyed by film stars and celebrities. The word derives from
the Latin *tannum*, the crushed oak bark used in the process of leather tanning. The resultant leather is
left with this particular hue that we refer to as tan, a colour not dissimilar to a Caucasian suntan, a pale,
warm tawny brown.

■ 02 TECHNICAL INFORMATION

RGB Colour
R 210 G 180 B 82

CMYK Colour
C 10 M 26 Y 43 K 1

LAB Colour
L 77 A 11 B 27

HSB Colour
H 34 S 33 B 82

Hexadecimal **Pantone**
D2B48C Red 032C

Closest Web-safe Colour
CCCC99

■ 03 COMMON COLOUR COMBINATIONS

■ **04** HISTORY AND CULTURE

The first uses of 'tanned' leather can be traced to about 2,500 BC, when the problem of hide putrefaction was solved. After removing the hair and excess fat the hide is washed and then stretched before applying tree bark, usually oak or chestnut, a natural source of the chemical tannin, which preserves it. The resultant colour of the leather is variable but is referred to as tan.

A suntan has not always been fashionable. Indeed from Roman times, people tried to emphasize their 'whiteness' by adding white colourant to their skin, and during the eighteenth and nineteenth century, a tanned complexion was associated with manual labour, something eschewed by the wealthy. It was not until the 1920s when the couturier Coco Chanel returned from a holiday on the French Riviera with an accidental suntan that the fad for sunbathing began in earnest. By the 1960s it was very fashionable for the rich and famous to be tanned, a status symbol. With the advent of the package tour it has now no longer the preserve of the wealthy to gain a tan. More recently so-called 'fake tan' lotions have become commercially available, to fake a tan using chemical skin dyes.

■ **05** EXAMPLES

■ Until the fourteenth century, the Great Pyramid of Giza in Egypt was the tallest man-made structure in the world. It took approximately 20 years to build for the pharaoh Khufu around 2,560 BC. The tan colour comes from the Tura limestone quarried to make the pyramid, using in excess of two million blocks, with each block weighing an average of three tonnes.

■ This interior has a Japanese feel to it, with its emphasis on horizontals and verticals. The window resembles a room screen as used in Japanese homes. The style of the black ebonized chairs is copied from nineteenth-century furniture designers such as Edward Godwin (1833–56) and others whose Aestheticism was owed to Japanese influences. The tan upholstery and tablecloths add warmth to the scheme that would otherwise be too formal and arid.

■ The teapot and stand shown here are influenced by some of Christopher Dresser's (1834–1904) designs of the 1870s based on Japanese

aesthetics. Dresser's designs were radical at the time because of the emphasis on a square form. This design takes the same format and recreates it in ceramic, using a distressed tan over a darker base colour.

■ Graffiti has now become an art form in its own right, with its artists now accepted as mainstream for producing illustrative and abstract designs. This work uses abstracted forms of nature, trees and flowers, to create a simply coloured design that could be adapted for use in textiles.

Colour Source Book

BEIGE

■ 01 DEFINITION

Often described as the blandest and most unimaginative colour, beige is also the most misrepresented when described. The colour is extremely pale yellow with a hint of black and sometimes referred to as ecru, from a French word meaning raw: silk and other materials in their natural state resemble the beige or ecru colour.

■ 02 TECHNICAL INFORMATION

RGB Colour
R 245 G 245 B 220

CMYK Colour
C 5 M 2 Y 12 K 0

LAB Colour
L 96 A -3 B 12

HSB Colour
H 60 S 10 B 96

Hexadecimal **Pantone**
F5F5DC 7499C

Closest Web-safe Colour
FFFFCC

■ 03 COMMON COLOUR COMBINATIONS

■ **04** HISTORY AND CULTURE

Although beige is synonymous with blandness, it is surprising how often it has been used in a variety of ways across the centuries. Soapstone is a beige-coloured soft rock that has been used for carving since ancient times. During the Ming dynasty in China delicate figures were carved in soapstone and enjoyed a high status, particularly among the educated elite. Ancient pre-Columbian artists in South America moulded delicate terracotta ceramic wares, often using only a beige-coloured slip to create a patterned design. In the eighteenth century the Sèvres porcelain company moved from soft to hard paste porcelain to produce a new range of Neoclassical designs. New coloured grounds were devised including the popular nankin (beige).

In the same century the painter Jean-Baptiste-Siméon Chardin was using beige in many of his still-life paintings in place of white. The Impressionist artist Edouard Manet (1832–83) used a bare unprimed beige canvas for some of his delicate one-colour portrait drawings in pastel. At the beginning of the

twentieth century, beige cardboard was employed by a number of artists such as Picasso, Braque and Jean-Paul Laurens (1838–1921) to make Cubist collage and sculpture. The Dutch artist Willem Hussem (1900–74) created a stir in the 1960s with his abstract black daubs on beige untreated canvas, as did his contemporary the American artist Cy Twombly (b. 1928).

■ **05** EXAMPLES

■ Quarry tiles are making a comeback after they first made their appearance as a decorative tile in the late nineteenth century as Ruabon clay quarry tiles. Here, they are placed in a random pattern to break up what would otherwise be a neutral and bland beige floor.

■ The Scarce Swallow butterfly is rarely to be found in the northern parts of Europe, preferring the orchards of middle France and northern Spain for its habitat. The distinctly marked beige and black markings of this insect identify it as an endangered species in some parts of Europe.

■ Since the 1960s when garish colours first made their appearance, there have been endless debates about their suitability. Since then beige has not had a good press as though neutrality is somehow an alternative without risk. As these garments demonstrate well-tailored garments are timeless and will not be faddish.

■ This corner sofa is designed as part of an interchangeable system. It is based on Japanese design with the use of black ebonized legs and rails and the emphasis on verticals and horizontals. The beige, rather than white, upholstery gives it a warm comfortable look and yet still manages to highlight the contrast.

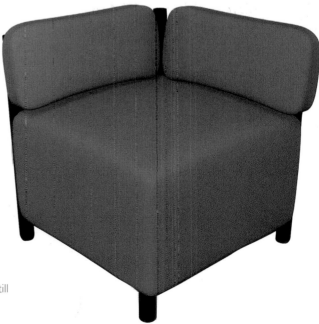

IVORY

■ 01 DEFINITION

The colour probably closest to white is ivory, which takes its name from the colour of the teeth of certain mammals. As a naturally occurring material, man has used it to carve implements and decorative objects since before ancient times. Since it has a softer look than white he has also used the colour for both interior and exterior decoration.

■ 02 TECHNICAL INFORMATION

RGB Colour
R 255 G 255 B 240

CMYK Colour
C 2 M 1 Y 6 K 0

LAB Colour
L 99 A -2 B 7

HSB Colour
H 60 S 6 B 100

Hexadecimal Pantone
FFFFF0 7499C

Closest Web-safe Colour
FFFFFF

■ 03 COMMON COLOUR COMBINATIONS

■ **04** HISTORY AND CULTURE

Strictly speaking, true ivory only comes from the African and Asian elephants, with the former's tusks being larger and superior in quality. It has always been valued as a commodity because of its rarity and its survival of disintegration over thousands of years. It has been widely traded but as demand has increased it has been necessary to harvest the material from other sources such as walruses, whales and hippos. Ivory has been used by many different cultures, beginning with the people of the prehistoric period, who used mammoth tusks for carving. Ancient and early Christian civilization have used it in both secular and religious carvings.

The high point for ivory carving was during the medieval period when it was used for all manner of religious artefacts, but in the high Victorian period many secular items were made and ivory inlays were also popular. The twentieth century has seen the introduction of synthetic ivory in order to prevent poaching and illegal trading in protected species.

■ **05** EXAMPLES

■ African elephants are the largest land mammals on the planet. They use their tusks as an incisor to strip bark and to cut their way into baobab trees to get to the pulp and also to dig for water. Fortunately they are no longer hunted legally for their tusks in mankind's quest for ivory.

■ Ivory seems to be the accepted colour for a child's Christening robes and other items of clothing, such as matching bonnet and boots. It is also the recognized colour for a young girl's confirmation dress when becoming a member of the Christian church.

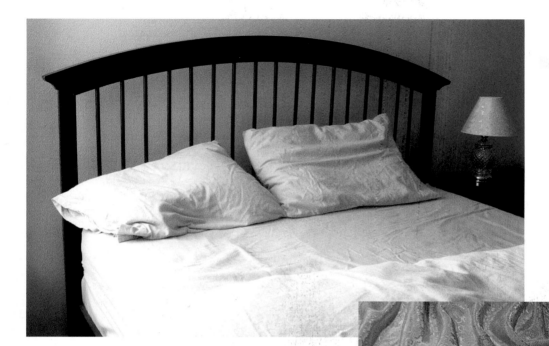

■ Normally the starkness and contrast that black and white suggests in any room can create a sense of sterility and emptiness. In the simple scheme of this bedroom, however, these problems are overcome by using ivory in place of white, both on the walls and in the bed linen.

■ This beautiful textile is created using ivory lace over a pale coloured silk. Lace making originated in fifteenth-century Europe, at a time when fabrics and techniques were being discovered following the opening of trade routes around the world.

■ Despite his lavish Bohemian lifestyle, James Abbott McNeill Whistler's (1834–1903) paintings often belied that tag, with his subtle use of tone and frequent use of a limited monochromatic palette. *Harmony in Flesh Colour and Black: Portrait of Miss Louise Jopling* (1843–1933) serves as the perfect exemplar. He was an advocate of 'Art for art's sake' and as such rarely gave his pictures titles, referring to them simply as 'symphony' or 'harmony'.

FLAX

■ 01 DEFINITION

Flax is a pale greyish-yellow colour so-called because of its likeness to flax seeds. Flaxen is often used to describe the blonde hair of some Caucasians, as in Claude Debussy's musical prelude *Girl With The Flaxen Hair* (1910). Flax can also be used to describe the colour of linseed oil, coming as it does from the seeds of the flax plant.

■ 02 TECHNICAL INFORMATION

RGB Colour
R 238 G 220 B 130

CMYK Colour
C 3 M 8 Y 59 K 1

LAB Colour
L 89 A 0 B 50

HSB Colour
H 50 S 45 B 93

Hexadecimal **Pantone**
EEDC82 120C

Closest Web-safe Colour
FFCC99

■ 03 COMMON COLOUR COMBINATIONS

■ **04** HISTORY AND CULTURE

Flax was probably originally cultivated in the Indian sub-continent to provide a number of useful products, all of which are still used today. The seeds are used to produce linseed oil, which is used in oil painting and in nutrition and medicine. The fibres of the plant are strong and are woven to make canvas and linen. This is one of the oldest textile industries in the world with the production of linen going back at least 5,000 years. Much of the finest flax is used in Ireland to make high-quality linen. Such is the strength of flax that the fibres are also used to make paper, rope and fishing nets.

Flax has been used for making artists' canvas since easel painting was invented. Depending on the fibres, they can be woven into a coarse flax canvas with a definite tooth, or a smoother fine-weave linen canvas. Artists often used flax canvases, the coarse grain being a significant part of their work, the most notable being Paolo Veronese (c. 1528-88). Later artists such as Paul Gauguin (1848-1903) also used flax as a ground. The colour flax has been used extensively in textile design and featured in many of the Arts and Crafts designs of C. F. A. Voysey.

■ **05** EXAMPLES

■ There are many different colours of sand in the world, depending on its geographical location and thus its geological content. Sand can vary between white sands in New Mexico to the black sands of volcanic areas such as Hawaii. The colour shown here is typical of most sands in the world, particularly desert areas.

This room has been made to resemble an Art-Deco scheme of the 1930s, in its excessive use of chrome for the framed mirror, the style and colour of the sofa and the flaxen-coloured decoration. The tall narrow vase adds the finishing touch.

William Morris described wallpaper design as 'quite modern and very humble, but as things go, a very useful art'. Under his leadership, Morris and Co. produced well over 50 different designs of Arts and Crafts wallpapers from the first, *Trellis*, designed by Morris himself in 1862, until his death in 1896. Even after his death, another 50 designs emerged from the firm. This 'Apple' design was made and produced in 1877.

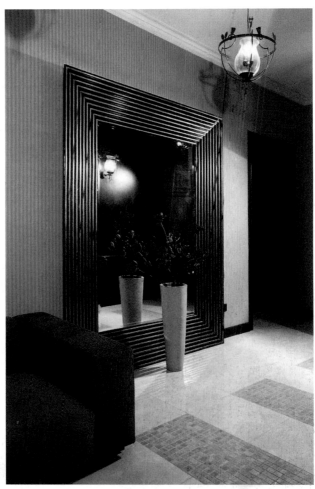

A geodesic dome such as this is made up of triangular elements that are able to distribute stress across a wider area that traditional roofs. The larger the roof, the stronger it becomes, a theory that was first developed by R. Buckminster Fuller in the 1940s. This design uses flax-coloured triangles and dark-brown struts to highlight its construction.

Colour Source Book

CORN

■ 01 DEFINITION

Corn is a delicate almost pure yellow colour akin to the grain of the corn or maize plant. In the past the colour was known as golden wheat. The colour is a slightly paler version of the artists' colour cadmium yellow. Corn is often used in packaging of food items, in conjunction with deep reds and browns, for example in coffee and chocolate. It was a colour much used in fashion and interiors during the 1950s and 1960s.

■ 02 TECHNICAL INFORMATION

RGB Colour
R 251 G 236 B 93

CMYK Colour
C 3 M 4 Y 74 K 0

LAB Colour
L 93 A -5 B 75

HSB Colour
H 54 S 63 B 98

Hexadecimal **Pantone**
FBEC5D 115C

Closest Web-safe Colour
FFFF66

■ 03 COMMON COLOUR COMBINATIONS

■ **04** HISTORY AND CULTURE

Although corn originates from Central and South America, the United States of America now grows nearly half of the world's corn. It is a basic staple food for humans that provides starch, oil and, of course, cereal grain. It is also used as a cattle fodder. In Europe, where France is the largest grower, corn is only used for cereal production. Sweetcorn is a variant to this crop. At the beginning of the nineteenth century, English production of corn was being undermined by cheaper imports, which led to the passing of the Corn Laws, designed to protect the profits of the wealthy landowners.

A number of the so-called Romantic artists such as John Constable painted several rural scenes at this time that were a comment on these laws, such as *Cottage in a Cornfield* (1815). These depictions of a rural idyll were also commenting on the loss of land due to the Industrial Revolution and the movement of farm labourers into the cities to man the factories that were being built. Today cornfields still make appealing subjects for landscape painting, both in England and Northern France.

■ **05** EXAMPLES

■ This small intimate theatre space (above) relies on only two colours in monochromatic harmony for the scheme. The natural-wood chairs that provide some texture also accent the corn colour of the décor. When the stage is empty, the scheme provides a warm and hospitable environment, and when lit and occupied the room becomes neutral.

■ The combination of yellow and black, two contrasting colours, works well in signage because of yellow's effect of advancing toward the viewer, making the distinction between background and text, easier. Corn is a clean hue of yellow, making it an ideal colour.

■ Markets in Mediterranean towns are always likely to provide a variety of fabrics and colours (see bottom left). The sunshine seems to bring out the radiance of all these colours, even the slightly muted colour of the corn material.

■ Corn is only grown in temperate areas of the world as it is highly dependent on water and cannot tolerate the cold. It is therefore planted in the spring. Over 600 million tonnes of corn is harvested worldwide every year.

■ The craft of stained-glass making which began in the eighth century continues to this day, using much the same methods. Today, however, we have the advantage of a broader and more stable range of pigments and colours.

 # GOLD

■ 01 DEFINITION

In the fifth century BC the Greek poet Pindar wrote 'water is best, but gold shines like fire blazing in the night, supreme of lordly wealth'. Man has shown his love of this most noble metal since ancient times, for example on Tutankhamun's funerary mask. Gold, with its characteristic yellow colour, is symbolic of great achievement (Olympic Games), of pagan (the sun) and religious spirituality (Christian weddings), of nobility (crown jewels and regalia) and of course wealth. Gold has traditionally been used as a basis for international monetary exchange with many advocates seeking a return to the Gold Standard.

■ 02 TECHNICAL INFORMATION

RGB Colour
R 255 G 215 B 0

CMYK Colour
C 0 M 12 Y 87 K 1

LAB Colour
L 89 A 8 B 97

HSB Colour
H 51 S 100 B 100

Hexadecimal **Pantone**
FFD700 109C

Closest Web-safe Colour
FFCC00

■ 03 COMMON COLOUR COMBINATIONS

■ **04** HISTORY AND CULTURE

Gold is found in nuggets or as small grains in rocks and can also be found in river beds as alluvial deposits. It is a soft metal and can be beaten into thin sheets to make gold leaf for decoration or drawn into a fine thread for embroidery. Because of its softness it is usually mixed with other metals to create an alloy, for example copper, to create rose gold or silver to make green gold. It is used extensively in jewellery, firstly because of its symbolic wealth, but also due to its resistance to oxidation and corrosion. It is this aspect that made it particularly suitable for use in wedding rings, being a metaphor for the indestructibility of the sacred vows. These same properties also made it useful for coinage. Gold has been revered as a precious metal since ancient times, mentioned many times in the Bible and used extensively by the ancient Egyptians for rituals. Alchemists in the medieval period sought to change lead into gold using the elusive 'philosopher's stone'. Medieval kings always wore a gold crown at their coronation, a symbol of the eternal light of heaven and their divine right to rule.

From the fifteenth century onward, the Europeans led many expeditions to and eventual conquests of South America and parts of Africa and Australia, such was their desire for gold. Thomas More, writing at this time, was critical of this quest and mocked the aspiration in his book *Utopia* (1516). The nineteenth century saw an unprecedented venture to mine gold at new sites in South Africa, California and Australia.

■ **05** EXAMPLES

■ Brightly painted houses such as these are to be found on many of the islands in the Caribbean. These gold and blue colours are typical of Barbados, where homes are known as 'chattel houses' since they own the property but not the land they are built on.

■ The designer of this stained-glass window has carefully chosen complementary colours to emphasize the wheat, a Christian symbol of resurrection. By setting it against blue, the 'neutral' colour of our earthly existence, the wheat is 'pushed' toward the viewer to emphasize the message.

To the Greeks and Romans, the star was a divine being in itself As a symbol it was later adopted by the Christian faith as a sign of Christ's coming and was therefore symbolic of hope. Today that same golden symbol is often placed atop the Christmas tree as that same symbol of hope.

Such colourful displays as this are the result of underground geothermal activity that melts the icecap, allowing the deposit of minerals from the rocks below. There are many of these thermal pools or baths around the world and, temperature permitting, they are used by humans for therapeutic bathing.

SAFFRON

■ 01 DEFINITION

Saffron, a spice and colouring dye is extracted from the saffron crocus (*Crocus sativus*) and dried. It is one of the oldest and remains one of the most expensive commodities in the world and is therefore often synonymous with wealth. Typically it takes about 70,000 flowers to yield 1 kg (2.6 lbs) of saffron. Saffron contains crocin, which when used as a dye produces a deep yellow-gold hue and is used as both a fabric and food colourant.

■ 02 TECHNICAL INFORMATION

RGB Colour
R 244 G 196 B 48

CMYK Colour
C 1 M 21 Y 87 K 1

LAB Colour
L 84 A 14 B 84

HSB Colour
H 45 S 80 B 96

Hexadecimal **Pantone**
F4C430 123C

Closest Web-safe Colour
FFCC33

■ 03 COMMON COLOUR COMBINATIONS

■ **04** HISTORY AND CULTURE

The saffron crocus was originally grown in the warm Eastern Mediterranean climate and harvested in the autumn. Dry saffron is unstable as a colourant, losing its intensity rapidly in light; it also needs to be stored in airtight containers to prevent oxidation. The origins of saffron as a cultivated plant are in either Greece or Asia Minor and began well over 3,000 years ago. There are a number of frescos that exist in these areas depicting the use of saffron as both a drug and a perfume. There is sufficient evidence to show that saffron was used as a colour fabric dye in the Hellenistic period (fourth century to first century BC) and then during the Roman Empire for people of high status.

During the medieval period saffron dye was used in illuminated manuscripts because of its colour intensity. Its use as a perfume, spice and colourant also became popular in Northern Europe during the sixteenth and seventeenth centuries and at this time England began growing the crop in the Essex and Suffolk areas, most notably at the renamed Saffron Walden, which became the centre for the trade. It was also grown on the Eastern seaboard of the United States. Today most saffron is grown in the area it originated in the Eastern Mediterranean and into the northern part of the Indian subcontinent.

■ **05** EXAMPLES

■ Normally associated with love and beauty the rose is the most popular garden shrub in England because of its fragrance. It has been extensively cultivated as a hybrid and since Victorian times its colour variations have been used to symbolize individual properties; the yellow rose denoting platonic love.

■ Since saffron originated in the Eastern Mediterranean, this Greek house aptly uses the colour as its wall colouring, acting as a complementary to the deep-blue sky. The colour, enhanced by the hot sun, suggests intense and deep warmth.

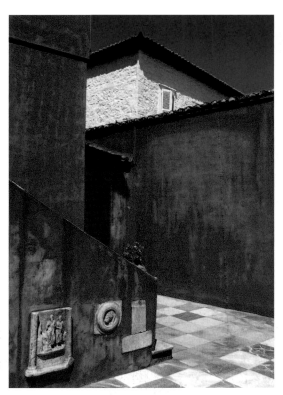

■ This boot gives the appearance of suede leather but is likely to be made of a synthetic material. Real suede is made from the inner side of a leather skin and because of its delicacy and lack of waterproofing, is unlikely to be used for everyday wear. Synthetic materials such as this are easier to dye since there are none of the inconsistencies associated with natural products.

■ This colour scheme cleverly uses saffron as a way of creating a period setting for this diner. A difficult colour to place in interior design, saffron was used extensively in interior design during the 1950s, the heyday of the American diner.

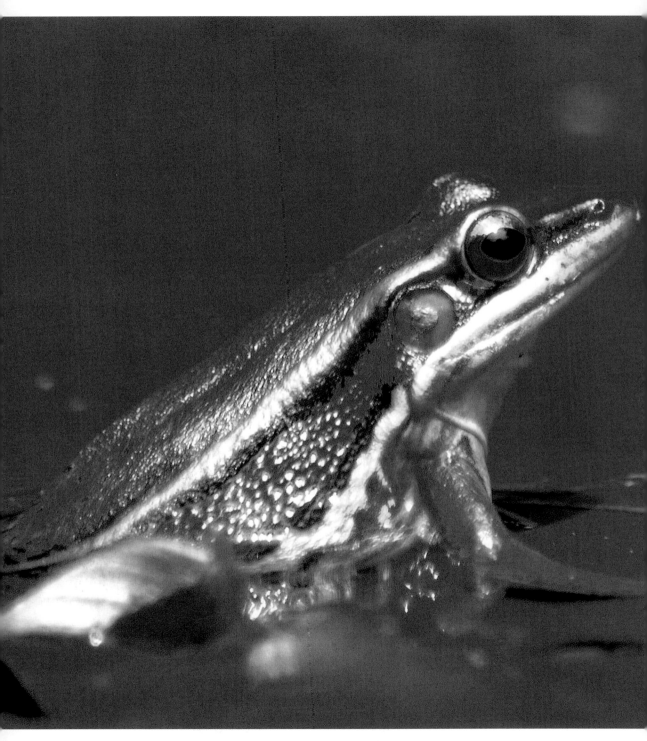

CHARTREUSE

■ 01 DEFINITION

The colour of chartreuse yellow is yellowish-green. It is a bright, cool colour with a vivid hue of high intensity, 87.5 percent yellow and 12.5 percent green. It was produced as a synthetic pigment from 1884. Chartreuse, also know as chartreuse green is 50 percent yellow and 50 percent green (phthalocyanine green and process yellow). Chartreuse yellow has positive mood traits of regeneration, confidence and coolness but can suggest evil. It is colour as sensation, a psychological tool to create an effervescent, bright aura.

■ 02 TECHNICAL INFORMATION

RGB Colour
R 127 G 255 B 0

CMYK Colour
C 45 M 0 Y 66 K 0

LAB Colour
L 87 A -90 B 91

HSB Colour
H 90 S 100 B 100

Hexadecimal **Pantone**
7FFF00 802C

Closest Web-safe Colour
66FF00

■ 03 COMMON COLOUR COMBINATIONS

■ **04** HISTORY AND CULTURE

Chartreuse takes its name from an herbal mixture created by Carthusian monks in 1605. The reviving greenish-yellow aperitif, known as Chartreuse, was originally considered an elixir; a tonic for good health. The recipe was created from an ancient manuscript and put into production by the Carthusian monks at their Grande Chartreuse headquarters in Voiron, France, close to Grenoble. The liqueur was used medicinally as a digestive, and it was said to promote long life. The alcohol content was increased when the drink became popular outside the monastic community. Two types are now produced: green chartreuse, a greenish-yellow colour, and yellow chartreuse a yellowish-green colour.

The invigorating aperitif is refreshing in small quantities; this echoes the use of the colour which needs to be carefully considered. In 1966, 'Love: A Psychedelic Celebration' was held on Thursday 6 October in Tompson Square Park, Los Angeles, to protest against the ban on LSD drug. Psychedelic colours such as those seen under the influence of the drug became fashionable colours: deep purple, violet, crimson, magenta, sapphire, cyan, chartreuse, lime and yellow were part of the fabric of youth culture. Complementary colour combinations were thrown together to create maximum impact, for clothing, shoes, bags, accessories, cars and album covers.

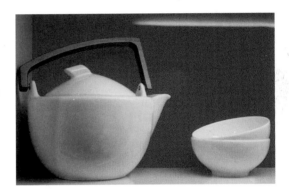

■ **05** EXAMPLES

■ The luminosity of the white china teapot and tea bowls is reflected in the intense colour of the chartreuse wall. The yellow-green hue is bright and clear. The colour is associated with invigoration, tonic, brilliance and intensity. The juxtaposition of white and green has a cooling effect.

■ The rich natural colours of the kiwi fruit mirror the tangy colours of chartreuse green and chartreuse yellow. Both are cool colours, associated with freshness and good health; the colour association creates a sensation of well-being and happiness.

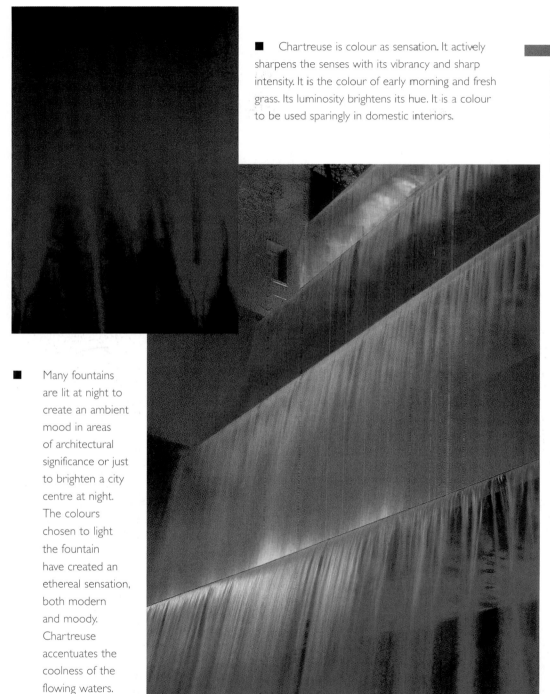

■ Chartreuse is colour as sensation. It actively sharpens the senses with its vibrancy and sharp intensity. It is the colour of early morning and fresh grass. Its luminosity brightens its hue. It is a colour to be used sparingly in domestic interiors.

■ Many fountains are lit at night to create an ambient mood in areas of architectural significance or just to brighten a city centre at night. The colours chosen to light the fountain have created an ethereal sensation, both modern and moody. Chartreuse accentuates the coolness of the flowing waters.

■ LIME

■ 01 DEFINITION

Lime is associated with the citrus fruit of greenish-yellow hue and with quicklime of greyish-white colour, which is used to make mortar. The greenish-yellow colour can be produced through a compound of primary blue and yellow, carefully graded. It is 75 percent yellow and 25 percent green, between chartreuse and yellow on the colour wheel. The word 'lime' gives meaning to the name 'Limey', a nickname for British sailors in the nineteenth century; a ration of lime, orange or lemon juice was known to prevent scurvy during the long voyages at sea.

■ 02 TECHNICAL INFORMATION

RGB Colour
R 191 G 255 B 0

CMYK Colour
C 29 M 0 Y 67 K 0

LAB Colour
L 91 A -53 B 97

HSB Colour
H 75 S 100 B 100

Hexadecimal **Pantone**
BFFF00 375C

Closest Web-safe Colour
CCFF00

■ 03 COMMON COLOUR COMBINATIONS

■ **04** HISTORY AND CULTURE

The colour is linked citrus fruits: limes, lemons, grapefruit and oranges. Lime is a colour associated with modern life, modern art and modernity. It is visible in paintings by the Fauves: a group of friends living in Paris at the turn of the nineteenth century, who used pure colours straight from the tube. They produced startling, vibrant works that 'sing' with colour and life. The Fauves palette of 'brights' included citrus lemon, lime green and orange. Vassily Kandinsky produced abstracts of outstanding clarity in bright citrus hues, mixed with strong red and luminous pinks and bright greens. Lime and lemon, magenta and cerise, orange and purple were popular colours in the 1950s, too, for fashion and interior design.

A revival of 'brights' set against perennial white occurred in 2006; for example in the colourful collections of the English designer Zandra Rhodes (b. 1940) and Italian designer Donatello Versace (b. 1955). The advertising industry makes much use of the colour lime to promote healthy living and connote a fresh, bright product. Web designers use lime in many colour formats and successful combinations, such as: violet, lime, orange and pink; deep lime, rich mauve, yellow and pale mauve; lime, light lime, sun yellow and blue.

■ **05** EXAMPLES

■ The grass parakeet, known also as a budgerigar, has lime-green and lemon plumage and is native to Australia. Grass parakeets are popular as a caged bird in the home. A small splash of bright cobalt blue under the eye contrasts with the citrus lime-lemon feathers.

■ A tropical jungle spirit is captured on a white background. Leaves in varied shapes and shades of green vie for attention. Citrus lime flowers in assorted sizes add further impact to a brilliantly fresh, eye-catching pattern. Lime and white make a good colour combination for bathrooms. White walls and bathroom fittings set against a lime-coloured floor or bathroom mat, with patterned blind or curtains, would create a fresh interior.

Through the use of fluorescent citrus lime a simple design for a notebook is transformed into an 'artwork'. Black typeset pays attention to company name and logo. A pen attachment is practical and does not detract from the quirky colour.

A lime and lemon baby's high chair has high-tech design features. Hard-wearing moulded plastic creates a futuristic look for a conventional piece of nursery equipment. Infants, babies and small children are drawn to bright citrus hues.

Cézanne said that painting was optical, 'that's where the material of our art lies; in what our eyes think…. Nature when we respect her tells us what she means'. He looked to colour and form to recreate what he saw: the hillsides, the views of Mont St Victoire, houses in the village or life in the fields in *Life in the Fields* (c. 1875).

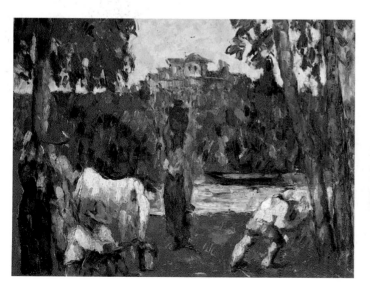

■ JADE

■ 01 DEFINITION

In Chinese the word jade means 'precious stone'. The most prized hue is emerald green. Jade invokes the Orient: linked to dragons, temples, carvings, jewellery, pottery and ornament. Its green-blue tone aligns with sophistication, desire, wealth and longevity. Jade was worn as a status of wealth by Chinese emperors, mandarins and court officials. It is considered to bring good luck. CMYK is 40 percent cyan, 30 percent magenta and black. The colour contrasts with warm orange or cerise. Tonal shades are olive and grey-green. The expression 'jaded' means to be worn out, weary or dull.

■ 02 TECHNICAL INFORMATION

RGB Colour
R 0 G 168 B 107

CMYK Colour
C 92 M 0 Y 72 K 1

LAB Colour
L 58 A -81 B 18

HSB Colour
H 158 S 100 B 66

Hexadecimal **Pantone**
00A86B 3405C

Closest Web-safe Colour
009966

■ 03 COMMON COLOUR COMBINATIONS

■ **04** HISTORY AND CULTURE

The jade stone is formed from two separate crystalline masses: nephrite and jadeite. Nephrite jade is associated with ancient Chinese dynasties. Objects were crafted in China 4,000 years ago and used for ornamental carvings and religious ritual. A piece of jade would be placed in the mouths of the dead. In Egypt the green stone had a magical-religious quality, used in ritual ceremonies. Jadeite stone was mined over 1,000 years ago, in provinces of Burma. This was called Chinese jade and exported to China in the late eighteenth century. Nephrite is a muted green with grey-brown hues; jadeite is a purer green due to the presence of chromium; the purest is emerald green in hue, referred to as imperial jade. Shades of jadeite (brown, lavender, yellow, black and a translucent white) result from various minerals present in the stone.

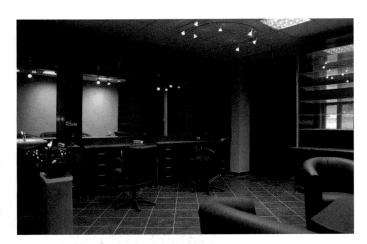

The colour of jade is also associated with wealth. The colour features in the paintings of the Pre-Raphaelite Brotherhood, active in the mid-nineteenth century. They used a palette of bright jewel colours to portray a bygone medieval fantasy of chivalrous knights and lovelorn maidens. The colour of jade toned with these decadent, sensual portrayals can be seen in *The Depths of the Sea* (1868–69) by Sir Edward Burne-Jones (1833–98).

■ **05** EXAMPLES

■ A hairdresser's studio is the perfect place to use shades of green. The colour creates a fresh, calming atmosphere. Jade, emerald and sap green are used for walls, chairs and flooring. The comfortable chairs add to the stylish interior design. Directional lighting above each mirror will focus attention on the client, not the room.

■ Jade-green sea water passes through the grey rock canyon; the hues of the water are created by light reflection from the stone and daylight from above. The naturally formed colours illustrate the harmonious combination of jade and natural stone.

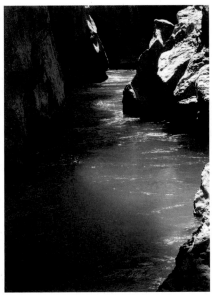

■ A jade canvas sets the tone for contrasting complementary colours. The clash of purples and pinks and blue-green adds depth and vibrancy. A non-figurative painting allows for abstract unstructured use of colour. The spectator enjoys the 'sensation' of colour contrasts and harmonies.

■ This textile design creates an optical illusion of fractured blue and green fragments of marble and jade stone. The chosen colours highlight the hues analogous to jade, from sapphire blue to emerald green. The cool colours work together in harmony and accentuate the contrasts. The fabric would be suitable for a bathroom; echoing a fresh-morning or cool-evening ambience.

■ In Van Gogh's *L'Arlesienne* (*Madame Ginoux*, 1890), the half-portrait of Madame Ginoux depicts her sitting at a table. Her left hand supports her chin and she sits in relaxed contemplation. She is at ease in the company of the artist. He paints her bright-eyed and inquisitive. Two closed books are stacked on the table in front of Madame Ginoux on a jade-green tablecloth. The green colour attracts the eye and one takes in the whole picture: the books, the woman's dark hair against the light-coloured background and her pale-green scarf and cuff.

FOREST GREEN

■ 01 DEFINITION

The term forest green represents a natural hue, much like terms such as: sage green, myrtle green, sap green, grass green and beech green, which all describe their salient characteristics. In the medieval period the green pigment colour would be taken from organic materials, crushed or boiled and reduced to create an earthy green. Forest green is analogous to emerald green and viridian green. It is a colour synonymous with the outdoors; countryside hikers and ramblers will wear it to match the forest colours.

■ 02 TECHNICAL INFORMATION

RGB Colour
R 34 G 139 B 34

CMYK Colour
C 86 M 4 Y 99 K 14

LAB Colour
L 48 A -75 B 48

HSB Colour
H 120 S 76 B 55

Hexadecimal **Pantone**
228B22 355C

Closest Web-safe Colour
339933

■ 03 COMMON COLOUR COMBINATIONS

■ **04** HISTORY AND CULTURE

Forest green evokes medieval times in Olde England and the legendary folk hero Robin Hood and his Band of 'Merry Men' living in Sherwood Forest. The colours of their clothing would be organic forest greens and browns, dyed with natural pigments. In England in the middle of the nineteenth century a revival of interest in the medieval period was kick-started by an architect and designer, A. W. N. Pugin who promoted the return to Gothic architecture. His ideology was carried forward by William Morris and the Pre-Raphaelite Brotherhood, a group of artist friends. Morris embraced medieval practices of dying fabrics with natural pigments. His dye works was set up at Merton, in Surrey, England. Morris produced handmade wallpapers and textiles.

His fervour for handmade, labour-intensive products reinvented the Guild system. It coincided with the height of the Industrial Revolution in Britain and the first of many synthetic aniline dyes available from

1856 when William Perkin invented the aniline dye 'Perkin's Purple' later named 'Mauve'. Many shades of natural green, including forest green and blues, bright reds, purples and mustard gold, featured in Morris's pattern book of designs with trees, foliage, flowers and birds. The ideals of the movement were taken further by the formation of the Arts and Crafts Movement (1884). The negative aspect was the princely cost of handmade furniture, stained glass, silverware and textiles; the organic forest-green fabric could only be afforded by rich patrons.

■ **05** EXAMPLES

■ The forests of Norway are renowned for their evergreen fir trees. Many are cut down in December to adorn the interiors of European homes, celebrating the Christian festival of Christmas. The forest trees look their most vibrant when decked in scarlet.

■ In European countries the illuminated green-cross sign indicates a chemist's shop or pharmacy; a symbol that is recognized worldwide. The simple graphic in forest-green colour is fresh and bright and easily seen from a long distance.

■ Green is a signal for action: from the 'walking' green-man graphic for pedestrian crossings, to the green traffic light. It also signals an emergency exit, with running-man signs to point the way. Forest green is the colour signifier.

■ The graphic Christmas card uses cutout forest green trees against a saturated azure sky. The stars indicate it is night. Green contrasts equally with red or blue; each colour, when placed together creates a vibrant image.

■ Forest green adds to the vibrant design of pink and red in sliced lemon and lime shapes. Secondary colours placed together brighten tone. The pattern would work well as kitchen curtain fabric, to sharpen a neutral colour scheme.

CAMOUFLAGE GREEN

■ 01 DEFINITION

The colour is primarily linked to military combat, hunters in the field and fashion apparel. The word 'camouflage', to make invisible through disguise, can relate to clothing or military equipment: planes, ships, guns, camps, factories and bird watchers' huts. It is a sludgy colour, muted in tone. Countryside wearers of camouflage green want to fit in with the landscape, not to disturb the wildlife, particularly if they aim to kill. The military wear it, to remain discreet and surprise their enemy. Fashionistas wear it as anti-war signifiers; alternatively, would-be machos might be emulating Sylvester Stallone in the *Rambo* films.

■ 02 TECHNICAL INFORMATION

RGB Colour
R 120　G 134　B 107

CMYK Colour
C 56　M 32　Y 60　K 5

LAB Colour
L 54　A -12　B 13

HSB Colour
H 91　S 20　B 53

Hexadecimal　**Pantone**
78866B　　　　8321C

Closest Web-safe Colour
669966

■ 03 COMMON COLOUR COMBINATIONS

■ **04** HISTORY AND CULTURE

The word 'camouflage' comes from the French word *camoufler*, meaning 'to disguise'. Military camouflage fabrics are made to order. The type of camouflage depends on the type of military combat, whether operations are in the desert, in the countryside or in snow-laden areas. A design may carry two to five different colours usually in drab greens, browns, sand and black. Camouflage fabric for snow would have black or grey irregular spots on a white background. The earliest use of camouflage uniform was in India during the second Boer War in 1888. Prior to this confrontation battledress uniforms had been made in bright colours, under the impression that a mass of vibrant colour would scare the enemy.

Tactics changed at the end of the nineteenth century and most countries followed the British precedent of drab greens and browns in an abstract multi-toned design. Different countries had their own style of camouflage: the Germans issued 'field grey' (*feldgrau*) to their troops; the Italians called their camouflage *grigio-verde* (grey-green). Each name signified the overiding colour of the pattern. The concept quickly adapted to other materials for camouflage: netting to cover tanks and camps with painted camouflage design for metal objects. Andy Warhol (1928-87), the American Pop-Art artist made several screenprints of camouflage design in the 1960s.

■ **05** EXAMPLES

■ The bathroom decoration in camouflage colours does not detract from the spacious interior. Furnishings are kept to a minimum. The colour emphasizes the empty space. The wall artwork of a beautiful woman adds mystery to the identity of the user.

■ The traditional type of camouflage-green pattern has shades of green, khaki, brown and black and is meant to conceal a person or object. This colour-pattern design denotes use in a wooded area or countryside location.

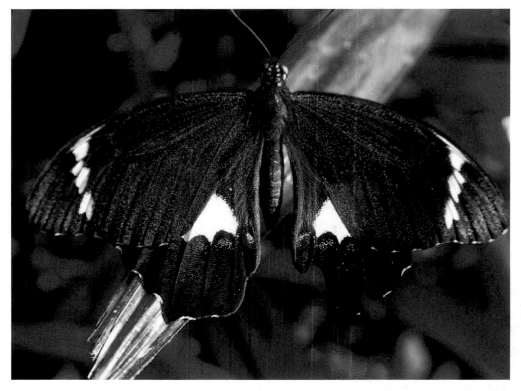

■ Butterflies love bright summer days. It is not essential for a butterfly to be camouflaged to sustain existence. This beautiful example is of dark green hue. It will search for highly coloured flowers from which to drink nectar.

■ Spray-painted graffiti shows the colours of camouflage: khaki, forest green, grey and white. The colours highlight, rather than camouflage, the abstract-pattern design. Graffiti is meant to be seen; the chosen colours may be symbolic to the artist.

■ Sludgy hues of camouflage green mix well with rough-textured, country-style ceramic pots. Drips of glaze, dribbling down the sides of the interior rim, add to the rough, home-made, organic perception. The tones of green and grey are restful to the eye.

MALACHITE

■ 01 DEFINITION

The word malachite is said to have two derivations: from the ancient Greek words *malakos*, meaning mallow, which alludes to its softness and *malhe*, which means grass, associated with its colour. It takes its *verdigris* (copper-green) hue from the malachite mineral of green hydrated-carbonite crystals. Its powers are said to create peace, security and success. It is the guardian stone of travellers, protecting them from danger. Pliny the Elder said in *Naturalis Historia* (*c*. AD 70) that the '… merit lies in the colour without being weak but limpid and rich'.

■ 02 TECHNICAL INFORMATION

RGB Colour
R 11 G 218 B 81

CMYK Colour
C 67 M 0 Y 68 K 0

LAB Colour
L 73 A -109 B 53

HSB Colour
H 140 S 95 B 85

Hexadecimal **Pantone**
0BDA51 354C

Closest Web-safe Colour
00CC66

■ 03 COMMON COLOUR COMBINATIONS

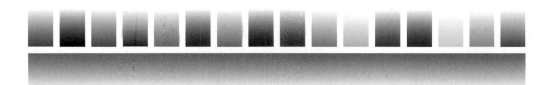

■ 04 HISTORY AND CULTURE

The green mineral most commonly found in copper mines is malachite. It is a semi-precious stone, which varies in colour from dark green to near black; like azurite blue it is a natural copper carbonate in crystalline form. The stone is banded and the bands vary in hue. Its early use was as a source of copper and for ornamental stoneware and jewellery. It is thought to be the world's oldest green pigment, first mined in Eygpt and found in tombs of 4th dynasty. The Egyptians also used it as a cosmetic in eye shadow and it was used in Tibet and Japan as a decorative paint. It is crushed to a powder to use as a pigment, which is moderately permanent, giving opaque cover. Cennino Cennini discouraged the powdered pigment to be crushed too much as this lessened the tonal strength, turning it toward grey.

In Europe it was a popular colour in wall paintings from the eleventh to sixteenth centuries. Hans Holbein the Younger (1497–1543) used it extensively as a background colour in commissioned portraits. He thought the deep-green hue 'pushed' the sitter's image toward the viewer. Malachite continued to be used in Persian paintings until the nineteenth century and the intense colour was favoured by artists of miniature paintings.

■ 05 EXAMPLES

■ The colour of a fisherman's old house on the island of Burano is malachite green, to symbolize the sea as his workplace. The island in the Venetian lagoon is rich in green, from seawater that surrounds it to the hues of the houses.

■ The copper-green of malachite emulates the water colour of the Mediterranean and South Seas. Rich in tone and colour changeable with variant light and opacity, malachite pigment appears in paintings of seascapes and tropical locations; the tonal hues varying from pale through to deepest green-blue.

■ The most popular colour for an artificial running track is green, to emulate grass. The deep malachite-green track base 'pushes' the lemon-yellow distance markers forward from its base colour. The lane lines in white harmonize the cool bright tones.

■ An illuminated green man stands out against a black background. The malachite neon colour is easy to see from a distance. The green walking man symbol is used globally for pedestrian crossing signs. Green to cross; red to wait.

■ The artist Paul Gauguin used a primitive colour palette, to depict village life on the island of Tahiti, where he was based 1891–1901. He painted this work in Paris during a return to the city. In *Nave nave moe* (1894) two young Tahitian girls sit in the foreground; their identical dress suggests they are one person. To the left the girl has a halo around her head, to symbolize purity or chastity; the girl next to her is about to eat an apple, a symbol of Eve and carnal knowledge. Gauguin paints in colours that create a sensation of sun and heat: malachite, fuchsia and magenta, crimson, sapphire and gold create an illusion of paradise, the Garden of Eden.

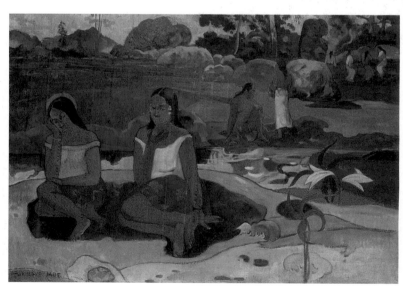

Colour Source Book

■ OLIVE

■ 01 DEFINITION

Olive takes its name from the fruit of the olive tree, which has its origins in Northern Mediterranean countries, particularly Greece and Italy. Olives are edible and crushed to make olive oil and derivatives. 'Olive skinned' refers to skin complexion that is yellowish green-brown, of persons living in Latin America and Mediterranean countries. The olive hue can be produced from a basis of raw sienna or from a synthesis of lemon-yellow and ultramarine. It has a soft and sludgy greenish-grey tone. Mixing lemon-yellow and black creates a more intense, darker and sharper, citrus shade of olive.

■ 02 TECHNICAL INFORMATION

RGB Colour
R 128 G 128 B 0

CMYK Colour
C 23 M 15 Y 97 K 32

LAB Colour
L 52 A -10 B 63

HSB Colour
H 60 S 100 B 50

Hexadecimal Pantone
808000 582C

Closest Web-safe Colour
999900

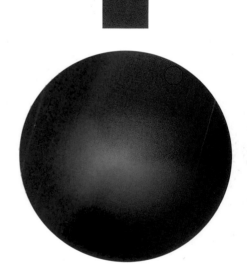

■ 03 COMMON COLOUR COMBINATIONS

■ 04 HISTORY AND CULTURE

In ancient Greece, the poet Homer referred to the olive oil made from the fruit of the olive tree as a luxurious product used by the aristocracy. A Greek myth that the first olive tree was found growing on the Acropolis was linked to the Goddess Athena as patroness of Athens. The olive and its hue are intrinsically linked to the people and to the countries of the Mediterranean. The olive skin-tones of native-born Mediterranean dwellers were replicated in Renaissance paintings by using an undercoat of *terre verde*, a brownish green mixed with white lead. It produced an olive hue, and it was painted in layers before adding the pink flesh-tones. Cennino Cennini, in *Il Libro dell'Arte (The Craftsman's Handbook*, c. early 15th century), recommended this method. Examples of this under painting skin-tone method are two unfinished works by Michelangelo (1475–1564) which hang in the National Gallery, London: *The Entombment* (c. 1501) and *Madonna, Child and St John with Angels* (c. 1506), also known as *The Manchester Madonna*. The unfinished works may be linked to a delay, perhaps waiting for paint materials such as the expensive lapis lazuli, to arrive. The colour imbues a sense of the Mediterranean landscape complete with olive trees on parched scrubland.

■ 05 EXAMPLES

■ A restful space is created by subtle toning of olive with neutral white on walls. An olive marble floor combined with touches of olive on the low sofa and desk furniture help to generate a calm space in which to work or relax.

■ Olives ripen from summer to autumn. Their dullish green is an autumnal shade, in harmony with earthy colours. The yellowish tint is heightened when contrasted with bright tertiaries such as magenta or crimson. It calms when combined with black, greys and browns.

Zen culture reflects purity and simplicity. It is life without ego; it is the unfinished. The bowl is symbolic of the minimalist Zen aesthetic. It is functional and beautiful. The earthy olive tone does not detract from the purity of its shape.

■ A metal riveted door is ravaged by time. Decrepit at its seams, rust has spread to the door knocker. The colour tones are muted and pleasing to the eye. The olive and rusted metal hues create a decadent abandoned scenario.

■ Geometric squares in burgundy red, a complementary colour to olive, and sharp white lift the background colour. A chromatic typeface draws attention. The colours influence the tonal value, changing olive from drab to bright and pushing forward its citrus-yellow undertones.

insideoutside

SEA GREEN

■ 01 DEFINITION

Sea-green has a blue-green hue, turning from colder blue toward a fresh watery green with reddish undertones. In nature it resembles pea green. It was also marketed synthetically as marine green, vivid green, paddock and guinea green. The colour of the sea depends on illumination from sunlight and moonlight, wind and weather variations. This colour is representative of the deep sea-bed, with translucent lighter tones. Colour theorist Wilhelm Ostwald used sea green as one of the four proto-colours (including red, blue, yellow), for his 24-segment colour circle.

■ 02 TECHNICAL INFORMATION

RGB Colour
R 46 G 139 B 87

CMYK Colour
C 96 M 4 Y 82 K 8

LAB Colour
L 49 A -61 B 18

HSB Colour
H 146 S 67 B 55

Hexadecimal **Pantone**
2E8B57 348C

Closest Web-safe Colour
339966

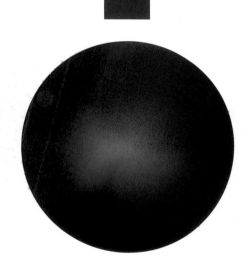

■ 03 COMMON COLOUR COMBINATIONS

■ **04** HISTORY AND CULTURE

The colour sea green is indelibly linked to the ancient Greek myths of Poseidon, God of the Sea. His wife Amphitrite, daughter of Oceanus, bore him a son, Triton, who had deep-green hair and lived in a palace on the sea bed with his parents. His main occupation, when not working for his father, was to raise a conch shell to his lips to calm the waves of the sea. Pausanias, a Roman historian, described Triton as having 'sea-green' eyes. (Pausanias ix.21:1) The colour was fashionable in Paris in the middle of the eighteenth century, made popular by the Marquise de Pompadour, mistress of King Louis XV. A portrait of the marquise (now in the Alte Pinakothek, Munich), painted in 1776, by François Boucher (1703–70) shows her relaxing in her boudoir, wearing a fine sea-green silk dress and robe, adorned with decorative salmon-pink flowers. The flowers are in a complementary tinted hue to highlight the richness of the exquisite fabric. The marquise had a great influence on the arts, particularly architecture, interior design and fashion. Her taste for sea green was copied in royal circles. The English potter Josiah Wedgwood (1730–92) produced the first piece of 'Jasperware' in 1792, he noted it '… a beautifull [sic] Sea-Green'.

■ **05** EXAMPLES

■ Sea-green tones are revealed in the pyramid of trees which line the exterior floor space of a glass skyscraper. The architectural form of the trees mimics the shape of the space they occupy. The blue-green hues of the foliage bring out the ash-mauve-purple complementary tones, which are possible with sea green.

■ Monochromatic tones of sea green are used for the floor and the iridescent mosaic wall tiles, made of small jewel-like tesserae. Its effervescent colour contrasts with the brilliance of the white porcelain bathroom fittings. The colour combination creates a fresh wide-awake sensation, perfect for bathroom routines in the early morning.

■ An old green wall tile shows vestiges of its history, when it once adorned a newer, smarter building. The rough orange-red brick has lost the original wall cladding to reveal its natural complementary colour to sea-green tiles.

■ The tiger and buffalo fight it out in a lush green forest of vibrant foliage in *Tropical Forest: Battling Tiger and Buffalo* (1908). Henri Rousseau (1844–1910) spent time painting trees, bushes and leaves in fine detail. Many of his paintings are set in the depths of the forest although each one was painted in the studio. He visited the local zoo and botanical gardens in Paris to replicate exactly the right tones in sea green, viridian and emerald, to create his fantasy jungle.

EMERALD

■ 01 DEFINITION

The emerald colour is associated with the grass-green gem stone. The characteristic colour comes from the presence of chromium in the purest emerald and through a light filter shows traces of red. Its double refraction reveals blue-green or yellow-green hues. To replicate emeralds, artists combined colourless oil with poisonous copper and arsenic, which led to death and the withdrawal of the recipe in the 1960s. Today a non-toxic formula creates the vivid light-green colour. Emerald can signify both beauty and deceit.

■ 02 TECHNICAL INFORMATION

RGB Colour
R 80 G 200 B 120

CMYK Colour
C 67 M 0 Y 60 K 0

LAB Colour
L 70 A -75 B 28

HSB Colour
H 140 S 60 B 78

Hexadecimal **Pantone**
50C878 7480C

Closest Web-safe Colour
66CC66

■ 03 COMMON COLOUR COMBINATIONS

■ 04 HISTORY AND CULTURE

The word originates from the Persian, later Greek word for green stone: *smaragdos*. An emerald stone is formed from beryllium-aluminium-silicate, a colourless mineral that produces emerald (grass-green), aquamarine (blue-green) and other stones. Emerald is the most precious beryl and was mined c. 1650 BC in ancient Egypt at Jebel Zubara; today the main sources are India, Siberia and South America. In ancient times the emerald was linked to eyesight and used medicinally for eye ailments. Records reveal that Emperor Nero liked to watch gladiatorial contests through a large emerald in order to remain calm. Francisco Pizarro, a ruthless Spanish conquistador who crushed the Peruvian Empire in 1534, was driven by the desire for emeralds.

Emerald green as a paint pigment was considered limited in use for artists, as it was not a green that occurred in nature. A typical recipe for making the paint pigment used sulphate of copper, oxide of arsenic and potash dissolved in hot water. It was later discovered that the poisonous arsenic content, liberally used in dyed wallpapers, contributed to many untimely deaths by inhalation of the fumes created in damp rooms.

■ 05 EXAMPLES

■ The colour of an emerald gem does not occur in nature but this rich harlequin pattern of green fields reflects the hues and tones accentuated by the strips of land contained within boundary walls and fences. It depicts order, cultivation and fertility. An aura of peace is associated with the emerald-green colour.

■ Strong, pure green sets off the ornamental ironwork attached to stone steps. It is a striking colour; a perfect shade to enhance the rounded metal and central-flower patterns. The intense colour draws attention to the design features of the staircase, in addition to the stylish appearance.

■ Green is the colour of the natural world. Emerald green imparts a sense of the country, to contrast a neutrally coloured, purpose-built fitted kitchen. Kitchen accessories in contrast colours of warm blues and reds will lift the cool neutral tones, particularly in a dull basement room, where colour can infer light.

■ Many of the colours analogous to emerald, that sit close by on the colour wheel, are shown in the patterns of this handmade quilt. Aqua, jade, turquoise and teal harmonize to add depth to the design. The green-blue hues create a soft and pretty visual effect. Touches of red lift the monochrome scheme.

CELADON

■ 01 DEFINITION

Celadon is a green-earth pigment of sea-green hue, which contains the mineral celadonite, a bluish-grey iron silicate. Synthetically it is a compound of chromium oxide, cadmium yellow and titanium-zinc white. Celadon is a pale grey-greenish colour. Chinese celadon porcelain, with a grey-green glaze, takes its name from this colour. Its analogous hues are rich-green colours ranging from greenish yellow to olive grey to bluish sea green.

■ 02 TECHNICAL INFORMATION

RGB Colour
R 172 G 225 B 175

CMYK Colour
C 35 M 0 Y 33 K 0

LAB Colour
L 84 A -34 B 17

HSB Colour
H 123 S 24 B 88

Hexadecimal **Pantone**
ACE1AF 352C

Closest Web-safe Colour
99CC99

■ 03 COMMON COLOUR COMBINATIONS

◼ **04** HISTORY AND CULTURE

The name may originate from the French word *céladon*, which has an association with the Greek word *keladon*, which describes the loud sound of a gusty wind or swelling sea. It may also have been named after a Sultan of Eygpt, Saladin, who gave a gift of 40 pieces of onion-green-ware to his uncle Sultan Nureddin. Alternatively, the name may be linked to the rather green, lovelorn character, Céladon, dressed in a pale-green beribboned suit, in pursuit of an impetuous shepherdess Astrée in the pastoral French novel *L'Astrée* (1607) by Honoré d'Urfée. The colour became fashionable in Paris when the book was published.

In crafts, celadon is a remarkable green glaze that originated in northern China in the ninth century. It was exported from China to Persia, later to Japan and Korea. The Chinese called it *mi se*, meaning mysterious colour. This was a name given to all glazes of grey-green but the expression has become synonymous with celadon porcelain. The porcelain glaze cracks when fired, a product of imbalance between clay and glaze, producing an imperfect crackled glaze but a beautiful piece of delicate porcelain, highly prized. Celadon porcelain remains in production today.

◼ **05** EXAMPLES

◼ Four handmade ceramics with celadon glaze show the true beauty of this delicate colour. The hue is understated and the organic shapes highlight the luminosity of the colour and the unusual design of the vases.

◼ The first vineyards were cultivated in ancient Greece. The height of summer sees the vines thick with foliage before it is stripped away, to allow the grapes to take all the nutrients from the soil. The pale leaves of the Chardonnay grapevine are in hues of celadon.

■ An outdoor vivarium creates a cool place to sit. Grey stone walkways are surrounded by cultivated trees and shrubs in various shades of green, which add to the serenity. Aquatic plants with pale soft-green stems and shoots are a natural hue of celadon.

■ Certain shades of green can create a restless feel if the hue is too intense. A grey-green wall colour is understated. It harmonizes with natural woods and neutral ceramics to create a positive ambience, the right tone for a bedroom or bathroom.

■ Celadon is known to have a meditative quality. It is associated with placidity, health, well-being and relaxation. The sludgy grey-green hue is an ideal colour for web design. It suggests Zen aesthetic. Neutral accents harmonize and highlight the on-screen buttons.

VIRIDIAN

■ 01 DEFINITION

Viridian is a transparent bluish-green permanent colour. The translation of the Latin *viride aeris* (copper green) explains the colour of the word. It is also referred to as *vert eméraude*. It is a natural pigment made from calcining boric acid and potassium bichromate. It is a permanent colour, unless overheated during its production. As a glaze it is vivid green; the hue is dulled if several thick layers are applied. It mixes with all yellows or blues; the tiny particles give a translucent bright glaze or wash. Its cold emerald hue is similar in tonal value to acrylic phthalocyanine green. Complementary colours are dark magenta or cerise.

■ 02 TECHNICAL INFORMATION

RGB Colour

R 64 G 130 B 109

CMYK Colour

C 88 M 13 Y 58 K 13

LAB Colour

L 48 A -41 B 2

HSB Colour

H 161 S 51 B 51

Hexadecimal **Pantone**

40826D 569C

Closest Web-safe Colour

339966

■ 03 COMMON COLOUR COMBINATIONS

■ **04** HISTORY AND CULTURE

Early uses of bright-green pigment were created from vegetable matter or crushed to a powder from stone such as emerald. In the twelfth century there are references to buckthorn berries (*rhamnus*) being used for the colour we know as sap green. In seventeenth-century Holland green pigments were created by extracting sap from rich green leaves or flower petals. In 1838 Pannetier and Binet of Paris first manufactured viridian, a formula of transparent hydrous oxide of chromium. In 1859 Charles Ernest Guignet of Paris patented viridian, also known as 'Guignet's Green'. He kept the formula a secret but made it available to artists. It is a transparent bluish-green permanent colour, very popular with the 'painters of modernity' in Paris and southern France 1860–1907.

The colour is associated with the Impressionists, due to its release on to the market *c.* 1860 in the early stages of their rise to prominence; they wanted new colours to reflect the vibrancy and sensation of the outdoor scenes they painted *en-plein-air*. Paul Cézanne used it in many of his Aix-en-Provence artworks. His use of it was limited as the pigment was costly, much more so than emerald green. On the canvas he would create his picture by using blocks of colour, small 'cubes' of different greens, yellows, umbers and blues.

■ **05** EXAMPLES

■ Viridian is copper green in hue, the colour of the ocean close to shore. The forest green trees
are reflected in the waters, which intensifies its depth of tone.

■ The diversity of blue and green is highlighted in the handmade mosaic. The colours suggest Turkish or Moroccan influence. The bright sea green, viridian, cyan and sky blue compilation evokes bright sunlight on dappled blue-green waters. Mosaics were originally made from cubes 'tesserae' of coloured marble. In ancient Greece they could embellish a small ornament or a vast expanse of flooring, to decorate a palatial home

■ The expression 'sacred geometry' applies to the mandala design. Mandala is a Sanskrit word for circle, symbolizing eternity and wholeness. From ancient times the circle has been associated with the microcosm and macrocosm, defining man and the universe. Viridian green is associated with calm and tranquillity, a perfect colour for a mandala. One can see mandalas everywhere, from the shape of the eyeball to a circular building.

■ Viridian evokes calm. The cup and spoon in light and shadow are defined by pale and deep tones of copper green. The dark edge creates the picture space. The colour is intense, making one notice the relationship between spoon and cup.

Colour Source Book

TEAL

■ 01 DEFINITION

Teal is a bluish-green primitive, ancient colour. On the colour wheel, as blue-green goes towards green, there is a transition from blue as an air symbol, to the colder green, a colour of the sea. Teal is a dark cyan or dark turquoise: 50 percent blue and 50 percent green; an intense tone of phthalocyanine blue and phthalocyanine green compound. Its contrasts are orange to maroon; analogous to hues from midnight blue to pine green and forest green. Teal expresses a mood of luxury; its saturated tones taking green toward darker hues. The medieval variant of teal blue-green is dark aquamarine.

■ 02 TECHNICAL INFORMATION

RGB Colour
R 0 G 128 B 128

CMYK Colour
C 97 M 6 Y 40 K 18

LAB Colour
L 46 A -50 B -13

HSB Colour
H 180 S 100 B 50

Hexadecimal Pantone
008080 3282C

Closest Web-safe Colour
009999

■ 03 COMMON COLOUR COMBINATIONS

■ **04** HISTORY AND CULTURE

Teal takes its name and colouring from a duck, the Common Teal bird; its wings are a deep blue-green. The rich hues of teal are reminiscent of the Orient, evoking the image of bazaars full of shops selling brightly coloured spices, handmade rugs, vibrant silks and raw gemstones. The colour was fashionable in the nineteenth century, the age of Romanticism. The paintings of French artists Eugène Delacroix (1798–1863) and Jean-Auguste Dominique Ingres (1780–1867) captured the mood and 'taste' for Orientalism, the Western view of the East. Rich blue-greens, mixed with mustards, oranges and rose crimson are the palette colours that evoke the magic of a different culture; sumptuous palaces and private harems. Ingres paid attention to fabrics, painting the intricate detail of a rich cashmere shawl or a fine silk dress.

The British artist David Hockney (b. 1937) who came to prominence in the 1960s, painted series of swimming pools, located in California. He used the hues of blue, including teal, to capture the atmosphere of cool waters in a sun-dried location. In *Nichols Canyon* (1980) he portrays a road winding toward a house in a canyon. The scenario is breathtakingly vivid, using teal, lilac, fuchsia and rose he captures atmosphere more than reality.

■ **05** EXAMPLES

■ A cool teal of blue-green sea tones is used as a backdrop to white signage, which accentuates the direction by denoting the expectation of the blue-green Pacific Ocean, at the point where it meets Pacific Beach.

■ Green creates a fresh, cool appearance, perfect for a hot country like Morocco where heat and sunlight can bleach out colour. On a doorway in the Medina of Marrakech, ceramic tiles in teal mark the entrance, enhanced by intricate scrollwork in the detail of the white door surrounds. Maroon-tinted walls add a warm tone and delicate contrast, symbolic of the warm climate.

■ Teal is a colour that evokes the ancient city of Byzantium, now Istanbul. It suggests markets full of spices, hot colours mixed with cool, richly coloured oriental rugs and precious gems for sale. The teal door is chipped and aged but the intensity of colour is vivid.

■ Complementary hot orange is the vibrant contrast colour to teal. The swirly graphic logo and tangy typeface offset the teal background. The combined colours of fiery orange and cool blue-green get the message across.

■ In *La Grande Odalisque* (1814), Dominique Ingres depicts a naked young woman lying languorously on a luxuriously dishevelled bed. She is half-sitting and looking over her shoulder at the spectator. Her bed is a mass of crumpled mustard-gold and white silk sheets. To add mystery and exoticism Ingres uses teal, sapphire and ultramarine for cushions and drapes to offset the delicate tones of her skin.

Colour Source Book

AQUAMARINE

■ 01 DEFINITION

Aquamarine as the word suggests is associated with the sea and seashore and marine life. It is taken from the Latin *aqua marina* meaning seawater. The translucent pale blue to light greenish-blue of aquamarine reflects the colours of the Mediterranean. Its analogous colours are the blue-greens ranging from cyan to jade and sea green. Its greyish-turquoise hue makes it a favourite for painters of seascapes and coastal paintings. The word is associated with the aquamarine gemstone, which has a translucent blue-green hue. The stone is said to protect seafarers from peril and the colour is associated with calm and meditation.

■ 02 TECHNICAL INFORMATION

RGB Colour
R 127 G 255 B 212

CMYK Colour
C 43 M 0 Y 26 K 0

LAB Colour
L 89 A -67 B 5

HSB Colour
H 160 S 50 B 100

Hexadecimal **Pantone**
7FFFD4 3395C

Closest Web-safe Colour
66FFCC

■ 03 COMMON COLOUR COMBINATIONS

■ 04 HISTORY AND CULTURE

Aquamarine, as its Latin name denotes, is associated with the colour of marine water, the blue-green hue reflecting the sun's light through it. Pliny the Elder, the Roman writer and theorist on natural history is said to have given aquamarine its name but this is disputed. The colour is linked to hues of the aquamarine stone, a companion to the emerald and formed from the same transparent beryllium-silicate component. It is found in the Ural Mountains of Russia and in South America, Pakistan, Africa and the United States. The precious stone was said to have magical powers to protect seafarers and travellers. It was proposed that it could cure illnesses if worn. It was a favourite part of an alchemist's array of cures and potions.

The use of aquamarine colour is associated with seascapes. When aquamarine is contrasted with alizarin red, purple or jade, the colour association is attuned to the sensuous. The mystical paintings of the Symbolists, a French art movement of the late nineteenth century, including Gustave Moreau (1826–98), Pierre Puvis de Chavannes (1824–98) and Odilon Redon (1840–1916) used a jewel-rich palette of aquamarine, jade, viridian, purple, vibrant reds and deep blues.

■ 05 EXAMPLES

■ The rich tones of aquamarine complement the plain metallic light fitting. The roughly textured wall suggests an intention to create a rustic style, with a colour that can be cooled with white or combined with hot pinks and reds.

■ Grimacing caricatures on the doors of Buddhist temples are placed there to scare away demons. Aquamarine blue-green is analogous to jade and turquoise and a favoured colour in Chinese ritual. It is associated with transforming anger into healing and purity, infinity and ascension. In China the colour is a symbol of the sea and the sky and infinity beyond. The sea-blue colour is linked to the turquoise stone, which was highly prized for its meditative qualities.

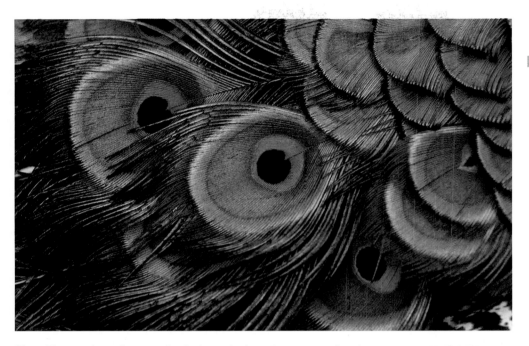

■ The true hue of aquamarine is shown in the colour surrounding the 'eyes' of the peacock feathers. The feather shows all the hues analogous to aquamarine. The jewel-coloured fantail is reserved for the male bird, fanned when courting the peahen. The rich iridescent greens and blues with golden brown tones, a result of photonic crystals in animal colouring, reflects the origins of the bird, in India.

■ The abstract design and colours of the fabric evoke art works by Jean-Auguste Dominique Ingres and the Romantic movement of the early nineteenth century. Ingres focused on life in the Turkish harem and used colours of teal, jade and aquamarine, mixed with purples, golden ochre and ultramarine to evoke decadence, beauty and the East.

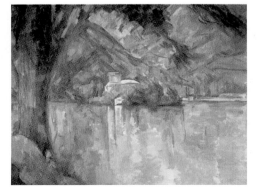

■ Cézanne painted *Le Lac d'Annecy* in 1896 during a holiday in the French Alps. He painted a turbulent lakeside scene in greenish-blues and black, with accents of pink and blue. The colours mimic the movement of the water. On his choice of palette colours he stated that, 'There is a colour logic ... The painter must obey it and nothing else.'

Colour Source Book

◼ CYAN

◼ 01 DEFINITION

Cyanine blue or cyan is equal to azure blue. It is a cool, refreshing hue also known as aqua; a mixture of cobalt blues and Prussian blues. The word 'cyan' comes from the Greek word *kuanos* meaning blue. The RGB tonal value is 50 percent blue and 50 percent green. In the printing industry the term 'cyan' has been in use since 1889. It is one of the four standard process colours used for colour printing: cyan, magenta, yellow and black. In computer terminology the names cyan and aqua are interchangeable, as they both refer to the same true blue. The colour is associated with cool bright waters of the Mediterranean and South Seas.

◼ 02 TECHNICAL INFORMATION

RGB Colour
R 0 G 255 B 255

CMYK Colour
C 55 M 0 Y 21 K 0

LAB Colour
L 86 A -83 B -22

HSB Colour
H 180 S 100 B 100

Hexadecimal **Pantone**
00FFFF 3275C

Closest Web-safe Colour
00FFFF

◼ 03 COMMON COLOUR COMBINATIONS

■ **04** HISTORY AND CULTURE

The ancient Greeks did not have different words for individual tones of blue. All blues were called *kuanos*, which included the present-day cyan, and the tone has been in use since ancient times. It appears on Egyptian wall paintings and Roman frescos. It was used by Renaissance painters of the fifteenth century, for example, Florentine Benozzo Gozzoli (1421–97) in *Saint Jerome and Friar* (c.1470).

The colour is usually associated with the bright clear waters of the South Seas. French painter André Derain (1880–1954), one of the original Fauve painters, used it liberally for example in *Landscape around Chatou* (1904–05). In keeping with the Fauves' aesthetic to paint sensation rather than reality, he painted the murky waters of the Thames River, London, a brilliant blue-green cyan, in *Waterloo Bridge* (1906). The Impressionist painter Claude Monet, earlier, had depicted the Thames in the same hue in

Charing Cross Bridge (1870); 'transporting', through colour, the grey of London waters to the tropics. Cyan is a colour that creates the sensation of sun, sand and tropical waters. It is utilized by tour operators and holiday promoters, particularly in brochures and on website pages to evoke clear waters and relaxation.

■ **05** EXAMPLES

■ The true blue hues of the sea are reflected in cyan. Its blue-green compound imitates cool blue-green waters, reflecting sunlight on calm waves. In an idyllic setting sleek yachts glide thorough a translucent sea, to drop anchor near shore.

■ The Spanish artist, sculptor and architect Antonio Gaudí (1852–1926) is renowned for his use of mosaic; whether to adorn the façade of a building or decorate chimney stacks, his palette reflected the warmth of Spain, surrounded by cyan-blue seas.

■ These small and delicate bright-blue flowers are of natural true-blue hue and the colour attracts the eye. Blue-green cyan compound imitates the blue colour of the natural world, such as blue flowers, warm seas and translucent skies.

■ CMYK cyan and black sharpen the picture tone. True-blue cyan pushes forward and highlights the badminton player and creates a simulation of form and space. Contrast and layout recall a cameo portrait of a black cut-out silhouette against plain ground.

■ Odilon Redon was one of the Symbolist painters, Symbolism being a short-lived art movement in the late nineteenth/early twentieth ceturies that included Gustave Moreau and Pierre Puvis de Chavannes. The artists' paintings concentrated on biblical or classical subjects, using a jewel-coloured palette to create mystic, erotic and exotic portrayals, such as *The Winged Man* (or *Fallen Angel*, before 1880) here.

AZURE

■ 01 DEFINITION

Azurite stone is termed *citramarino*, to denote its European origin, 'this side of the seas'. The stone produces the azure pigment. It is a cool colour, associated with calm and tranquillity. 'Azure skies' is a term that defines its colour. Vincent van Gogh used it as a complementary colour, he explained: 'To exaggerate the fairness of hair, I come even to orange tones, chromes and pale yellow ... I make a plain background of the richest, intensest blue that I can contrive, and by this simple combination of the bright head against the rich blue background, I get a mysterious effect, like a star in the depths of an azure sky.'

■ 02 TECHNICAL INFORMATION

RGB Colour
R 0 G 127 B 255

CMYK Colour
C 70 M 41 Y 0 K 0

LAB Colour
L 52 A 1 B -78

HSB Colour
H 210 S 100 B 100

Hexadecimal **Pantone**
007FFF 2935C

Closest Web-safe Colour
0066FF

■ 03 COMMON COLOUR COMBINATIONS

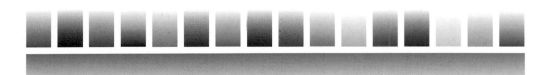

■ **04** HISTORY AND CULTURE

Azure, from azurite stone, was the most important pigment in European painting in the Middle Ages. It was cheaper and more accessible than ultramarine and was used as its replacement when ultramarine proved too expensive for a patron to purchase. It was also the most popular blue pigment in the Far East. Azurite can be found in paintings of the Sung and Ming dynasty in central China. It was available in Egypt in the Fourth dynasty but not widely in use due to preference for other blue pigments. Hungary, Romania, Southwest Africa and Chessy, in France, are known sources.

Azurite, also referred to as chessylite, is the same form of crystalline copper-carbonite mineral as malachite. Its blue produces a greenish-yellow undertone. It is easily crushed and ground to create powdered pigment. The coarsest pigment is used for dark blue, while lighter shades are produced by refining the powder. This was useful to medieval painters when considering brightness of hue and gradations of sky colour to replicate light. In his projected treatise on painting, Leonardo da Vinci discussed the use of blue in relation to aerial perspective: 'the blue of the sky arises from the density of the mass of illuminated air interposed between the upper darkness and the earth'. ('On Aerial Perspective', *Codex Urbinas, c.* 1270).

■ **05** EXAMPLES

■ The interior of the mall is top lit with azure-blue hues to replicate the sky. The colour gives a fresh cool ambience to the plain stone walls. Azure induces calm and peace, just perfect for a daytrip to the shops.

■ The United Nations (UN) emblem was approved in 1946. The flag illustrates a map of the world from a centrifugal North Pole. It has conventional crossed branches of laurel leaves to symbolize peace; a tradition that originated in ancient Greece. The light-blue azure background associates blue with calm and tranquillity. Peacekeeping forces of the UN wear distinctive azure blue berets, to symbolize neutrality and UN presence in war zones.

■ Stripy azure blue and white beach tents echo the colours of the azure to aquamarine sea. The colours are popular at the beach; they denote marine life and maritime pastimes. The fresh cool colours contrast with the sun and sand.

■ Websites selling summer holidays prefer to use a blue and white graphic colour scheme. It connotes blue skies and blue sea, sunshine and relaxation. Conversely, for winter holidays websites change to reds and white, to connote speed and skiing and an invigorating vacation in the snow.

■ In Leonardo da Vinci's *The Madonna Litta* (c. 1480), the Madonna holds her child tenderly, looking down at him as he looks out toward the viewer. The azure blue of her robes are echoed in the mountainous landscape, seen at a distance through windows. In his treatise on painting da Vinci made reference to the horizon of the landscape looking bluer in the distance.

CERULEAN BLUE

■ 01 DEFINITION

The word 'cerulean' comes from the Latin *caelum* meaning sky or heavens and *caeruleus* meaning blue. In France it is known as *bleu celeste*. Cerulean blue is a rich-blue pigment that is favoured by landscape artists for the replication of sky. It has a limited opacity of bright greenish-blue. The intense colour has the psychological effect and visual sense of inducing peace and tranquillity. It evokes crystal-clear skies on a mid-summer day, lazy picnics and strollers in the landscape, balmy breezes and pastoral pleasures. Cerulean blue mixed with cadmium red produces a dense shade of violet.

■ 02 TECHNICAL INFORMATION

RGB Colour
R 0 G 123 B 167

CMYK Colour
C 96 M 19 Y 6 K 13

LAB Colour
L 46 A -31 B -37

HSB Colour
H 196 S 100 B 65

Hexadecimal **Pantone**
007BA7 633 C

Closest Web-safe Colour
006699

■ 03 COMMON COLOUR COMBINATIONS

<div style="writing-mode: vertical-rl;">

CERULEAN BLUE

</div>

■ **04** HISTORY AND CULTURE

Cerulean blue is made from a compound of cobalt and tin magnesium, which needs to be heated at high temperatures to produce the colour. The formula was discovered by a German scientist, Andreas Höpfner. It proved a good colour for oil painting because of the purity of its hue and for sky replication. The pigment replaced azurite in popularity, but was less popular for watercolour due to the chalkiness of its wash. Use of the colour was increased when George Rowney marketed it as 'coeruleum' in 1860, both for oils and watercolours. The colour is also associated with a small Venezuelan bird, the cerulean warbler (*dendroica cerulean*), which inhabits the coffee plantations of South America. It has a bright-blue head, back and tail feathers with an underbelly of white crossed by a thin black line. The natural contrast colours of the bird's plumage create a vivid combination. In Islamic art and design cerulean blue is a favourite for replication of sky and sea. The accepted practice of non-figurative art for religious buildings leads to blue being used for celestial representations. The Blue Mosque in Istanbul is so-named because the interior is decorated with 21,043 blue tiles, which create a haze of blue in the air.

■ **05** EXAMPLES

■ Blue-jean colour ranges from navy through to indigo and pale sky blue. This shade in cerulean blue is one of the most popular. It contrasts and harmonizes with every other colour. The hard-wearing jeans fabric, originally Serges De Nimes, allows the dyestuff to retain its colour and with age it fades to add 'vintage' quality.

■ In Islamic-religious architecture it is the tradition not to have figural representation. Instead, the exteriors and interiors of mosques are extensively decorated with patterned tiles in jewelled colours.

268

■ The expression a 'cerulean sky' refers to the bright-blue skies that herald October days in early autumn. The high-altitude cirrostratus clouds are wispy thin, against the translucent cerulean vista.

■ Expressive thick brushstrokes mimic the rhythmic movement of oceanic waves. White mixed with cerulean blue captures the white surf and the sunlight reflected on the waters. Its artist, Pauline Breijer, gave it the title *Blue Waves*, which connotes the blues of the ocean. Without a title, the oil painting would reflect the imagination of the viewer.

■ 1960s high-fashion colours were expressed on everything from cars, to doorknobs to radios. This radio model in cerulean blue is now a collector's item. A renewed interest in portable radios has seen the return of 'retro classic' models such as the 1958 Bush Transistor Radio, available once more.

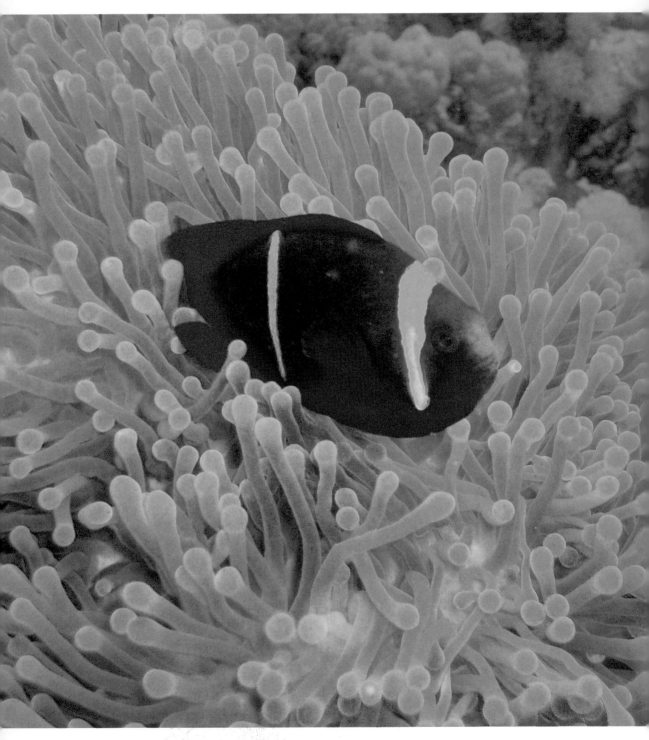

TURQUOISE

■ 01 DEFINITION

The turquoise is a massive opaque sky-blue to pale-green mineral. In geological terms it is a hydrous basic aluminium phosphate, initially mined in the Maghara Wadi mines in the Sinai Peninsular, which were worked by the pharaohs, and the Nishapur mines of Persia (now Iran). However, its arrival into Western Europe was via the Ottoman Empire of Turkey, hence the name. The colour turquoise is directly related to the luminous blue green of the mineral.

■ 02 TECHNICAL INFORMATION

RGB Colour
R 48 G 213 B 200

CMYK Colour
C 66 M 0 Y 30 K 0

LAB Colour
L 74 A -73 B -12

HSB Colour
H 175 S 77 B 84

Hexadecimal **Pantone**
30D5C8 3275 C

Closest Web-safe Colour
33CCCC

■ 03 COMMON COLOUR COMBINATIONS

■ **04** HISTORY AND CULTURE

The word 'turquoise' comes from the Old French *pierre turquoise*, the 'Turkish stone', though the word is now used more frequently in its colour sense than in reference to the stone. This is unlike 'emerald', which retains both its literal and figurative senses. Turquoise jewellery was first used by the Egyptians as early as 5,500 BC for beads. Later they inlaid turquoise in gold to create necklaces and rings. In pre-Columbus America the native Indians also created necklaces and pendants from the mineral. Young gentleman returning from their grand tours of Europe and Orient brought the stone into Western European consciousness in the seventeenth century. It subsequently became a staple element in Victorian and Art-Nouveau jewellery. Among many cultures there was, and still is, a belief that turquoise brings foresight to anyone wearing it and that the stone and the colour protects people from danger. The Aztecs and Egyptians also believed it brought prosperity. American Indians visualized turquoise as combining the spirits of the sky and the sea and used it to bless their warriors.

■ **05** EXAMPLES

■ The Hawaiian shirt, which became a vogue, sometimes deliberately kitsch, fashion item in the USA during the 1950s, following Hawaii's admission to the United States, includes turquoise in its palette of colours inspired by tropical birds and flowers.

■ The mud-brown adobe buildings of Santa Fe in New Mexico are highlighted by turquoise, a colour familiar to the area through the turquoise beads worn by the native Navajo and Pueblo Indians and considered sacred by them.

■ The Iznik tiles of the Ottoman Empire first appeared in the 1500s as a substitute for the expensive Ming porcelain of China. Turquoise was the first of the tertiary colours used against the original solus colour of cobalt blue; subsequently potters added pistachio green and a strong earthy red.

■ The Art-Deco district of Miami, built during the Depression years of the 1930s, used turquoise in combination with flamingo pink, sea green and a tropical yellow-green to convey the sense of escape and enjoyment.

■ Italian designer Emilio Pucci (1914–92) used to go diving with an aqualung and a camera to capture the turquoise, coral and emerald of the Mediterranean to add their hues to his flamboyant print colours during the 1950s and 1960s.

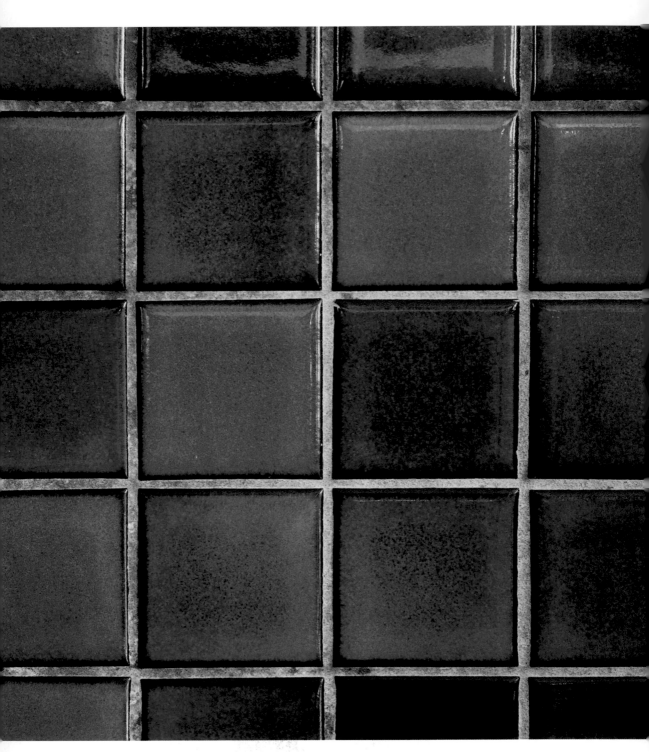

Colour Source Book

COBALT

■ 01 DEFINITION

Cobalt is a silver-white magnetic natural metal, found in nature. Cobalt blue is a pigment containing cobalt and aluminium oxides. The word derives from *kobald*, the German word for goblin mines, perhaps in reference to cobalt blue's dark, ethereal hue. The tone can range from pale to deep blue, depending on whether the cobalt particles are fine or course. It needs 100 percent oil to grind it as an oil paint and its low refraction can turn it greenish-yellow unless mixed with white. Cobalt blue is a good pigment for sky scenery and for glazes in ceramics. It is the colour of 'heaven'; symbolic of meditation, eternity and loyalty.

■ 02 TECHNICAL INFORMATION

RGB Colour
R 0 G 71 B 171

CMYK Colour
C 98 M 73 Y 0 K 1

LAB Colour
L 30 A 13 B -65

HSB Colour
H 215 S 100 67

Hexadecimal **Pantone**
0047AB 293C

Closest Web-safe Colour
003399

■ 03 COMMON COLOUR COMBINATIONS

■ **04** HISTORY AND CULTURE

Cobalt ores were used as a colorant for glass and glazes in Egypt 4,500 years ago. Figurines of this hue were discovered in the tombs of the Fifth dynasty. Cobalt-blue glass beads, made in Iran, date to 2,250 BC. Its use in ceramics in Mycenae and Ethiopia dates to 1,200 BC. Cobalt oxide in a cake form, ground into powder, was used by potters in Persia and Syria. It was imported from Persia to China as a colorant for the production of blue and white porcelain, c. AD 600. It was named *wuming yu*, which means 'nameless'.

The blue of stained glass in the Middle Ages was pure cobalt; from deep to light, toward sapphire. Pulverized blue potassium glass (cobalt blue) is named smalt. European artists used smalt as a pigment from the fifteenth century, particularly in Northern Italy around Venice, where cobalt glass was in

production. Georg Brandt, a Swedish chemist and mineralogist, was the first person to isolate the colour in ores in 1730. The French chemist Louis-Jacques Thenard was set a task by the government to create a synthetic replacement for ultramarine. He made cobalt blue and commercial production started in 1807. Today cobalt-blue dye is much used for the production of blue and white porcelain in Denmark.

■ **05** EXAMPLES

■ Streaks of brilliant cobalt blue saturate the night sky. A black tree is outlined to dramatic effect against its varied hues. Deep shades of purple-blue cobalt and black can evoke atmosphere and mystery, desolation and danger, or adventure into the unknown.

■ In bright sunshine skyscraper buildings with floor-to-ceiling windows of glass need to draw glare and brightness away from the interior. Blue glass is ideal as it absorbs the sun's rays. It creates a calming experience within, conducive to the working environment.

■ Blue and white imparts an aura of coolness. Production of handmade tiles to decorate columns in patterns of mosaic has existed for thousands of years. The Persians first used the cobalt-blue glaze on tiles in their mosques, to represent heaven.

■ The quilt maker's use of contrasting complementary colours, fiery tangerine orange and cobalt blue intensifies the stunning design. Side by side the colours vie for attention and draw the eye to the pattern of noughts, crosses, circles and squares.

■ Aqua and cobalt are close together in the spectrum of colours. Each balances the other, creating fresh clear tones for these pretty plates. Cobalt has been used for centuries in glass and ceramic production, giving clarity and lightness.

COBALT

CORNFLOWER BLUE

■ 01 DEFINITION

The colour of cornflower blue relates to the annual garden flower *centaurea cyanus* of the same name. It has a daisy head with grey-green leaves and the tone is deep blue. There are pink, red, purple and white cornflowers, too. The small flower heads intensify the colour. In the spectrum cornflower blue sits between violet and viridian, close to cobalt blue and denim. This blue is used on the black, white and blue tricolour flag of the country of Estonia; to symbolize a blue sky above the land. The colour has no relation to cornflour, a starch extracted from maize and used as a culinary product.

■ 02 TECHNICAL INFORMATION

RGB Colour
R 100 G 149 B 237

CMYK Colour
C 58 M 32 Y 0 K 0

LAB Colour
L 60 A -3 B -54

HSB Colour
H 219 S 58 B 93

Hexadecimal **Pantone**
6495ED 279C

Closest Web-safe Colour
6699FF

■ 03 COMMON COLOUR COMBINATIONS

■ 04 HISTORY AND CULTURE

The blue cornflower is recognized as one flower that is a true blue in hue. It is associated with the Virgin Mary, particularly in paintings and frescos of the Renaissance period which show her in cornflower blue; a symbolic colour of humility and royalty. In 1775 the innovative designer and the 'father of English potters', Josiah Wedgwood introduced a fine-grain unglazed ceramic called Jasperware. The first batch of samples were sea green in colour but later perfected to a pale and deep cornflower blue. In production it was available in several shades of blue from sapphire to lilac blue; other varieties included sage green and black. It took Wedgwood four years to perfect the pale blue colour but once in production the special cornflower blue colour made it a perennial favourite.

The fashion for blue ceramics continued into the late nineteenth century. William de Morgan (1839–1917) was a painter who turned to pottery. He set up a kiln in Fulham, London, and produced fine pots, vases and ceramic tiles in fashionable jewel-like colours of malachite, turquoise, cornflower, teal, pure lemon yellow and manganese purple. His tile designs of curling plant tendrils, wild animals and Iznic patterns are replicated to this day.

■ 05 EXAMPLES

■ The unmistakable blue of the Mediterranean surrounds this beautiful building; the dome of blue is contrasted against brilliant white walls. Each colour accentuates the heat of the sun and cool depths of the sea. Many tones of blue can be seen, from the pale blue of the sky to the mid-blue horizon leading to the deeper tones of sea blue.

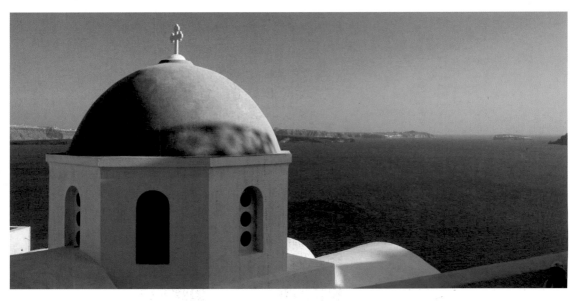

■ Looking like feathery hats on Ladies' Day at Ascot, the 'batchelor button' cornflowers show off their brilliant blue petals. Analogous tones of blue reflect the light, accented by deep purple-blue stamens and contrasting green stems; together creating a natural portrait of harmonious colour, set against a frosted backdrop.

■ Rebecca Zieleznik's light cornflower blue stripes of colour are casually applied to the neutral canvas, which accentuates the colour, pushing it

forward from the picture plane. Splashes and dribbles of purple ink and black oil paint create a three-dimensional abstract. It is a pleasing combination of colours, which create a cool and bright, sharp abstract.

■ A painted sundial imitates a working model. The middle-brown centre contrasts with the deep blue of the dial surrounds. The irregular dye pattern accentuates the simplicity of the design with shades of dark- and light-blue cornflower mimicking the lights and shadows of sunlight.

 # DENIM

■ 01 DEFINITION

Denim blue takes its name from a hard-wearing jeans fabric, which originated from Nimes, France. The dyestuff used is a synthetically produced indigo, not its organic predecessor, which was difficult to process, timely to make and putrid in odour. Denim RGB is a percentage of red 21 percent, green 96 and blue 189. CMYK is cyan 89, magenta 59, yellow and black 0 as percentages of 100. Denim blue is associated with cowboys and the American West. It is a universal fabric a great equalizer between classes and worn by nearly every nationality and creed.

■ 02 TECHNICAL INFORMATION

RGB Colour
R 21 G 96 B 189

CMYK Colour
C 89 M 59 Y 0 K 0

LAB Colour
L 39 A 0 B -61

HSB Colour
H 213 S 89 B 74

Hexadecimal **Pantone**
1560BD 2935C

Closest Web-safe Colour
0066CC

■ 03 COMMON COLOUR COMBINATIONS

■ 04 HISTORY AND CULTURE

Denim blue is intrinsically tied to the denim fabric, which has wide tonal values from indigo to powder blue. In reference to the fabric 'denim', used for jeans, the etymology of the word arises from 'De Nimes' to mean 'from Nimes' in France, so it may relate to the fabrics produced in the area. The word 'jean' may have derivated from the North Italian city of Genoa, referring to a hardwearing fabric worn by Genoese sailors. The rise in popularity of the fabric came through film; 1930s moviegoers saw cowboys wearing denim in Westerns set on ranches. The work clothes became popular as weekend wear and were sold through American catalogues, such as Sears and Roebuck, before appearing as fashionable clothing in stores.

Denim was identified with youth culture in the 1950s, worn by screen heroes such as James Dean and Marlon Brando. The denim jean was banned from schools and formal workplaces which increased its popularity. The marketing of the Levi 501 brand as part of 'life', increased its success and pushed the fabric and the denim-blue colour toward high fashion in the 1970s. Today, designers make a new style of jean for every season, in every colour of blue. The denim-blue hue remains the most popular.

■ 05 EXAMPLES

■ The irregularities of naturally dyed denim are accentuated in the rough texture of this fabric. The cord twist in denim and white picks up the base colours. The early denim fabrics would fade over time, leaving the irregularities of the natural dye highlighted.

■ Blue dominates the flower petals of the cornflower. A myriad of blue tones surround the delicate pale magenta-to-violet core. Nature's natural colour combinations show perfect contrasts, which highlight the depth of natural-blue hue.

■ Two hues of denim are replicated here: the lighter hue of the sky, which is reflected in the darker hue of the glass of the high-rise. Both colours are associated with blue skies, sunny days and relaxation.

■ Shades of denim blue, lilac and violet create a harmonious combination of faded colours in this intricate piece of scrollwork. The ornate detailing suggests

Eastern influence. The colours are calming and meditative. Set against a neutral backdrop the ornate design will blend and tone with its surrounds. Use of complementary green will bring the colours into sharp focus, highlighting the delicacy of the hues.

■ A cool blue-coloured quilt picks up the tonal values of denim blue. The colour is understated and creates a relaxed, casual atmosphere for interiors. The wall hanging in blue tones adds interest to a plain room.

■ STEEL BLUE

■ 01 DEFINITION

The name is founded on colours emanating from steel-metal production; variant shades of blue-grey surface during the manufacturing process. Steel blue is a dullish blue. It is a compound of greyish blue and greenish blue with a slight red undertone. It tones with pale and dark grey, navy blue and polished metal. Steel-blue pigment first appeared in 1817, marketed as the colour of tarnished steel but later changed to the bluer representation that is produced today. It is a solid, formal colour, connoting 'nerves of steel'.

■ 02 TECHNICAL INFORMATION

RGB Colour
R 70 G 130 B 180

CMYK Colour
C 82 M 30 Y 4 K 2

LAB Colour
L 51 A -17 B -37

HSB Colour
H 207 S 61 B 71

Hexadecimal **Pantone**
4682B4 7461C

Closest Web-safe Colour
3399CC

■ 03 COMMON COLOUR COMBINATIONS

■ **04** HISTORY AND CULTURE

'Steel blue' is linked to all metals, not just steel. It denotes the products of the motor industry and is a popular colour for cars. The colour name, not necessarily the colour, adds sophistication to car design. The BMW 330 cic, a fifth generation 'C' series, launched in 2006, markets the car through speed, body shape, performance and sporty blue-steel colour. An all-in-one package to entice new and existing customers to buy the car. The present-day concern of global warming has made architects and designers carefully consider the materials they use to retain a sustainable future.

Selfridges' retail emporium in Birmingham designed by Future Systems in 2003 uses 15,000 spun aluminium discs to enclose its organic 'skin'. The discs shimmer in sunlight and reflect the weather patterns;

the hues are the colour of steel blue. The Swiss Re building in London is ergonomically shaped to reduce heat loss and retain light in a tightly enclosed space. The steel and glass takes on hues of steel blue when viewed from a distance. Antwerp's new Law Courts designed by architect Richard Rogers (b. 1933) have a remarkable metallic roof structure, rather like witches' hats. The silvery peaks are a shimmering steel blue in the sunlight.

■ **05** EXAMPLES

■ Blue is not a natural rose colour because its genus lacks the pigment delpinidin, which is contained in naturally blue flowers. Scientific advancement has allowed a blue rose to be created through genetic engineering. The soft shade of rose in steel blue is synonymous with mystery and expectation.

■ A cloudy sky intensifies the steel blue of the glass windows on this corporate building. It harmonizes with nature's lighter and darker blue tones, as though chosen from a colour wheel. The subtle, sophisticated blue accentuates the architectural form.

Sunglasses are worn to keep out the harmful rays of the sun and cut the bright glare of its reflection. They are worn as a fashion item too, even without sun. Steel-blue lenses will create a cool blue view. The colour harmonizes with pale-grey frames, echoing the grey undertones of the colour.

■ Van Gogh loved to paint flowers, most notably his many depictions of bright-yellow sunflowers. In *Still Life With Thistles* (1890) he has chosen the wild thistle and uses steel blue to create a soft, light pastel portrait.

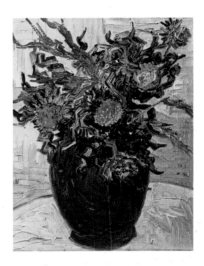

■ A blue leather sofa is a luxury item. The colour creates a calm and meditative atmosphere. The combination of monochromatic deep-blue walls and steel-blue sofa intensifies the colour saturation. Steel blue is a perfect colour for office boardrooms or reception areas; it is not loud, but it is noticeable.

POWDER BLUE

■ 01 DEFINITION

Powder blue is a pale light blue. It is linked to male newborn boys; blue is a signifier of masculinity. Pale pink is traditional for infant girls to denote femininity. The soft shading of powder blue is known to calm and sooth. The artist Vassily Kandinsky likened light blue to the music of a flute: airy and filled with light. It is similar in tone to duck-egg blue. An earlier name was baby blue, introduced in 1892. It was a darker hue than the present pigment. Dark powder blue is known as 'smalt'. Powder blue colour connotes blue skies, serenity and meditation.

■ 02 TECHNICAL INFORMATION

RGB Colour
R 176 G 224 B 230

CMYK Colour
C 33 M 1 Y 8 K 0

LAB Colour
L 85 A -22 B -11

HSB Colour
H 187 S 23 B 90

Hexadecimal **Pantone**
B0E0E6 318C

Closest Web-safe Colour
99CCFF

■ 03 COMMON COLOUR COMBINATIONS

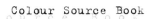

■ **04** HISTORY AND CULTURE

Powder blue is obtained from smalt, a pigment of cobalt-blue glass. The colour has been used since the Middle Ages but new formulas of smalt, produced in the late eighteenth and early nineteenth century, increased its use. The name originally referred to a darker blue 'dark powder blue', nearer to its cobalt-oxide origins. The dark-blue dyestuff was popular for laundering cotton fabrics. It was recommended to be used to avoid yellowing of white clothes. A small solid lump would be tied in a muslin bag, to rinse in with white fabrics, to make them look whiter. The 'blue' dye is still available today. The darker hue was used for military uniforms of the Royal Air Force, a colour associated with sky.

The powder-blue name was changed to denote the paler hue because its name had led to a confusion of colours. It changed from dark blue, to denote the lighter shading and is analogous to baby blue, a traditional colour for clothing newborn baby boys. The colour is used to create an air of calm; perfect for a nursery. A room with lots of exterior light will highlight its clear icy undertones and it blends well with neutrals.

■ **05** EXAMPLES

■ Powder-blue walls and sofa harmonize the diverse mix of architectural motifs. The natural-wood flooring and classic Doric columns offset wooden and metal furnishings, medieval mirrors and a glass chandelier. The soft blue is used as a backdrop for each object.

■ Lesser Burdock flower heads are purplish blue when in flower, from July to October. The winter frost dulls their colour to powder blue, fading to brown. The 'bur' seed heads cling to the clothing of a passer-by and stick to a sheep's woolly coat.

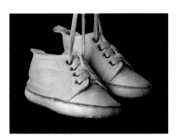

■ Powder blue and white sneakers update the traditional use of 'blue for boys' and 'pink for girls' colours for newborns: twenty-first century clothing for babies has produced stylish colours in line with high fashion but some time-honoured colours never fade away.

■ In this piece of ceramic made from dyed concrete and glass, cobalt-blue background offsets the paler hues of powder blue and cyan, fading to greys. A darkly bright emerald-green fish swims through a sea of blue.

■ Using his Pointillist technique of complementary dots or points of pure colour, Georges Seurat aimed to portray the atmosphere of a weekend on the banks of the Seine at Asnières outside Paris. In this detail from *Bathers at Asnières* (1884) he uses powder blue to capture the haze of sky and water, where workers relax by the river in their free time.

Colour Source Book

■ PRUSSIAN BLUE

■ 01 DEFINITION

Prussian blue is a dark blue with reddish tint. The name is taken from its eighteenth-century origins in Prussia where it was used as a dye for military uniforms. In Germany it is known as Paris blue. It is a blue of beautiful semi-transparent translucency, which has high tint-strength. It needs careful use as it will dominate any colour mixed with it or placed near to it. Prussian blue mixed with lemon yellow creates a cold greenish hue; mixed with cadmium yellow it produces a greyish-green, closer to olive. It is used in paints, enamels and lacquers.

■ 02 TECHNICAL INFORMATION

RGB Colour
R 0 G 49 B 83

CMYK Colour
C 94 M 63 Y 19 K 44

LAB Colour
L 16 A -7 B -30

HSB Colour
H 205 S 100 B 33

Hexadecimal **Pantone**
003153 7463C

Closest Web-safe Colour
003366

■ 03 COMMON COLOUR COMBINATIONS

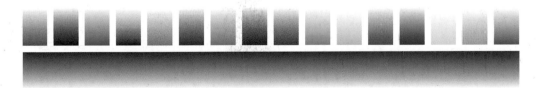

■ **04** HISTORY AND CULTURE

Prussian blue is a strong reddish-blue tint mineral (ferric ferrocyanide); the first modern, artificially manufactured synthetic pigment. Experiments with iron oxidation carried out by the colour maker Diesbach of Berlin in 1704, mixed solutions of potassium ferrocyanide and iron chloride to try to make a synthetic cochineal-red pigment. Diesbach mistakenly used contaminated potash containing animal oil which produced a pale red; further experiments increased the intensity to purple-blue, now known as Prussian blue. From its sale to the public in 1724, it overtook azurite and ultramarine as the most popular blue. It was described as being 'equal to or excelling ultramarine' and cost a fraction of the price. It remained so to the nineteenth century.

Pablo Picasso used it for paintings during his 'Blue Period' and Paul Gauguin painted outlines of his subjects directly on to the canvas in diluted Prussian blue. Other artists include Thomas Gainsborough, John Constable, Claude Monet and Vincent Van Gogh. Alkali ruins the colour, making it unsuitable for fresco painting. It has been replaced by phthalocyanine blue. Today, as part of medical treatment a formula made from Prussian-blue solution (not the paint pigment) can remove certain radioactive materials from a person's body, usually taken in capsule form under medical supervision.

■ **05** EXAMPLES

■ Five ties for five days at the office: silk ties in analogous hues of blue illustrate the subtlety of combining monochrome shades. On its own, each tie will add sophistication to a plain shirt or contrast a patterned one.

■ The variable tonal values of Prussian blue are noticeable when a grey-blue building is set against a paler hue sky. Many skyscrapers in California use blue filter glass for windows, to tone down the glare from sunlight. The result is architectural chic.

PRUSSIAN BLUE

■ 01 DEFINITION

Prussian blue is a dark blue with reddish tint. The name is taken from its eighteenth-century origins in Prussia where it was used as a dye for military uniforms. In Germany it is known as Paris blue. It is a blue of beautiful semi-transparent translucency, which has high tint-strength. It needs careful use as it will dominate any colour mixed with it or placed near to it. Prussian blue mixed with lemon yellow creates a cold greenish hue; mixed with cadmium yellow it produces a greyish-green, closer to olive. It is used in paints, enamels and lacquers.

■ 02 TECHNICAL INFORMATION

RGB Colour
R 0 G 49 B 83

CMYK Colour
C 94 M 63 Y 19 K 44

LAB Colour
L 16 A -7 B -30

HSB Colour
H 205 S 100 B 33

Hexadecimal **Pantone**
003153 7463C

Closest Web-safe Colour
003366

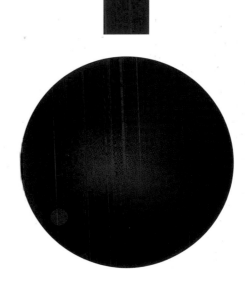

■ 03 COMMON COLOUR COMBINATIONS

■ **04** HISTORY AND CULTURE

Prussian blue is a strong reddish-blue tint mineral (ferric ferrocyanide); the first modern, artificially manufactured synthetic pigment. Experiments with iron oxidation carried out by the colour maker Diesbach of Berlin in 1704, mixed solutions of potassium ferrocyanide and iron chloride to try to make a synthetic cochineal-red pigment. Diesbach mistakenly used contaminated potash containing animal oil which produced a pale red; further experiments increased the intensity to purple-blue, now known as Prussian blue. From its sale to the public in 1724, it overtook azurite and ultramarine as the most popular blue. It was described as being 'equal to or excelling ultramarine' and cost a fraction of the price. It remained so to the nineteenth century.

Pablo Picasso used it for paintings during his 'Blue Period' and Paul Gauguin painted outlines of his subjects directly on to the canvas in diluted Prussian blue. Other artists include Thomas Gainsborough, John Constable, Claude Monet and Vincent Van Gogh. Alkali ruins the colour, making it unsuitable for fresco painting. It has been replaced by phthalocyanine blue. Today, as part of medical treatment a formula made from Prussian-blue solution (not the paint pigment) can remove certain radioactive materials from a person's body, usually taken in capsule form under medical supervision.

■ **05** EXAMPLES

■ Five ties for five days at the office: silk ties in analogous hues of blue illustrate the subtlety of combining monochrome shades. On its own, each tie will add sophistication to a plain shirt or contrast a patterned one.

■ The variable tonal values of Prussian blue are noticeable when a grey-blue building is set against a paler hue sky. Many skyscrapers in California use blue filter glass for windows, to tone down the glare from sunlight. The result is architectural chic.

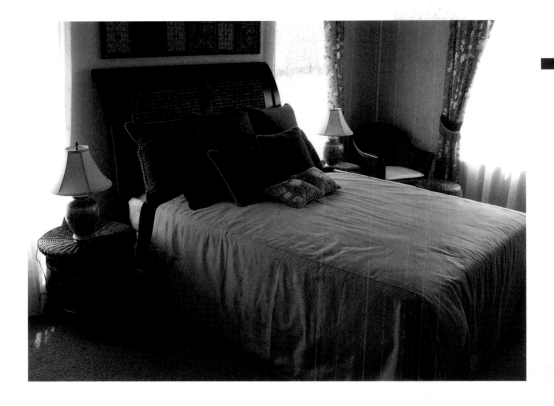

■ An intense Prussian blue contrasts with the neutral palette of cream and sand, on walls, floor and bed furnishings, accented by dark rattan furniture. Multi-print curtains of yellow and blue pick up the deep blue of the cushion covers.

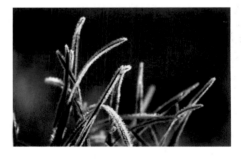

■ The winter grasses have been touched by frost. The tips look blue, alluding to an ice-cold temperature that will freeze the dew. A bright light, which focuses on the foliage, contrasts the backdrop of translucent Prussian blue.

■ This print is one of a series 'Thirty Six Views of Mount Fuji' (there are actually 46). In *The Hollow of the Deep-Sea Wave off Kanagawa* (1829–30) Hokusai uses Prussian blue to intensify and contrast the whiteness of the foaming waves and to mirror the hues of the snow-capped mountain in the far distance.

ROYAL BLUE

■ 01 DEFINITION

The name is derived from its intense blue colour. Its original meaning is not clear, possibly associated with King's Blue or the French *bleu royale*, associated with King Louis XIV. The colour is connected to precious pigments and stones such as ultramarine and sapphire. It sits between manganese blue and turquoise in the colour spectrum. RGB has full saturation of blue, half hue on green and a quarter hue on red. CMYK contains no yellow and no black. The name suggests formality but the colour is a lively hue, evoking the sun shining in a royal-blue sky. It was a colour favoured by porcelain makers for blue and white pottery.

■ 02 TECHNICAL INFORMATION

RGB Colour
R 65 G 105 B 225

CMYK Colour
C 76 M 50 Y 0 K 0

LAB Colour
L 46 A 15 B -71

HSB Colour
H 225 S 71 B 88

Hexadecimal **Pantone**
4169E1 2726C

Closest Web-safe Colour
3366CC

■ 03 COMMON COLOUR COMBINATIONS

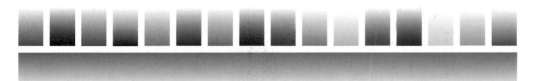

■ **04** HISTORY AND CULTURE

The colour name royal blue has been used to differentiate the highest quality ultramarine, which is made from lapis lazuli, from lesser qualities. The costly ultramarine pigment, more expensive than gold, earned it the name royal blue due to the exclusive patronage its cost incurred. The royal-blue colour was popular for enamelling: Islamic enamellers in seventeenth-century Iran produced exquisite jewellery pieces, superior in colour and quality to European enamelwork. Blue has been used in the production of Chinese porcelain for many centuries.

In eighteenth-century England the passion for Chinese 'Blue and White' instigated pottery makers to copy imports, replicating the style and colours. In 1744 the Bow Porcelain Factory in East London was the first to patent it, as Canton ware. The Chinese-blue underglaze was replicated using royal blue. The Sèvres porcelain factory in Paris produced exclusive porcelain tableware and ornamental objects

in royal blue until the French Revolution of 1789 ended the patronage of King Louis XVI and the French royal family. The French conceptual artist Yves Klein (1928–62) gave the colour a new name: he used royal blue exclusively for his art but renamed it International Klein Blue (IKB).

■ **05** EXAMPLES

■ The stunning aura of light royal blue creates a sensational backdrop to the jagged rock face and natural arch. The sand tones of the bleached rock and the clarity of royal blue harmonize.

■ An intricate pattern illustrates dark royal blue and light royal blue contrasted with burnt sienna as a background colour. Islamic art reached its apogee in the tiled interiors of its mosques. The most beautiful colours and abstract designs were created in praise of Allah.

■ Brightly coloured rocking chairs line up in the sun; vivid colours hide the old wood. Variable hues of royal blue in light and dark tones sit either side of contrasting light burgundy red. Rocking chairs connote relaxation and time off.

■ The online internet search engine Google was started as a research project by Larry Page and Sergey Brin in 1996. The Google graphic uses primary red, yellow and blue. The colours in the title have remained constant since 1998 but have changed positions in the redesigns of the word. At one point an exclamation point was included but now removed. The current official Google logo is based on 'Catull' typeface, designed by Ruth Kedar.

■ The Infanta Margarita Teresa, daughter of King Philip IV, was eight years old when Diego Velásquez (1599–1660) painted this portrait. *The Infanta Margarita Teresa in a Blue Dress* (1659) shows her wearing a court dress of dark royal-blue velvet. Her golden hair is contrasted with the deep blue of the fabric and the golden brocade that decorates it. From an early age portraits of her were painted regularly to send to German Emperor Leopold I, because from birth the princess had been betrothed to her cousin Leopold.

SAPPHIRE

■ 01 DEFINITION

The word 'sapphire' translates from a Greek word for blue. Its main colour association is with the strong brilliant hues of the sapphire gem, an opaque to translucent blue variety of quartz. Other sapphires of pink, yellow, violet and green are referred to by gem colour, only the blue hue is termed by the sapphire name alone. A sapphire is said to bring wealth and it is a symbol of the heavenly sphere. The colour is linked to sapphire-blue flowers, water and skies. The 'blue' in the music *Rhapsody in Blue* (1924) composed by George Gershwin is sapphire.

■ 02 TECHNICAL INFORMATION

RGB Colour
R 8 G 37 B 103

CMYK Colour
C 97 M 80 Y 10 K 30

LAB Colour
L 14 A 15 B -47

HSB Colour
H 222 S 92 B 40

Hexadecimal **Pantone**
082567 2757C

Closest Web-safe Colour
003366

■ 03 COMMON COLOUR COMBINATIONS

■ 04 HISTORY AND CULTURE

Sapphire pigment is formed from a compound of iron oxides and is lightfast. The colour was widely in use during the medieval period; associated mainly with sapphire stained-glass and gemstones. The first Gothic building was created for the statesman, historian and minister of the Church, Abbot Suger, at St Denis in Paris (c. 1136). The monumental pointed arches created light-filled spaces for stained-glass window interiors. Sapphire was the predominant colour; through its symbolic representation of the celestial heavens and the Holy Family. In his treatise *De Diversis Artibus* (*On Diverse Arts*, 1100–20) twelfth-century Benedictine monk Theophilus discussed the subject of glass and colour. For 'Divers colours of glass not transparent' he recommended recycling ancient objects and glass mosaics, to make 'coloured gems … costly plates of sapphire … and windows'. (Book II, 12).

The colour continues to hold its appeal. Sapphire is favoured by royalty because it is a symbol of loyalty. British royal-family members, including Queen Elizabeth; the Queen Mother, Queen Elizabeth II; the Princess Royal, Princess Anne; and Diana, Princess of Wales, all chose sapphire engagement rings. Their choice may have been to reflect duty and loyalty to the Crown and the country.

■ 05 EXAMPLES

■ Sapphire is used to add a marine touch to the shutters, door and gate of a Mediterranean house. Neutral walls emphasize and dramatize the rich deep blue. An anchor placed to the right of the door adds to the naval theme.

■ The celestial sky with its galaxy of stars was replicated on medieval church ceilings, using colours of sapphire with gold or silver stars to symbolize heaven. The night sky shows the depth and translucence of the sapphire hue, intensifying the starry light.

NAVY BLUE

■ 01 DEFINITION

Navy blue is a very dark blue. The vat dye colour is produced from the chemical compound indigotin, a product of the deoxidization and re-oxidization process of leaf fermentation of the indigo plant. The depth of shade of blue depends on the time and frequency of its immersion in the solution. CMYK is nearly 100 percent cyan, 83 percent magenta and 20 percent black. Maroon is its complementary colour, with accent colours of powder blue and cyan. It is a colour that is a mark of aristocracy, quality, intellect, reserve, history and tradition. It evokes high standards, sophistication, reliability, confidence and safety. It instils calm and concentration and suggests conservative methodology and worthy deeds.

■ 02 TECHNICAL INFORMATION

RGB Colour

R 0 G 0 B 128

CMYK Colour

C 97 M 83 Y 6 K 20

LAB Colour

L 12 A 42 B -69

HSB Colour

H 240 S 100 B 50

Hexadecimal Pantone

000080 2745C

Closest Web-safe Colour

000099

■ 03 COMMON COLOUR COMBINATIONS

■ **04** HISTORY AND CULTURE

Navy blue is a cool colour: a dark blue-black linked to smart business suits, yachting blazers and school uniforms, naval dress, deep oceans, flags and ensigns. The navy-blue pinstripe is favoured by city workers in the financial district, who wear their sharp suits like a uniform. It is the traditional dress-code colour for those at sea: Royal Naval, seamen, yachtsmen, fishermen and lifeboat crews. In Britain the 'navy blue' colour was established in 1748 by the Royal Navy, to differentiate between plain dark blue and the dark blue worn with white, utilized by the Naval officers. Prior to this naval officers had worn a variety of colours from red, blue, white and grey.

It was not until the mid-nineteenth century that all naval seamen of all ranks were dressed in navy blue. This was due to lower ranks taking only short-term employment in the Navy. In 1802 the US Navy established their naval dress code of navy blue and gold. The customary fabric for uniforms is dark navy wool serge, which is hard-wearing, smart and comfortable.

■ **05** EXAMPLES

■ A crisp shirt and navy-blue tie is traditional dress for the office. The colour signifies sobriety, hard work and loyalty. Its dark shade makes it suitable for sombre occasions too, such as funerals and memorial services. Politicians favour navy blue to show sincerity.

■ The metallic open-plan staircase is offset by the dense colour of navy-blue walls. It creates a sense of elegance and modernity, mixed with mystery and sophistication. Navy blue can create a visual sensation of coldness but the warmer metal brings harmony.

■ Rain droplets on a spider's web emphasize the intricate structure and jewel-like shapes within the pattern. The backdrop

of navy blue connotes darkness, night and the near invisible spider, which hides from prey until it is trapped in the net.

■ A fabulous handmade pottery mug is glazed in a dense shade of navy blue. Rough shape and rich colour make this mug tactile; it demands to be picked up and used. As an ornament the blue hue will create a focal point.

■ *Christ in the House of Mary and Martha* (c. 1654–56) is considered to be the earliest known painting by Jan Vermeer (1632–75). Less than 20 colour pigments were on his palette. In the painting the darker hues of navy blue, for one of the robes of Christ, would suggest the clothes of an ordinary man, but the symbolism of deep blue is of royal birth and embodies the concept of the Holy Family.

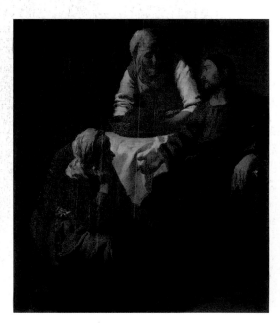

STACKING PALLETE P.6.

ULTRAMARINE

01 DEFINITION

A rich shade of purplish blue that takes its name from the Latin word *ultramarinus* meaning 'from across the sea' and the Italian *azzuro oltremarino* (blue from beyond the sea), also known as lazuline blue. The colour is created from lapis lazuli stone crushed to powder. The first soaking produces a rich violet blue. It can be created synthetically by mixing sodium carbonate, sulphur and clay. The colour is associated with the nobility, the exotic and the beautiful; with wealth, taste, luxury and intellect. 'Titian Blue' is another name by which it is known, referring to its use by the Venetian artist Titian.

02 TECHNICAL INFORMATION

RGB Colour
R 18 G 10 B 143

CMYK Colour
C 98 M 84 Y 4 K 13

LAB Colour
L 15 A 44 B -73

HSB Colour
H 244 S 93 B 56

Hexadecimal **Pantone**
120A8F 2738C

Closest Web-safe Colour
000099

03 COMMON COLOUR COMBINATIONS

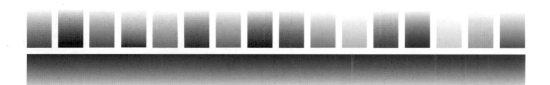

■ **04** HISTORY AND CULTURE

During the Middle Ages and Renaissance 'ultramarine' was the term for lapis lazuli, a precious stone mined in Afghanistan and hewn from rock by means of heat. The difficulties of abstracting the stone and the remoteness of the mountainous location made it hard to acquire and more expensive than gold to buy. In Eygpt it was used for jewellery and decorative ornaments but to European artists it was the crown jewel of colour pigments. It was sought to decorate religious manuscripts as only the finest and most expensive pigments were deemed worthy of God. Cennino Cennini, author of *Il Libro dell'Arte (The Craftsman's Handbook)* writes in detail of the process for creating the pigment from the crushed lapis. He describes ultramarine as 'illustrious, beautiful, and most perfect, beyond all other colours'. The cost per gram was so expensive that artists' patrons would stipulate in contracts the designated areas of the artwork. Titian's *Bacchus and Ariadne* (1520-30), is a fine example of how the patron showed his wealth, through generous use of ultramarine. In the early nineteenth century a French industrial chemist, Jean-Baptiste Guimet, invented a synthetic replacement known as French ultramarine at a much-reduced cost.

■ **05** EXAMPLES

■ Hand-knitting is a process of labour and patience. The ultramarine colour highlights the rich texture of the thick yarn. The wool is interlaced with blues and pinks to add to and soften the depth of blue.

■ The hyacinth macaw parrot is a found along the Amazon River in South America. He is an exotic colour of ultramarine from head to tail end. Eye rings and part of the lower beak are in strong yellow, which contrast the vibrant blue.

■ A monochromatic room in shades of blue creates an air of cool sophistication. Patterned armchairs in rich ultramarine create the focal point; the blue sofa and pale walls harmonize with the neutral accessories of cream lampshades, glass tables and patterned floor.

■ The woman is mysterious; is she flirting or just passing by? The purple-blue hues of ultramarine exaggerate seduction and sensuality. The colour adds a sense of intrigue and focuses the eye on the girl more than the background.

■ The half-portrait of Henry VIII (c. 1537) depicts him in regal finery. Symbolically his high-born status is reflected in the use of ultramarine, a paint pigment reserved for the richest patrons. Hans Holbein the Younger favoured a strong, rich background colour of ultramarine, jade or teal, to push an image forward. Holbein was popular as a portrait artist for his ability to paint an accurate likeness. King Henry's face and magnificent clothes and jewels are represented in fine detail.

PURPLE

01 DEFINITION

Purple has the shortest wavelength in the spectrum. It has many shades from lilac to indigo. It is a colour which encourages deep contemplation or meditation. It has timeless associations with royalty and nobility. The colour visually communicates fine quality, wealth, ingenuity, and status. Purple brings together love (red) and wisdom (blue). It is linked to justice. It can symbolise mourning, death, suffering and misery. With white it connotes purity and humility. Excessive use can signal introspection and the wrong shade may communicate something that is of little value, brash, or vulgar. Kandinsky perceived it aurally as '"...pure tones of little bells...called "raspberry-coloured sounds" in Russian.'

02 TECHNICAL INFORMATION

RGB Colour
R 102　G 0　　B 153

CMYK Colour
C 69　M 90　Y 0　　K 1

LAB Colour
L 30　A 58　B -54

HSB Colour
H 280　S 100　B 60

Hexadecimal　**Pantone**
660099　　　　2602C

Closest Web-safe Colour
660099

03 COMMON COLOUR COMBINATIONS

■ **04** HISTORY AND CULTURE

The first purple pigment was Tyrian purple, a dyestuff produced by the Phoenicians in the city of Tyre, a port in Phoenicia, over 2,000 years ago. The dye was produced from the secretions of the mollusc *Murex trunculis* and *Murex brandaris*; the purple pigment was the most expensive dye in the world. The dye gave a rich and deep colour that was so rare and valuable it became reserved for royalty. Pliny the Elder in Naturalis Historia, (Book 19, Chapter 5), remarks on Queen Cleopatra's use of sails tinted purple, to denote her royal ship, at the Battle of Actium in 31 BC. In ancient Rome, the emperor alone was allowed to wear purple robes; the senators wore purple ribbons on their togas. The tradition was continued by German emperors, wearing purple as a symbol of power.

In medieval times purple continued to be made from mollusc shells; mixing purple paint required the artist or dyer to obtain vermillion (red) and ultramarine (blue), which were also rare and extremely expensive. Today the colour continues to be used on specific occasions to denote high status. For many years it was a difficult colour to reproduce in paint or dyestuffs until William Perkin discovered his first synthetic dye in 1856, which he was going to name Tyrian purple but changed it to 'mauve'.

■ **05** EXAMPLES

■ Painted deep purple, and reminiscent of the 1970s hippie era with its passion for wild colour, it was fashionable to drive cars in psychedelic colours: acid green, orange, magenta, citrus lemon, and hot purple: any colour other than black.

■ Purple-hued flowers create a focal point in a room setting. The 'Flag Iris' appears in many colours from the most popular pale blue and deep purple, to reds, pinks,

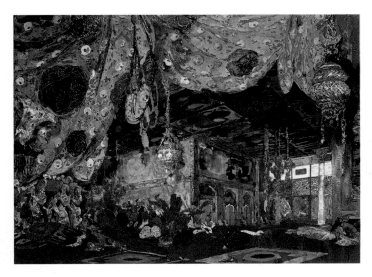

oranges and yellow plus white. The genus *Iris* lives up to its meaning of 'rainbow'.

■ In 1909, the bold colours of the Ballet Russes banished the popular pastels of the day. The set for the ballet *Scheherazade* used draperies, cushions and carpets in vibrant reds, purples and blues instead of the usual painted scenery. Costumes were sewn in

brilliant colour never before seen in the theatre. The impact was immediate: smart drawings rooms of the day were transformed into 'harems' decorated with richly patterned drapes, Oriental carpets and cushions.

■ Purple graphics reflect the energy of Kansas State University's Solar Racing Car Team; they have created

a twenty-first century car powered solely by the sun. The poster uses purple rays on a paler background to symbolise the rays that heat the solar machine.

■ Coats of arms traditionally feature five colours: blue (azure), red (gules), black (sable), green (vert) and purple (purpure), plus gold and silver. These colours each symbolise something. Purple, for example, represents justice, sovereignty and royalty. Combined with the other colours and symbols, heraldry is used to represent a town, city, county or family, amongst others.

■ INDIGO

■ 01 DEFINITION

Indigo is considered to be the world's oldest dye colour. Dark blue indigo is associated with batik prints and denim jeans. Modern-day use varies from cosmetics to chemical indicators in science. Sourced from a plant that needs to be fermented, it is associated with times when hand-dyeing methods were used in Eygpt, South America, India and China. The northern hemisphere woad plant can produce a similar dye colour and is sometimes referred to as northern indigo; the indigo plant may be referred to as tropical, Asian or Eastern indigo or tropical and sub-tropical woad.

■ 02 TECHNICAL INFORMATION

RGB Colour
R 75 G 0 B 130

CMYK Colour
C 82 M 97 Y 1 K 4

LAB Colour
L 22 A 49 B -53

HSB Colour
H 275 S 100 B 51

Hexadecimal **Pantone**
4B0082 2597C

Closest Web-safe Colour
330099

■ 03 COMMON COLOUR COMBINATIONS

■ **04** HISTORY AND CULTURE

The earliest use is thought to be *c.* 3,000 BC in Egypt. Fragments of colour have been found in pharaoh tombs. Its use as a textile dyestuff is recorded at Thebes, ancient Greece, dating to 2,500 BC. Herodotus of Halicarnassus discusses its use in *Histories* (*c.* 450 BC). The dye is made from several plants of the *Indigofera* genus. The dark-green oval-shaped leaves are fermented and become the main source for the dye colour. The plant's red flowers turn to peapods and are also used. The plants grow up to 2 m (6 ft) in height. Two particular species are favoured: *indigofera tinctoria* (from Asia and India) and *indigofera suffructiosa* (from Central and South America). Indigo as a pigment dye is produced from indicant, the compound in the plant that creates the blue colour we associate with it.

The Portuguese explorer Vasco de Gama found a maritime route to India in 1498 and brought indigo to Europe. In 1865 Adolph von Baeyer, an industrial chemist and Nobel laureate, began experiments with indigo, which led to the creation of a synthetic dye. The success of it led to a reduction in natural indigo production and by 1900 the market was redundant.

■ **05** EXAMPLES

■ Stained glass refracts its colour through sunrays, creating a kaleidoscope of colourful hues. The pattern is made up from various shades of coloured glass; here mirroring the many shades of indigo, from paler blue to strong purple.

■ The graffiti artist has used indigo blue to make an outline over the pale greys of the boxer's body shape. It defines the pose and draws attention to the bulging muscles, boxing gloves and boxer's head in the tense ready-for-action stance.

■ Aubergine (*Solanum melongena*) is botanically a berry, not a vegetable. In season from May to October, it originates from India and the colour mimics the indigo plant's fermented leaf colour. The purple-rich shade reflects the hot climates where both plants flourish.

■ Indigo is the perfect dye colour for fabric. The depth of colour depends on the strength of the pigment and amount of times the fabric is immersed. It can create shades from mid-blue to darkest purple, producing intense natural hues.

◼ AMETHYST

◼ **01** DEFINITION

Amethyst is a synergy of medium purple with pinkish hues. It takes its name from the amethyst-quartz stone, a natural mineral. In its pure form it can vary in shade from lilac to deep purple. The Venerable Bede distinguished deep-purple amethyst as the colour of heaven. The colour is associated with purity, harmony and regal status. Its visual effect is to soothe and calm. It tones with silver grey, blue plum and deep burgundy. CMYK is 50 percent blue and 50 percent red.

◼ **02** TECHNICAL INFORMATION

RGB Colour
R 153 G 102 B 204

CMYK Colour
C 46 M 54 Y 0 K 0

LAB Colour
L 54 A 42 B -44

HSB Colour
H 270 S 50 B 80

Hexadecimal **Pantone**
9966CC 7441C

Closest Web-safe Colour
9966CC

◼ **03** COMMON COLOUR COMBINATIONS

■ 04 HISTORY AND CULTURE

Amethyst is the most precious stone of the quartz family and in ancient times amethyst was considered to have magic qualities. It was worn to protect the wearer from harm or as an antidote against poisoning and it was a symbol of status. The tomb at Abydos of the Eygptian King Zer, dating from 3,200 BC, revealed the body of a princess whose arm was decorated with many bangles of gold, incised and encrusted with stones of amethyst and turquoise. The origin of the word is from *amethystos* the ancient Greek word for sober. To Greeks it was believed that wearing the amethyst stone, a prized piece of jewellery, or drinking from goblets made of amethyst, would prevent intoxication. Purple amethyst represented the Gods.

Pliny the Elder in his works *Naturalis Historia* associated the name with the purple-red colour of wine. A Greek, later Roman, legend links Bacchus the wine god with Amethyst a maiden. Bacchus falls out with the goddess Diana and determines to set wild beasts on the next person across his path. Amethyst is the unlucky one and calls to Diana to help her escape. Diana can only turn her to stone to protect her. In remorse Bacchus pours wine over the transparent stone, creating the amethyst colour.

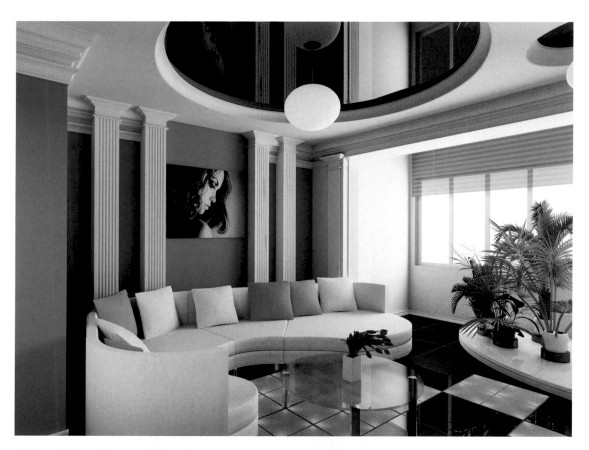

■ 05 EXAMPLES

■ Amethyst walls create a feeling of space in this room (see left) that is both contemporary and classical in design. The mix of cool purple with pinkish undertone creates a crisp setting and understated look. Complementary yellow is used for flooring with shades of silver grey, soft blues and green to accessorize the neutral furnishings.

■ Amethyst (see above) is found from Siberia to South Africa in the silica-rich liquids formed by gas cavities in lava. The untreated transparent quartz is dichroic, splitting light through it into rays of bluish violet and reddish violet. When the stone is heated to 400–500 degrees centigrade it turns reddish or brownish yellow in colour.

■ The varied hues of amethyst are defined here (see above), showing the vast range of colour values that it contains. The swirls of pattern mimic the multifaceted transparency of the natural quartz stone. The underlying primary colour of blue at its core reveals tones of purple through to strong pink.

■ Edgas Degas (1834–1917) is famed for his portrayals of young ballet dancers working in the theatres of nineteenth-century Paris. Degas gained access backstage to watch them rehearse and perform. In this pastel on paper the shimmering blue of amethyst creates movement between the dancers, rendering their beauty, youth and vitality in colourful hues in *Blue Dancers* (1899).

LAVENDER

■ 01 DEFINITION

The word is possibly derived from the Latin verb *livere*, to be bluish in colour. Its hues are a combination of pale blues with a trace of red. The soft colour is associated with fragrant beauty, femininity and everlasting love. The expression 'lavender days' encapsulates the rich enjoyment of later life. The name is linked to the sweet-smelling shrub *Lavandula officinalis*, or *Lavandula vera*, which flowers in the warmth of mid-summer. Its aroma is said to create an aura of happiness. The expression 'lay up in lavender' refers to the practice of laying dried flowers among stored linen to protect it from moths; the wider meaning was to conserve carefully for later use.

■ 02 TECHNICAL INFORMATION

RGB Colour
R 181 G 126 B 220

CMYK Colour
C 35 M 45 Y 0 K 0

LAB Colour
L 64 A 41 B -38

HSB Colour
H 275 S 43 B 86

Hexadecimal **Pantone**
B57EDC 2572C

Closest Web-safe Colour
CC66CC

■ 03 COMMON COLOUR COMBINATIONS

■ **04** HISTORY AND CULTURE

Lavender is a native herb of the Mediterranean region. It has been used as a medicinal herb for over 2,500 years. In ancient Egypt it was used to scent and purify the body during mummification. The Greeks considered it an excellent remedy to ward off chest infections and the Romans used it medicinally and to disinfect and scent the communal baths. It was popular too as after-bath oil for the skin. Romans spread the use of lavender throughout their empire. Lavender was referred to as spikenard in the Bible and there is written reference to 'oil of spike', made from the distillation of flower heads of *Lavendula spica*, being used by artists as a pigment thinner in the seventeenth century. It is considered that its use may date back much earlier.

In the nineteenth century lavender was used in smelling salts to revive the faint-hearted and today lavender oil is used in aromatherapy to calm, relax and energize. At the present time, research is being carried forward in the use of lavender as an aid to prevent agitation in sufferers of severe dementia. It is also being tested as an ambient air fragrance, to reduce the anxiety of patients during dental treatment.

■ **05** EXAMPLES

■ The fabric colour combinations of sharp greens, bright lavenders and shades of blue on a fresh white ground conjure up early summer. The pattern emulates the flighty, dancing movements of butterflies emerging from the chrysalis, to drink from flower heads.

■ A vibrant lavender-coloured wall shows the extremes of the lavender palette, which spans from pale blue to warm pink. The colour can add warmth to liven up a north-facing wall, which gets minimal sun. The terracotta pots accentuate the colour, to complement it.

■ Masterful use of painterly technique masks an image of foliage to create an abstract form. The translucent tones of primary blue used with tertiary pinks, mauves, purples and gold demand visual attention and almost overwhelm the presence of soft lavender hues.

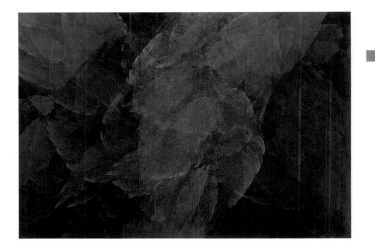

■ Two-colour dominant lavender and lilac used with harmony accents. Lavender graphics are used as visual colour signals of femininity, beauty, harmony and love. Through skilful use, the muted lavender on soft white links to the message the magazine wants to give: a bride-to-be's expectation of marriage and long-term happiness.

■ Caspar David Friedrich's seascape *The Stages of Life* (c. 1835) is a symbolical portrayal of the journey through life. Set in soft lavender skies with golden hues, a group of people gather at the shoreline in the central foreground. Behind them, five ships travel toward the horizon, each one symbolizing the various stages of life, from youth to old age.

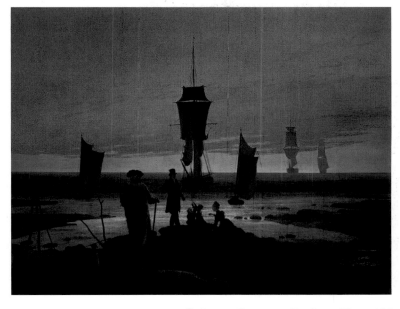

LILAC

■ 01 DEFINITION

Pale pinkish violet in colour, the hue is linked to the flowering lilac shrub which produces heady, fragrant blossoms in May. Lilac is associated with pretty cottage gardens and scented bowers. Cadmium red mixed with cobalt blue produces a soft lilac. When added to white it captures the varying shades from violet through to white lilac. It is a hard colour to pinpoint because the light will alter its subtle shading. It is perfect for spaces with shadows and sunlight, to allow its subtle changes to transpire. An adage of the lilac plant states that 'to plant a lilac is to plant a memory'.

■ 02 TECHNICAL INFORMATION

RGB Colour
R 200 G 162 B 200

CMYK Colour
C 16 M 36 Y 2 K 0

LAB Colour
L 73 A 24 B -13

HSB Colour
H 300 S 19 B 78

Hexadecimal **Pantone**
C8A2C8 672C

Closest Web-safe Colour
CC99CC

■ 03 COMMON COLOUR COMBINATIONS

■ **04** HISTORY AND CULTURE

Lilac pigment can be seen in Persian miniature landscape paintings of the sixteenth century. Examples are in the collection of the Metropolitan Museum, New York. The depiction of salmon-pink hills, purple sandstone or lilac rocks has often been considered unusual but the colours are true to nature. The rocks and hills of Persia (Iran) take on a different hue, due to fiercely intense sunlight and the natural colour, confirming that the artist was painting from nature. The variable colour of lilac can be illustrated in two paintings. In *Lilac Bouquet* (1889) the artist Paul Gauguin depicts a garden bouquet of lilacs in a vase on a table. Dusky hues of lilac evoke the passing of time. Edvard Munch used lilac quite differently in *Geese in an Orchard* (c. 1911) where lilac shadows dapple the ground surrounding white geese.

The lilac colour is bright and uplifting, the colour of the natural flower blossom. In Britain the lilac is synonymous with cottage gardens in early summer. One can smell a fragrant lilac blossom before spotting the bush or tree. In pop-music culture the expression 'Lilac Wine' (1994) is synonymous with a love song written by James Shelton and recorded by Nina Simone in 1996. It evokes the sensual heady days of a blossoming relationship.

■ **05** EXAMPLES

■ Ceramic is porous before glazing and the vase clearly displays the saturated tones of lilac from greyish blue through to soft red. At the edges of each rim the pale-pink undertone present in Lilac pigment shows through.

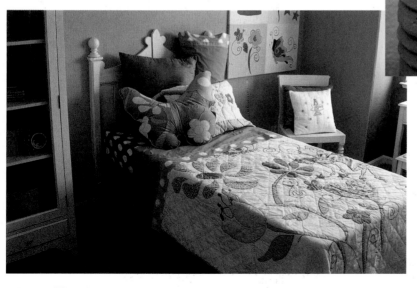

■ Contrast colours of creamy yellow and pale lilac are used for the walls of this fairy-tale bedroom. The colours are followed through on the wall hanging and furnishing fabrics, using deep lilac for cushions and bed linen. Sharp green is used in small amounts as accent colour.

■ The common lilac, *Syringa vulgaris*, originated from Eastern Europe. It flowers in April and May. A close-up of the tiny flowers on a stem of blossom reveals the delicate natural hues of the lilac petals and stamens.

■ The web screen is two-colour dominant with harmony accents of lilac pinks and grey. The graphic shows the variation possible in the colour of lilac; all calming, muted colours to symbolize the product.

■ Paul Gauguin captures the air of relaxation and the dreamy mood in this painting of Tahitian village life in *The Siesta* (1891–92). The women sit around chatting at siesta time. Their coloured dresses in are in pastel harmonies, accentuating their femininity.

■ **04** HISTORY AND CULTURE

The synthetic pigment mauve (mauveine) was the first aniline (synthetic dye) colour. It was created accidentally by teenage chemist, William Perkin in 1856. He was experimenting with the production of artificial quinine. He discovered that benzene extracted from tar produced a purplish colour. He explained: 'I was endeavouring to convert an artificial base into the natural alkaloid quinine but my experiment, instead of yielding the colourless quinine, gave a reddish powder. With a desire to understand this particular result, a different base of more simple construction was selected, namely aniline, and in this case obtained a perfectly black product. This was purified and dried and when digested with spirits of wine gave the mauve dye.' Perkin named it Tyrian purple to associate it with nobility but the fashion for 'mallow' – a natural mauve hue – was the height of style in Paris and the talk of London which led to his synthetic pigment being renamed mauveine or mauve.

Perkin patented the product, opened a dye works in London and began production in 1858. His success was truly established when Queen Victoria wore a mauveine-dyed dress at the International Exhibition in London in 1862.

■ **05** EXAMPLES

■ This retro abstract is reminiscent of the 1970s passion for clashing colours. The placement of dark blues next to deep orange shows how complementary colours side by side create visual impact. The delicate mauves soften the brash contrasts.

■ The orchid displays the natural hues of mauve. The colour of its petals is harmonized with veins in purplish pink. The stamens of yellow are complementary to mauve, a noticeable contrast colour aimed to attract insects to pollinate it.

■ Colour can be manipulated to create a sense of space and ambience. In the bedroom mauve walls create warm tones. The monochrome colour scheme of

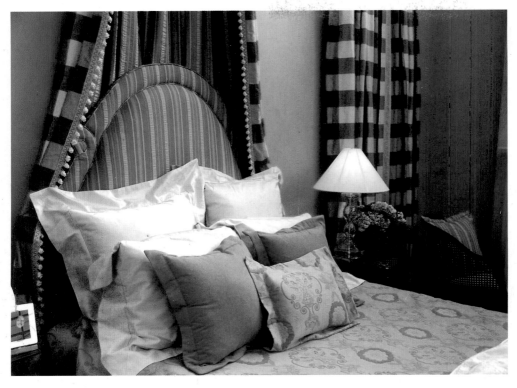

blues and mauves allows different pattern designs to create interest without overwhelming the colour scheme.

■ The plain black background accentuates the central logo. The mood is created through colour combination. The stronger tonal value of mauve shows its rich, warm hues, which visually stimulate the eye and create the focal point.

■ Claude Monet stayed in Pourville from July until October in 1882. In *The Shadows of the Sea: the Cliffs at Pourville* (1882), Monet uses tonal values of mauve to create a long deep shadow across the water. His use of pure pigment colours and quick brushstrokes captures the motion of the sea and light reflected on the water.

Colour Source Book

PINK

■ 01 DEFINITION

Pink is a softer, less-violent red. It is associated with babies, especially little girls. While red stirs up passion, studies have shown that large amounts of pink can create physical weakness in people, which is perhaps the reason for the colour's association with the so-called 'weaker' sex. Most people think of pink as a feminine, delicate colour.

■ 02 TECHNICAL INFORMATION

RGB Colour
R 255 G 192 B 203

CMYK Colour
C 0 M 28 Y 6 K 0

LAB Colour
L 86 A 31 B 7

HSB Colour
H 350 S 25 B 100

Hexadecimal **Pantone**
FFC0CB 176C

Closest Web-safe Colour
FFCCCC

■ 03 COMMON COLOUR COMBINATIONS

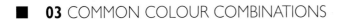

■ 04 HISTORY AND CULTURE

Pink is one of 11 basic colour terms in the English language. In the 1960s two anthropologists studied worldwide colour naming. Many languages had only two colour terms, one for light and one for dark, while English had the most: green, yellow, orange, red, white, black, blue, purple, grey, brown and pink. Pink is considered a colour of good health and life: we speak of people being 'in the pink' and when we are happy or content we are 'tickled pink'. It can also be a derogatory term: 'pink collar' is sometimes used to describe a female worker or someone who is low in the office hierarchy.

Both red and pink denote love, but while red is hot passion, pink is romantic and charming. Pink is used to convey playfulness (think hot pink flamingos) and tenderness (pastel pinks). In Japan, the colour pink serves two purposes. It can be used to show childish innocence, but is also associated with sexuality and is a popular colour that is used in sexual advertisements. Pink will also tranquillize: research suggested that pink makes people calm and soft-hearted.

■ 05 EXAMPLES

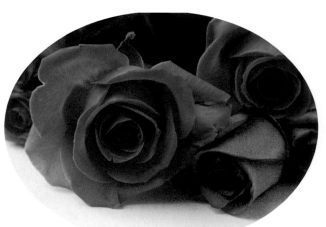

■ Pink is regarded by many as the colour of love and romance. Card and florists' shops become a sea of red and pink around Valentine's Day; pink flowers, particularly roses, are also a popular colour for wedding flowers and bouquets, as pictured here.

■ *The Pink Panther* first appeared in 1964 in the title sequence for the film of the same name. Drawn by Hollywood animator Friz Frelung, the pink cat was such a success that later that same year he appeared in his first solo cartoon, *The Pink Phink* (1964). Although he has not appeared in any new animations since 1980, the pink cat remains a distinctive film icon.

■ The breast-cancer awareness lobby has adopted the colour pink as its campaign colour. With its traditional female connections, this colour has become rapidly associated internationally with breast-cancer charities and fund-raising efforts. The pink ribbon and wrist band are two readily recognizable symbols of breast-cancer awareness.

■ In the world of fashion, pink made its first real impact in the 1950s, after the patriotic red, white and blue decade of the 1940s. In 1951 a fashion designer created 'hot pink', sparking a pink frenzy, as exemplified in this vintage 1950s dress. Since then, the colour pink has been present in fashion to varying degrees and is enjoying a resurgence in popularity in the current decade.

■ This Barbie website is targeted specifically at young girls. The heavy use of the colour pink, combined with the child-like graphics and fonts makes it appealing to children and further reinforces the association between girls and the colour pink.

PUCE

■ 01 DEFINITION

The name comes from the French *puce*, the word for a flea, which is derived from Latin *pulic*, *pulex*, for 'dark red'. Puce colour is associated with the blood-sucking insect and its hues are dark rose and brownish purple to purplish pink. The colour has warm rich tones, similar to maroon and closer to red more than blue in the spectrum of colours. A misnomer is that puce is green in colour; perhaps being confused with 'puke', the word for vomit. The colour symbolizes beauty, delicacy, charm and refinement.

■ 02 TECHNICAL INFORMATION

RGB Colour
R 204 G 136 B 153

CMYK Colour
C 5 M 52 Y 16 K 1

LAB Colour
L 67 A 36 B 6

HSB Colour
H 345 S 33 B 80

Hexadecimal **Pantone**
CC8899 701C

Closest Web-safe Colour
CC9999

■ 03 COMMON COLOUR COMBINATIONS

■ **04** HISTORY AND CULTURE

English usage of 'puce' dates from the 1780s. An edition of *The Lady's Magazine* in 1798 reports that a dress worn by Queen Charlotte on her birthday had a 'body and train of puce-coloured velvet'. It was an extremely popular colour during the Regency period. In 1805 the magazine forecast the fashionable colours for ladies' fashion, textiles and furnishings that year to be 'green, yellow, and puce'. In the April 1860 edition of *The Illustrated London News* it depicted the Paris fashions, including a dress of dark puce velvet, trimmed with silk. Puce was also fashionable as coloured pattern detail on English and European porcelain and china, including Chinese imports. The name, not the colour has dropped in popularity since the end of the nineteenth century but it continues to be used in the textile and fashion industry and as paint pigment for artists.

In the early 1970s the colour became highly fashionable once more as part of the Laura Ashley collection of floral print dresses. The fashion was for ankle length smock-style dresses evoking country maids and pastoral pursuits, even in the city. Pretty colours such as puce, celadon, sapphire, maroon and powder blue were printed on cotton fabrics, to make clothing and linens and many accessories.

■ **05** EXAMPLES

■ Colourful beach houses in muted tones of yellow and blue are placed either side of rose pink and puce huts. The yellow-blue primaries harmonize with sea, sand, sun and blue sky. The reddish-pink tones of colour create contrast and vibrancy. Plain wood huts on an English seafront might prove dull; colour brightens and enlivens the scenery, whatever the weather.

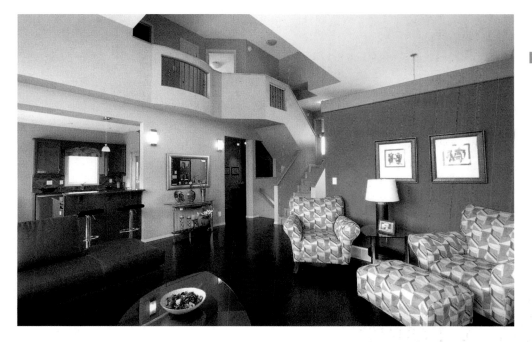

■ A large open-plan living area with dark-wood flooring could create a cold atmosphere, but the use of puce colour on one wall and a toning puce-coloured sofa adds warmth and colour to the room setting. It draws together the room space and accents the neutral furnishings.

■ Porcelain and china tea sets in decorative floral patterns were popular in the eighteenth century. Neutral white backgrounds were printed with delicate sprigs of pretty flowers and leaves. Popular colour patterns were in puce and celadon or blue and white.

■ The small redbud tree is also known as the Judas tree, because it is thought that this was the type of tree from which Judas Iscariot hanged himself. Originating in the Eastern Mediterranean, it has blossom of vibrant puce-coloured purplish-red flowers.

ROSE

■ 01 DEFINITION

The colour identifies with the bush or climbing plant of the *Rosa* genus, which produces beautiful roses in multifarious shades. Leon Battista Alberti defined its colour in *Della Pittura*, 'We see some roses which are quite purple and others like the cheeks of young girls'. It is a pure chroma hue, between red and magenta on the colour wheel. Rosewood, rose water and rose diamonds all have rose hues. It has many associations, for example, 'rose-tinted glasses'. In the 1750s the Sèvres porcelain factory created rose-coloured porcelain 'Rose de Pompadour' in honour of Madame de Pompadour, the French king's mistress.

■ 02 TECHNICAL INFORMATION

RGB Colour
R 255 G 0 B 127

CMYK Colour
C 0 M 70 Y 21 K 0

LAB Colour
L 64 A 93 B 17

HSB Colour
H 330 S 100 B 100

Hexadecimal **Pantone**
FF007F 812 C

Closest Web-safe Colour
FF0066

■ 03 COMMON COLOUR COMBINATIONS

■ **04** HISTORY AND CULTURE

Rose madder, known as madder pink and madder lake, is a transparent red pigment, which is made from the root of the madder plant, *Rubia tinctorium*. It is a wild plant prominent in the Northern Mediterranean. In Greece, lumps of rose madder have been found in Athens and Corinth, dating to the second century BC, possibly used as a colorant for textiles and pottery. It was cultivated in Italy, France, the Levant and Switzerland. England's source may have been Zealand, through the Netherlands. Traces of rose madder have been found on Anglo-Scandinavian textiles from the tenth and eleventh centuries in York, England. It was a popular colour in medieval France and Italy, both for artists and as a dyestuff for fabrics.

It is now produced synthetically but was originally formulated by mixing dyeing chalk with boiled brazil wood (which produces a blood-red extract) and alum. In *Il Libro dell'Arte (The Craftsman's Handbook)*, Cennino Cennini gives his recipe: 'Take a pound of kermes [cochineal] and a little brazil [brazil wood]; cook them together with lye and a little rock alum; and when you boil it you will see that it is a perfect crimson colour'. Rose madder is a weaker grade of alizarin crimson.

■ **05** EXAMPLES

■ Tonal hues of rose pink harmonize the window setting. The spectator is visually drawn to the rose-painted shutters. Rose-tinted geraniums fill the contrasting terracotta containers on the window ledge. Bright-rose gingham curtains lift the window space.

■ The juxtaposition of greenish-yellow, blue-orange and rose-coloured lustre bowls placed together highlights the theory of using complementary colours next to each other: opposites in the colour spectrum create a visual intensity of warm and cool tones.

■ The flower is synonymous with an English rose garden where the heady scent of roses fills the air. A bouquet of roses is a symbol of love and romance Pink crimson roses express passion, while rose pink connotes everlasting love and white signifies purity.

■ The album graphic uses a neutral background to splash hues of rose from crimson-rose pink and purples to muted rose-brown. The title name is printed in pale rose pink. *The Rose of Shiraz* alludes to a beautiful girl from Iran.

Troyer
Rose de Shiraz

■ Tonal shades of rose add warmth to the contrasting pattern colours used in the window design. A 'rose window' is a circular window of stained glass filled with ornamental tracery. The name is taken from the shape of the rose flower.

Colour Source Book

CERISE

■ 01 DEFINITION

Cerise is a light, clear cherry red. Its meaning is taken from the French word *cerise*, derived from the Greek *kerasion* and the Latin *cerasus*, meaning 'cherry'. Produced in 1858, as a cherry red it has since changed to a bluish-red colour with a complementary of green. It is analogous to greyish rose and ruby red. Cherries are a summer fruit, which have a deep-red to purple-red colouring. The small beries are vividly bright, leading to expressions alluding to the colour, such as 'cherry red'. The name 'cerise' is used in fashion as a more glamourous alternative to 'cherry'.

■ 02 TECHNICAL INFORMATION

RGB Colour
R 222 G 49 B 99

CMYK Colour
C 0 M 81 Y 39 K 0

LAB Colour
L 57 A 78 B 25

HSB Colour
H 343 S 78 B 87

Hexadecimal **Pantone**
DE3163 1787C

Closest Web-safe Colour
CC3366

■ 03 COMMON COLOUR COMBINATIONS

■ **04** HISTORY AND CULTURE

Cherry red, or cerise, is a colour associated with Hollywood glamour. It was made popular in the 1940s by MGM and Paramount starlets. Post Second World War, the film American film industry utilized young film actresses to add glamour and promote cinema going. The female stars' clothing on and off set was colourful, using luxurious fabrics in bright colours, such as cerise, magenta and crimson. At home most young women still made their own clothing and chose fabric colours to imitate their on-screen favourites such as Rosalind Russell, Veronica Lake, Joan Crawford and Ginger Rogers, who define the era.

The colour proved popular in the 1950s in Britain and was one of the key colours used to create The Festival of Britain showcase in London in 1952; a celebration of the best of British design. New

materials, such as plastic were gaining in popularity, and provided a cheaper alternative to wood for products from moulded chairs to bathroom fittings. Colour was uppermost in designers' minds. The days of worrying over the correct shade of beige or green were over; hot magenta, cherry red, cerise and every vivid shade were used to boost sales and get consumers into the shops, to revive the post-war economy.

■ **05** EXAMPLES

■ Magnolia buds blossom in late April and May, a sign of warmer weather and longer days. This variety in a delicate cerise is contrasted by nature's own palette of bright-green leaves, young shoots and brown branches.

■ Opposites attract when tertiaries of cerise and jade meet. The bright reddish pink complements the green base and both colours stand out on equal terms. The combination may evoke the heat of the

tropics or the culture of the Orient. The colours evoke the paintings of twentieth-century artists, such as Georges Braque, Ernst Ludwig Kirchner (1880–1938) and Andy Warhol.

■ Cerise-on-cerise is vividly bright, just right for a north-facing room to connote heat and light. Choose a lighter tone for walls or just a few accent pieces in cerise, in lampshades or cushions, to echo the walls.

■ The first moulded plastic chairs to be mass-produced were designed by Charles and Ray Eames in 1948. The colour was bright red. Shiny chairs in cerise are a 'welcome' sign. The strong bold colour will cheer up any setting, inside or out. Cerise hues of purple reddish pink allow a wide range of contrasting and analogous colours to be combined with it.

MAGENTA

■ 01 DEFINITION

Magenta (*fuchsin*) is a warm colour of bright violet-red. It was first produced as an aniline dye in 1859. It has a green-bronze surface, which tones to red. On the colour wheel it sits between bluish red and purple. It will warm any blue and cool any yellow. It is the basic red in CMYK four-colour printing; on the process wheel it sits between red-violet-red and red; and on the light wheel it sits between blue and red. Its complementary colour is green. Most greys contain magenta. The Victorian garden designer Gertrude Jekyll called it 'malignant magenta', to show her abhorrence of industrial colours becoming fashionable in horticulture. The colour is a symbol of passion, energy and vitality.

■ 02 TECHNICAL INFORMATION

RGB Colour
R 255 G 0 B 255

CMYK Colour
C 21 M 56 Y 0 K 0

LAB Colour
L 68 A 101 B -51

HSB Colour
H 300 S 100 B 100

Hexadecimal **Pantone**
FF00FF 807C

Closest Web-safe Colour
FF00FF

■ 03 COMMON COLOUR COMBINATIONS

■ **04** HISTORY AND CULTURE

Two different aniline dyes were created by different chemists (at the same time, but independently) to create the colour magenta. One aniline type, formulated by Simpson, Nicholson and Maule, a London company, named their product after the Battle of Magenta, in Northern Italy in 1859. Its name is an allusion to it. The other aniline composition was formulated by the Frenchman E. Verguin in 1858–59; the chemical compound was called *fuchsin* as he had linked its colour to the fuchsia flower. The bright violet-red is sometimes referred to as fuchsia. Magenta eventually became more

popular than aniline mauve because it was cheaper. The only difficulty was that it was not fast in light and was not suitable for fresco paintings due to its reaction to alkali.

Magenta was favoured by the Impressionists; its colour alluding to hot sun and summer days outdoors to capture the frisson of life in late nineteenth-century Paris. *In Open Window, Collioure* (1905), Henri Matisse captured the sensation of colour in bright magenta, sea green, jade, yellows, greens and blues, and the spirit of the port harbour from his open window. He stated that sky was not necessarily blue. He did not paint what he viewed as a depiction of reality; he painted the sensation of what he experienced.

■ **05** EXAMPLES

■ The hot-pink chair colour has the tonal values of magenta's purple-red undertones. It adds to the modernity of the chair's simple shape and design. Magenta as an accent colour can brighten and warm a neutral room interior.

■ The electric hues of violet-red magenta and fiery orange, both warm tones, are perfect for candle lamps. Cooler white contrasts and creates a pleasing colour group of bright, sharp shapes. Candle light will highlight the warmth of magenta.

■ The vivid pink waterlily (*nymphaea*) captures the essence of magenta hue. The colour, reminiscent of high summer, ties in with the aquatic plant's southern-hemisphere origins. Claude Monet used magenta's violet-red to replicate the water lilies in his garden.

■ The magenta colour gives a psychedelic quality to the layered graphic pattern. Small circles of silver-grey and greyish black break up the square shapes to complement the dominating reddish-violet hues. Grey and magenta work well together as a colour combination.

■ There is a feel of the 1960s in this pattern of reds, pinks and purples. Small splashes of bright green complement the flowery textile pattern of magenta with hues of red and pink. The warm tones reflect the heat of the tropics.

AMARANTH

■ 01 DEFINITION

Amaranth, the Greek word for 'unfading', is part of the genus *Amaranthus*, the pigweed family of herbs, vines and trees. It is a deep reddish purple to dark-greyish purple-red. One variety 'Love Lies Bleeding' is so-called from its deep blood-red colour, reddish flower heads and tinted leaves and stems. The pigment, which is permanent, was available from 1690. The density of colour saturation and greyish tint makes it a colour to harmonize with all shades of grey to black. Amaranth is symbolic of eternity, immortality and everlasting love. Variations of this name are amaranth rose or amaranth purple.

■ 02 TECHNICAL INFORMATION

RGB Colour

R 229 G 43 B 80

CMYK Colour

C 0 M 79 Y 53 K 0

LAB Colour

L 58 A 81 B 38

HSB Colour

H 348 S 81 B 90

Hexadecimal **Pantone**

E52B50 Red 032C

Closest Web-safe Colour

CC3366

■ 03 COMMON COLOUR COMBINATIONS

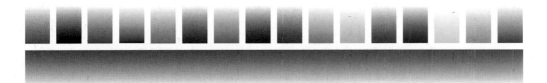

■ **04** HISTORY AND CULTURE

Amaranth takes its name and colour from a varied plant species, one of which is an edible plant. The seeds are milled and toasted. The green leaves can be boiled as vegetables. Grown in Africa, the Americas and known in Asia and Mediterranean Europe in ancient times, amaranth was sacred to the goddess Artemis and a symbol of immortality in ancient Greece, where it decorated temples and tombs and sacred places. It was believed that the plants had herbal powers, beneficial to healing. The plants that have reddish leaves and stems were used for magic rituals and ceremonial occasions; the leaf still retaining its colour after withering. In regions of India the traditional bride wears a vivid red sari, such as the colour of amaranth mixed with white. The colour has returned regularly as a colour of high fashion.

In 1950s Britain the Teddy Boy (and Girl) fashion for teenagers included luminescent shirts, dresses and accessories in amaranth, lime, orange and citrus lemon; it made a reappearance in the 1960s as the one of the psychedelic colours including lime green, citrus yellow, shocking pink and purple; colours that matched the music of the period.

■ **05** EXAMPLES

■ Warm and cool tertiary colours are mixed together in a stack of napkins. Amaranth is a contrast to lime and bright yellow. Colours of shocking pink and cobalt blue harmonize with amaranth. The stack is reminiscent of the colour palette of Post-Impressionist French artists nicknamed the Fauves (wild beasts). The paintings were filled with vibrant reds, limes, yellows, blues and greens.

■ Waterlilies reflect the sunrays from the water which surrounds them. The rich reddish-pink petals of the beautiful flower are amaranth in tone. The orange-pink stamens at its core reveal a natural colour combination of warm hues.

■ A dodecahedral pattern in amaranth is accented with gold and warm brown. It shows the colour's ability to combine with different tertiaries. The result is visually pleasing. The muted colour combination contrasts with the vibrancy that amaranth brings to hotter pinks and purples.

■ Chairs in amaranth, with additional mauve and dark-blue fittings, will lift the atmosphere in an auditorium. Bright warm colours set the tone. Reds are used to invigorate and stimulate. Amaranth is a good colour choice for seating at public events.

■ In the late 1960s and early 1970s Op Art was fashionable, defined by the illusory optical paintings of Bridget Riley (b. 1931). It was reflected in fashion and furnishing textiles too. This pattern in circles of amaranth and cream reflects the craze for optics.

ALIZARIN

■ 01 DEFINITION

Alizarin, pronounced uh-lih-zuh-ruhn, is a natural pigment extracted from the madder plant. The word may be a form of the Arabic *al usara*, meaning juice extract. It contains two distinct dyes: a fiery-orange *purpurin* and bluish-red *alizarin*. The colour created is a fluorescent orange-red that dominates any other colour placed near it. It is a bright, primitive colour, an attention-seeking red, hot and zingy. It is a strong dye to be added sparingly to other pigments. 'Madder lake' is the expression used when binding a natural-pigment dye, such as alizarin, to a white-powder base.

■ 02 TECHNICAL INFORMATION

RGB Colour
R 227 G 38 B 54

CMYK Colour
C 0 M 81 Y 73 K 0

LAB Colour
L 57 A 80 B 53

HSB Colour
H 355 S 83 B 89

Hexadecimal **Pantone**
E32636 Warm Red C

Closest Web-safe Colour
CC3333

■ 03 COMMON COLOUR COMBINATIONS

■ **04** HISTORY AND CULTURE

Alizarin is extracted from the roots of *Rubia tinctorium* and *Rubia peregrine*. Wild-plant varieties grow in the Mediterranean region. Roots of the madder plant are dried and crushed before boiling in a weak-strength acid to dissolve and ferment the dye. Since 1,500 BC it has been in use as a dyestuff in Central Asia and Egypt. Cloth dyed with madder-root pigment was found in the tomb of the Pharaoh Tutankhamen. Pliny the Elder in *Naturalis Historia*, describes Alizarin as madder, having a stem of five leaves and red seeds. (Book 19, chapter 17). Fragments of madder pigment have been found in ancient Corinth and Pompeii.

In the nineteenth century, rising textile sales increased the search for synthetic dyestuffs. In 1868 two German chemists, Carl Graebe and Carl Lieberman, produced a synthetic alizarin pigment (synthetic madder) from the coal-tar product anthracine. It was the first dyestuff to be reproduced in this manner and to substitute a natural vegetable dye. Its popularity led to the decline of the madder-growing industry. William Perkin also synthesized it at about the same period, but independently of the German team. Alizarin when mixed with some pigments, such as ochre and burnt umber, can lose its permanence. Manipulation of the chemicals can achieve hues from ruby to scarlet.

■ **05** EXAMPLES

■ Nature creates vibrant red flowers and berries to attract birds, bees, butterflies and other insects, which will help to propagate the flower and sustain existence. Bees can distinguish red from other reddish, long-wavelength colours such orange and yellow. The complementary-coloured yellow-green core draws insects to them.

■ Alizarin-red furniture will brighten a room and create a strong statement. The modular shape of the matching sofas highlights the singular vibrant colour. Neutral flooring and subtle-furnishing accessories will complement and enhance the red focal point.

■ Residents of the tiny island of Burano in the Venetian lagoon use colour to brighten house doors, windows and exterior walls. Fiery alizarin-coloured walls harmonize with the warm-orange tones next door but the powerful red dominates the multicoloured row.

■ Alizarin-red evokes feelings of vitality, warmth, heat and fun. Bright-red mittens will attract attention and be easier not to lose; perfect for toboggan rides in icy weather or instant hand-warmers for cold wintry days.

■ Chunky red-glazed cups and saucers add visual warmth to the colour scheme of red and white. The inner-white bowl offsets the primary colour. A set of bold red chinaware can lift the monotones of a neutral kitchen space.

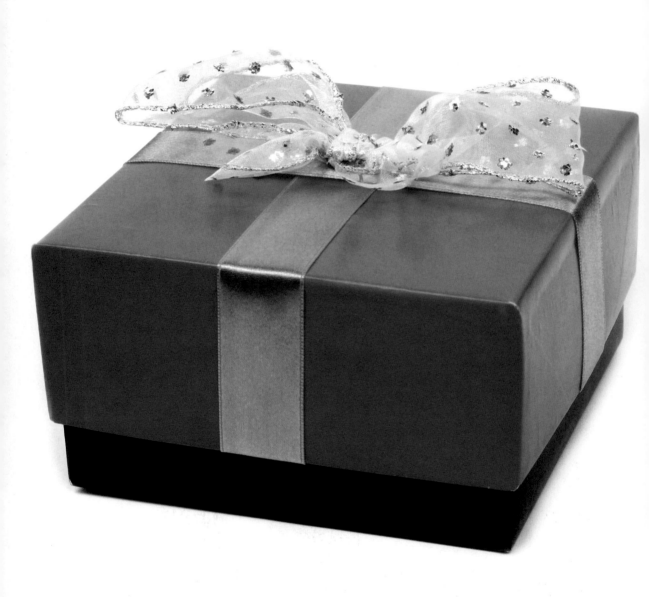

Colour Source Book



FUCHSIA

■ 01 DEFINITION

Fuchsia is a warm colour. Walls painted in fuchsia will dominate a room interior. The colour adds drama, excitement and a sense of decadence. Used as an accent colour it draws the eye to it. Fuchsia sits between cardinal and alizarin crimson on the colour wheel. The name is associated with the pendulous tubular flower, which is usually bicoloured, having petals of one hue and tube and sepals of another. The tropical colour symbolizes extreme happiness and romance; cheerfulness, excitement, harmony and joy. The colour's negative traits include eccentricity, a hot temper and the artificial.

■ 02 TECHNICAL INFORMATION

RGB Colour
R 255 G 0 B 255

CMYK Colour
C 21 M 56 Y 0 K 0

LAB Colour
L 68 A 101 B -51

HSB Colour
H 300 S 100 B 100

Hexadecimal **Pantone**
FF00FF 807C

Closest Web-safe Colour
FF00FF

■ 03 COMMON COLOUR COMBINATIONS

■ **04** HISTORY AND CULTURE

The South American *onagraceae*, (the evening primrose family) genus *Fuchsia* was posthumously named after Leonard Fuchs a German botanist, physician and professor of medicine. Fuch's is recognized for having produced perhaps the first scientific description of plants. His work *De historia stirpium commentarii* (1542), published in Basle and known as Fuch's Botany, is a classic work of botanical literature. The intensity of its hues is associated with hot climates.

Fuchsia-flower colours were used extensively by the Fauves, a group of friends including Henri Matisse and Maurice de Vlaminck (1876–1958), to replicate the movement of colour. The paintings were not well received when exhibited in Paris at the Salon d'Automne in 1905; art critics referred to the paintings of 'wild beasts' and the room where they were exhibited as 'a cage'. The vibrancy of fuchsia and its analogous colours alizarin crimson to cardinal were mixed with clashing complementary colours, for example in *The Pink Studio* (1911) by Matisse.

In 1950s America the growth of the pop-music industry instigated a craze for bright colours, including fuchsia-coloured Cadillacs. England copied the craze and British singers, such as Cliff Richard wore fuchsia-coloured jackets (or fluorescent lime or green), with black shirts and trousers, copying the American pop idol Elvis Presley. Female fans wore fuchsia lipstick.

■ **05** EXAMPLES

■ The genus of *Fuchsia* has 119 varieties of evergreen shrubs and small trees. Flower heads bloom in summer in a variety of colour combinations. The variety 'Dollar Princess' has pendulous double flowers: cerise-red tubes and sepals and purplish-pink petals. The natural colour combination shows how pinks, purples and reds work together.

■ Iridescent mugs are reminiscent of the 1950s love of luminous clothes, accessories, furnishings and make-up. Multi-hued glazes create a contemporary look using contrast colours.

■ The tonal range of fuchsia has been used by the graffiti artist. Black irregular lines separate the tonal values. Fuchsia's red-blue combination is evident in the pinkish-purple colours.

■ One piece of furniture in the right colour can set the atmosphere. Fuchsia is a colour of sensation; one feels its presence. It is a mood colour, hot, sultry and driven by style. The wall colour in cyan accents the sofa colour creating a fresh, stylish setting in a neutral corner.

■ Maurice de Vlaminck was one of the group of artists referred to as Fauve, 'wild beast', for his use of vivid colours that clash and vibrate. In *Kitchen Interior* (1905) he portrays the sensation of being in the kitchen rather than the reality of it. He uses fuchsia to light the window frames with carmine floors and teal, turquoise and aquamarine walls and furnishings, to recreate a vibrant busy kitchen interior.

Colour Source Book

CARDINAL

■ 01 DEFINITION

Cardinal appeared as a colour reference in 1698. Etymology of the word shows that it derives from Latin *cardo*, 'hinge'. Many definitions do not relate to the pigment colour. For example, a 'cardinal rule' is one that needs to be followed; everything hinges on it. In Christian teaching, 'cardinal sins' are seven deadly vices. The four cardinal points of Earth are north, south, east and west. The word has its strongest associations with the colour red, particularly in relation to a cardinal of the Catholic Church, who wears brilliant-red vestments The English usage after 1889, refers to the red wardrobe of a cardinal.

■ 02 TECHNICAL INFORMATION

RGB Colour
R 196 G 30 B 58

CMYK Colour
C 1 M 94 Y 76 K 1

LAB Colour
L 50 A 73 B 40

HSB Colour
H 350 S 85 B 77

Hexadecimal **Pantone**
C41E3A 185C

Closest Web-safe Colour
CC3333

■ 03 COMMON COLOUR COMBINATIONS

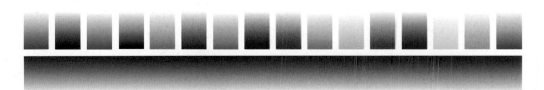

■ 04 HISTORY AND CULTURE

In the earliest portrayals of the Virgin Mary, a cardinal red was quite often the colour used for the robes of the Madonna, until blue became the more popular symbol. In Chapter XLII of *Il Libro dell' Arte (The Craftsman's Handbook)*, Cennino Cennini's treatise on painting, he wrote of a colour red called hematite: 'The pure stone is the colour of purple … and has a structure like vermilion…. This colour is good on a wall, for working in fresco; and makes a colour for you like a cardinal's purple …'. Later in 1464 when Paul II was anointed pope, he sanctioned the use of a strong red, made from *kermes* (a blood-dye extract from the dried Kermes insect, which were boiled in a bag for 45 minutes) and known as 'Cardinal's Purple', a scarlet-crimson red, for vestments.

In the natural world, the cardinal bird has distinctive red plumage; its family name *Cardinalidae* denotes the colour. An iridescent fish Cardinal Tetra, (*Paracheirodon axelrodi*) has body colour divided into silver and red. In Britain, cardinal floor polish is a household product for staining stone floors bright red.

■ 05 EXAMPLES

■ These worn-in boots will have made an impact wherever they travelled. Red boots are a favourite with rock stars perhaps to denote difference. When Cardinal Ratzinger became Pope Benedict XVI, in 2005 he showed his love of fashion by wearing red loafers by Prada, under his ceremonial clothes.

■ Buildings in red stone are native to Britain because of the colour pigment of base material taken from quarries. Buildings painted in red are seen, in profusion, in hotter climates, particularly in the Mediterranean and the Southern hemisphere, as well as in locations such as Greece or Cuba, the Virgin Islands and Mexico.

■ The cardinal bird (*Cardinalis cardinalis*) is so-named because of its striking red plumage. It uses its colour to attract the female, which is brown with a cardinal-red beak. The northern cardinal, native to North America, is seen here in the depths of winter; his bright hue contrasting with freshly fallen snow.

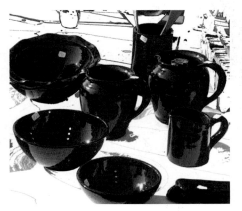

■ Ceramics in cardinal red will always be noticed. The colour is fiery, particularly when set against a white background. It captures the eye's focus and plans to shock. It is a theatrical colour which evokes dynamism, style and taste. To create an exotic feel, combine it with intense orange and pink.

■ Renaissance artist Raphael Sanzio (1483–1520) in his *Portrait of a Cardinal* (1510–12) portrays a young cardinal seated, wearing the symbol of his office, cardinal-red vestments. The rich-red colour is foremost in the painting, a representation of the authoritative status of the cardinal's role, rather than the sitter.

Colour Source Book

BURGUNDY

■ 01 DEFINITION

The name is taken from the wine of the same name produced in the French district of Burgundy. It was introduced as a synthetic colour pigment in 1915 and it has reddish-purple hues from dark greyish-purple to very dark purplish-red, a compound of cadmium red and cobalt blue. Analogous hues range from maroon to purple with a complementary of forest green. Burgundy is a good corporate colour that alludes to sophistication and official business, with a hint of powerful undertone. It is a strong colour and combines well with forest green, dark olive, cream and navy blue.

■ 02 TECHNICAL INFORMATION

RGB Colour
R 144 G 0 B 32

CMYK Colour
C 8 M 93 Y 87 K 21

LAB Colour
L 36 A 60 B 39

HSB Colour
H 347 S 100 B 56

Hexadecimal **Pantone**
900020 1805C

Closest Web-safe Colour
990033

■ 03 COMMON COLOUR COMBINATIONS

■ **04** HISTORY AND CULTURE

The colour has ancient associations. The pre-historic cave paintings in Tajikistan in the Shakhty Cave show figures painted in brick red with wine-red detail. The colours are made from a ferriferous compound mixed with fat. Heating turns the ferric-oxide compound into red or reddish-brown pigment. The burgundy colour is synonymous with the Burgundy region of France, which produces wines in hues from rich ruby to deep reddish purple, hence the colour name. There is not one particular red wine called Burgundy but at least 90 varieties grown in the region.

Two late-fourteenth century Valois Dukes of Burgundy, Philip II known as Philip the Bold and his son John the Fearless, were both patrons of the arts. During their reigns they succeeded in attracting many artists to their court at Dijon, notably the Limbourg Brothers (*c.* 1400), Henri Bellechose (*c.* 1415–40) and Claus de Werve (*c.* 1380–1439). Artists and artisans were set to work to produce paintings, illuminated manuscripts, sculptures, silverwork, tapestries and jewellery. It became known as the 'Burgundian Court style'. A paint pigment close in hue to Burgundy, called 'Wine Red', was in production *c.* 1700.

■ **05** EXAMPLES

■ The beauty of a rose is displayed in this burgundy-coloured flower. Rich, glowing purple-tinged red roses are synonymous with everlasting love. They are a traditional flower colour for a ruby wedding anniversary, to celebrate 40 years of marriage.

■ A pagoda-style roof line and rich burgundy paint colour accentuate the striking architecture. A monochrome colour used in this way, adds warmth to the design, while not detracting from the building's exterior features.

■ The luminosity of the burgundy-coloured vase highlights the dark purplish-red hues in its glass.

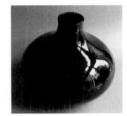

The simplicity of the design creates more awareness of the rich colour. The variant tones are shown in the light, ranging from deep purple-red to rich red wine.

■ The rich full-bodied hues of burgundy have been achieved in the wool dye, perfect for a chunky hand-knit sweater to brighten up a cold wintry day.

Burgundy red suggests Christmas, firesides, glasses of rich red wine; the colour perhaps accentuated by the presence of a pine-green tree, its complementary colour.

■ Amedeo Modigliani (1884-1920) said, 'to paint a woman is to possess her'. Here he creates an intimate scene, which the viewer is invited to witness. A naked woman

sits on a burgundy-coloured sofa. Her skin is delicately translucent and its pale colour is accentuated by the rich red burgundy background. The warm tones highlight her shape. In *Large Seated Nude* (1920) Modigliani paints her lips with a burgundy shade of lipstick to triangulate foreground and background with her face and body.

■ CARMINE

■ 01 DEFINITION

Carmine is a rich crimson known also as the pigment crimson lake. It is a carminic acid compound, extracted from dried cochineal. The word relates to the French *carmin*, evolved from the Arabic *kermes*. It has the tense red-blue tones of blood. Recipes for its manufacture were published from 1656 and it was known as jack rose (Maerz and Paul), crimson pink (Martin-Senour) and crimson (Webster). It is a similar hue to Winsor red deep (Winsor and Newton). It ranges from vivid red to purplish red and has transparency.

■ 02 TECHNICAL INFORMATION

RGB Colour
R 150 G 0 B 24

CMYK Colour
C 6 M 92 Y 92 K 19

LAB Colour
L 37 A 61 B 46

HSB Colour
H 350 S 100 B 59

Hexadecimal **Pantone**
960018 180C

Closest Web-safe Colour
990000

■ 03 COMMON COLOUR COMBINATIONS

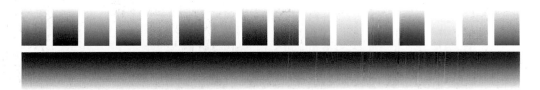

■ **04** HISTORY AND CULTURE

The pigment name is alizarin crimson, a transparent bright red. The natural dye colour is perfect for yarns, wools, fibres and textiles. Its 'raw' material is cochineal, created from the blood of crushed female bugs, and it is farmed today in Spain and South America. The favoured method is to infest prickly pear cacti with the cochineal parasite, wait until it has fed well on the plant and when swollen harvest it. At this point the insect looks like a small piece of cotton wool but when crushed produces an intense blood-red stain. The Aztecs used carmine for paint, cosmetics and to dye textiles. Carmine is the E additive in cosmetics and foodstuffs. The Aztecs' Spanish conquerors brought it to Europe in the sixteenth century.

In Britain after the Second World War, rationing of everyday products from food to clothes and cars continued until the early 1950s. The colour gained popularity in the fashions of the 1950s when, post-rationing, the dull fabrics and colours of the war-years were swept away to be replaced by the 'New Look' and wonderfully rich colours for furnishings, clothes, lipsticks, scooters and cars. Bright-red carmine lipsticks and the Mini car in bright red evoke the period.

■ **05** EXAMPLES

■ Chinese red is carmine in tone and intensity. A brass butterfly holds together red-lacquered doors. Delicate butterflies and flower heads are painted on the doors' surface to harmonize the design and lighten the rich red tones.

■ Red and green primaries are used in one design where a blood-red carmine outer coating with emerald-green interior contrasts with a cup and saucer in pale yellow and brown tones. A reflective table surface mirrors the ceramics and adds depth of hue.

The peacock butterfly takes its name from the 'eyes' on its wings, which resemble the 'eyes' on a peacock's fantail. The carmine of its variegated wings tones in with the rust-red furry body. Upper and lower wings each have a pair of 'eyes' to ward off predators.

■ Monochrome greys, black and white need an accent colour to liven a room setting. Carmine cushions create a visual focal point and divert attention from the simple furniture and blank walls. A white ceramic vase with tall dried flowers accentuates room height.

■ *The Running Man*, also known as *The Peasant between Cross and Sword*, was painted 1932–34 by Ukrainian-born artist Kasimir Malevich (1878–1935) during the period of the great famine in the Ukraine when millions of people, mostly peasants, died. In this haunting work a man in the forefront runs quickly along a road, his feet blackened. He is depicted between a blood-red cross and blood-tipped sword. Is it the choice he must make? The bright-blue background brings to the forefront the symbolic colours of blood-red carmine, regenerative green and the purity of white.

<div style="writing-mode: vertical">CARMINE</div>

■ MAROON

■ 01 DEFINITION

Maroon takes its colour from the Italian word *marrone* or in French *marron* meaning chestnut. On the colour wheel it sits between mahogany and ochre. It is a compound of purple and brown, which creates a brownish-red hue, a dark and intense shade. It is linked to 'Indian Red' which is a pigment of iron oxide producing a brownish-red colour. The colour-word has no association with the word 'maroon', meaning to abandon or leave a person behind as punishment, nor any connection with the explosive device which makes a loud bang. The colour is associated with emotional mood: lament, tragedy, ecstacy.

■ 02 TECHNICAL INFORMATION

RGB Colour
R 128 G 0 B 0

CMYK Colour
C 11 M 89 Y 93 K 31

LAB Colour
L 31 A 55 B 46

HSB Colour
H 0 S 100 B 50

Hexadecimal **Pantone**
800000 484C

Closest Web-safe Colour
990000

■ 03 COMMON COLOUR COMBINATIONS

■ 04 HISTORY AND CULTURE

The word 'maroon', to denote colour, entered the English vocabulary in the 1790s. The colour was fashionable in Paris, which created a demand for the dyestuff to produce textiles for furnishings and clothing in England. The colour reappears in fashion on a regular basis. In the 1990s the popularity of the anti-fashion 'grunge' style, taken from the music-industry promotion of grunge music, brought muted, darker colours to the forefront. Maroon, indigo and earth browns and greens fitted the carefully constructed 'non-fashion' look.

In art the later paintings of the American artist Mark Rothko (1903–70) used horizontal blocks of maroon colour. Tate Modern's collection includes nine paintings from a series he made in the 1950s, originally destined for the Four Seasons restaurant in the Seagram building, New York. The intensity of colour saturation in the series *Black on Maroon* (1958–59) and *Red on Maroon* (1959) impart the mood of its hues. Rothko used sensational colours such as maroon, to draw the spectator in; to create an experience of the 'sublime'. He wanted to engage each person on an emotional level, so that they felt they were the subject of the painting. The paintings show the power of the colour to hold the viewer's attention.

■ 05 EXAMPLES

■ Red-brown wood, similar in colour to maroon, has been crafted to make a chopsticks set. The hues of the wood imitate the colour pigment. Japanese chopsticks are normally made of lacquered wood or bamboo, while Chinese are in raw wood or bamboo.

■ Tonal values of maroon are revealed by light through leaf foliage, showing the reddish undertone of its compound colours. Fall in New England, USA, is renowned for the hue of the tree leaves: browns and maroon, yellows and red, which create stunning scenery.

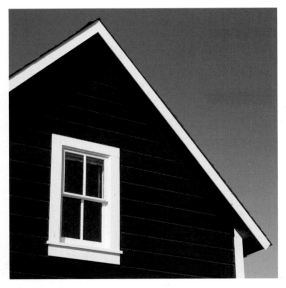

■ A clapperboard house is a Colonial style, which may have a cool porch and a white picket fence. Maroon paint gives a smart, fresh look and emulates a warm wood tone. White contrasts the colour and highlights the decorative roof design.

■ Maroon is a suitable colour for interior and exterior decoration. Neutral interior walls can be warmed up with textured maroon furnishings and fabrics, carpets or shag-pile rugs. It is a subtle colour, both tasteful and chic.

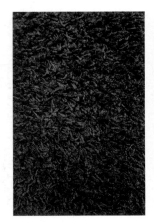

■ The Victorians loved maroon as a wall colour and it continues to be popular. In this dining room maroon harmonizes with the mahogany table and chairs and offsets the central flower arrangement of cream and maroon, which add richness to the setting.

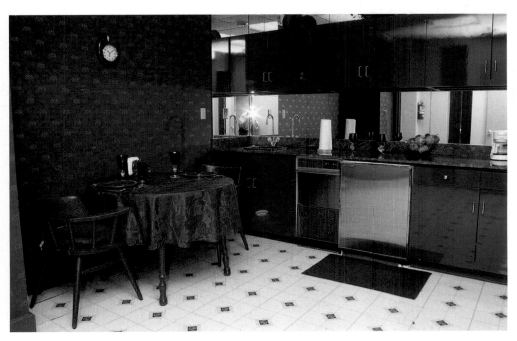

■ CRIMSON

■ 01 DEFINITION

The word 'crimson' is from the Spanish *cremesin* and Arabic *qirmizi*, a dye made from a Mediterranean insect, *kermes*. Its hue is between maroon and scarlet. Crimson is linked to the face, cheeks and ears. The colour produces a sensation of passion and adventure, a Ferrari sports cars and Marilyn Monroe's lips. It can allude to crimes of passion, secret liaisons and lacy underwear. Crimson skies are a warning of bad weather in the Northern hemisphere but in the tropics means scorching days turning into balmy evenings with a crimson sunset. Santa Claus' outfit and Red Riding Hood's cloak also have strong associations with crimson.

■ 02 TECHNICAL INFORMATION

RGB Colour
R 220 G 20 B 60

CMYK Colour
C 0 M 86 Y 70 K 0

LAB Colour
L 55 A 81 B 47

HSB Colour
H 348 S 91 B 86

Hexadecimal **Pantone**
DC143C 1788C

Closest Web-safe Colour
CC0033

■ 03 COMMON COLOUR COMBINATIONS

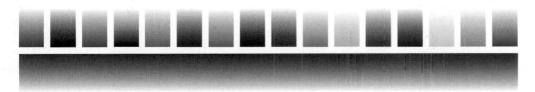

■ **04** HISTORY AND CULTURE

In ancient times one of the best sources for crimson colour was *kermes*, a dyestuff. The colouring matter is kermesic acid. *Kermes* is an Arabic word for a crimson-coloured wingless insect, which inhabited certain oak trees. The female insects were extracted from their habitat in live oak trees and crushed to produce the *kermes vermilio* when dried. The effect was similar to the crushing of cochineal insects for carmine. Kermes lost popularity because the insect for cochineal was larger and produced more blood to create the dyestuff, so making it less expensive. Crimson was used extensively in the Middle Ages, particularly in Italy for fabric dye. It was the foremost dye for scarlet cloth and the most expensive. Crimson was used by the Spanish artist Velásquez. In his famous *Portrait of Pope Innocent X*, 1650) he shows the pope wearing a crimson silk mozzetta (a short cloak). The artist Francis Bacon (1909–92) later made his own version *Portrait of Pope Innocent X* (1953, there are several versions) and reworked the original to show the pope screaming; he is wearing a purple mozzetta, to match his mood.

■ **05** EXAMPLES

■ Too much red in a room can be overwhelming but a bright red couch makes a strong statement of modernity. It infers style and luxury. In 1938 the artist Salvador Dali (1904-89) designed the iconic Mae West lip-shaped sofa in crimson red.

■ Red is invigorating and crimson curtains have a dramatic effect in a room interior, at best in a room that is not used everyday as the colour drains energy. In a large space crimson can look commercial or tacky.

■ A Victorian shop front is more noticeable through the use of sharp crimson against the complementary hues of cerulean blue. The colour contrast adds vibrancy to the plain house front. Crimson used sparingly will accentuate any object.

■ Crimson is synonymous with blood red. Against the black background a bloodied hand dramatizes the graphic image. Crimson red alludes to danger, death and fear of the unknown. The graphic image would send a different message if it were in white and blue.

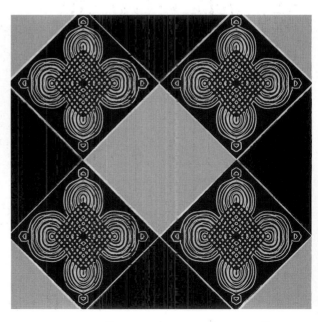

■ The crimson Moroccan tile typifies a hot country and the custom of tiled rooms to stay cool. In Northern Europe, a north-facing bathroom in tiles of crimson red can cheer a cold outlook and add brightness to dull walls.

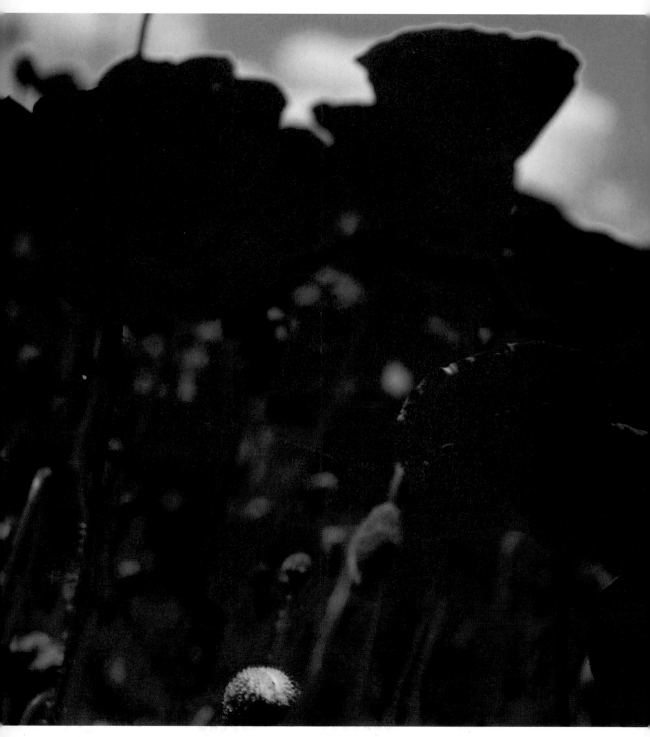

■ Red is invigorating and crimson curtains have a dramatic effect in a room interior, at best in a room that is not used everyday as the colour drains energy. In a large space crimson can look commercial or tacky.

■ A Victorian shop front is more noticeable through the use of sharp crimson against the complementary hues of cerulean blue. The colour contrast adds vibrancy to the plain house front. Crimson used sparingly will accentuate any object.

■ Crimson is synonymous with blood red. Against the black background a bloodied hand dramatizes the graphic image. Crimson red alludes to danger, death and fear of the unknown. The graphic image would send a different message if it were in white and blue.

■ The crimson Moroccan tile typifies a hot country and the custom of tiled rooms to stay cool. In Northern Europe, a north-facing bathroom in tiles of crimson red can cheer a cold outlook and add brightness to dull walls.

■ SCARLET

■ 01 DEFINITION

The colour scarlet has links to status. The pope often wears scarlet robes in public and the colour is traditionally worn by cardinals of the Church. It is also associated with carnal knowledge. The Bible has many references to the colour scarlet, as a sign of immorality: 'the woman was arrayed in purple and scarlet colour' (Revelations.17:4), hence the term 'a scarlet woman'. The origin of its name may have been taken from a bolt of Persian fabric. Analogous hues are vermilion, alizarin and crimson, cerise, cardinal and fuchsia. It is an intense colour, also known as scarlet lake, a synthesis of vermilion and cochineal lake.

■ 02 TECHNICAL INFORMATION

RGB Colour
R 255 G 36 B 0

CMYK Colour
C 0 M 70 Y 74 K 0

LAB Colour
L 63 A 88 B 79

HSB Colour
H 8 S 100 B 100

Hexadecimal **Pantone**
FF2400 172C

Closest Web-safe Colour
FF3300

■ 03 COMMON COLOUR COMBINATIONS

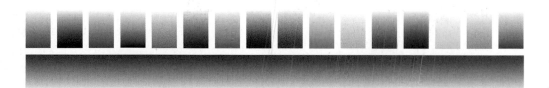

■ **04** HISTORY AND CULTURE

Ancient Egyptians obtained the colour from the red-orange flower heads of safflower *Carthamus tinctorius*, one of the oldest plants in the universe. The Phoenicians, considered the earliest civilization to use scarlet dyestuff, obtained it from the *Coccus ilicis* (kermes), an insect that infested an evergreen oak tree (*Quercus coccifera*), on which it fed. The scales of the insect were used for dye. The Romans used this technique to dye textiles and the colour was a symbol of high status. The Bible states that Roman soldiers wrapped Christ in a scarlet robe, to mock him as 'King' of the Jews. (Matthew 27:28).
In 1878 Biebrich Scarlet invented a non-permanent synthetic red acid dye, 'scarlet', which rivalled cochineal in brightness. (Cadmium scarlet, a compound of sulphur and selenium, is permanent).

The scarlet pigment materialized Impressionists' paintings; part of a vivid palette, which reflected modernity. The Fauves, particularly Henri Matisse, used hues of red, including scarlet. Before the First World War the Italian Futurists related scarlet, and colours analogous to it, to speed and the excitement of the motor car, symbolic of the modern machine age. After the Second World War the American Colour-Field painters expressed emotion in Abstract art: vermilion, scarlet, crimson and carmine were used to create sensational works of block colour.

■ **05** EXAMPLES

■ The heart is associated with the core of our being and blood, the source of life. Scarlet captures the energy of a heart-throbbing experience; echoing the challenges of being alive.

■ Scarlet satin sheets signify passionate nights and steamy romance but combined with black may connote darker carnal obsessions. Red satin evokes the era of sexy, glamorous screen goddesses of 1940s.

Nature illustrates the startling combination of natural complementary colours, a vibrant scarlet and bright leaf green. Winter is over when the spring flowerbeds sizzle with an array of scarlet tulips.

An architectural feature of semi-circular balconies on this multi-story building is accentuated by painting them deep yellow. The colour contrasts with the scarlet-coloured wall, which warms the plain exterior.

Silver grey and scarlet suggest decadence and luxury. The richly patterned lampshade and ornate stand complement the lace-patterned swag drapes. The subtle lamplight catches the shimmering crystal pennants to complete the setting.

COLOUR
THEORISTS

The earliest colour theorists have been sourced to ancient Egypt and India. At that time people related colour to the elements: fire was red, water was white and the earth was black. Colour was a mystery; not understood. In ancient Greece, Pythagoras linked music to colour and astronomy; this was continued by Isaac Newton in the seventeenth century. Plato refined earlier theories in *Timaeus* (360 BC). He stated that colour emanated from 'rays' of vision in the eye, which 'met' particles surrounding objects. Aristotle debated colour theory in *On Sense and Sensible Objects* and *On Colour* (c. 350 BC). He recognized seven significant colours: white, yellow, red, violet, green, blue and black. Florentine Leon Battista Alberti wrote the first modern critical analysis *On Painting* (1435–36), which is discussed in the following pages.

Leonardo da Vinci then took up Alberti's theory and the ideas of Aristotle in *Treatise on Painting* (c. 1492), later published in 1651. In 1666 Isaac Newton discovered that colour is light and revolutionized colour theory. His findings are discussed here, as well as those of Johann Wolfgang von Goethe, who disagreed with him. Others followed Newton, to explain and classify colour. The following pages discuss some of the prominent people who created unique colour theories.

LEON BATTISTA ALBERTI

The fifteenth-century Florentine writer, architect and theorist, Leon Battista Alberti (1404–72) used simple terms to explain the phenomenon of colour and light, in his treatise *Della Pittura* (*On Painting*, 1435). To him it seemed obvious that, 'colours vary according to lights, since every colour, when placed in shadow, seems not to be the same one that it is in brightness'. He was occupied with appearance, in that light and shade made objects appear and disappear: 'Shadow makes colour dark, whereas light makes colour bright where it strikes.' He observed a close relationship

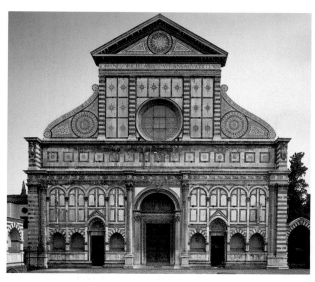

Alberti's paintings of buildingswere full of technical detail and appear almost photographic.

between colours and light, 'when light is lacking colours are lacking; when light returns, colours return'. (Book I)

Della Pittura was the first modern treatise on the theory of painting. Its publication in Latin was timely, for Florence was gripped by Humanist influence and filled with rich patrons wanting to commission works and employ the best artists, sculptors and architects. His practice and theory were revelatory and the book was later published in vernacular Italian, to widen its readership to non-Latin-speaking artisans. Alberti wanted the artist as much as the patron to gain knowledge, through his research and practice. This led to the rise of the informed artist as talented individual, away from the medieval practice of apprentices and masters, working as anonymous craftsmen in a workshop for a patron. His treatise, a sourcebook of art theory and practice, accelerated this change.

Fifteenth-century Italy was a wildly exciting time to be an artist, sculptor and architect, epitomized by works of art, such as Florence Cathedral's dome and theories, such as Alberti's.

Alberti's colour theory was based on four primary colours: red, green, yellow and blue. He noticed that a colour was more vibrant when placed next to one that was most unlike itself; a step toward complementary colour in action. Visual perception and ways of seeing are argued in Book I; Book II concentrates on the artist, with practical advice on colour and representation. In particular Alberti believed that man, nature and mathematical science were as one and used mathematical logic to prove his colour theories. He himself learned about one-point perspective from Florentine architect Filippo Brunelleschi (1377–1446), designer and builder of the new dome of Florence Cathedral (1420-36); and the paintings of Florentine artist Masaccio (1401–28). His book relates perspective to the creation of space in the picture frame and the effect of light, shade and colour upon it.

Works of art created after the book publication clearly show evidence of Albertian theory. *Della Pittura* informed the theories of later writers, notably the treatise of the painter Piero della Francesca (1410/20–92) *De Prospective Pingendi* (*Of the Perspective of Painting, 1480-90*) and *Trattato della Pittura* (*Treatise On Painting*, c. 1492–1519) by Leonardo da Vinci.

The Raising of the Son of Theophilus by Massacio, a friend and contemporary of Alberti who was one of the first to make use of perspective in his painting.

SIR ISAAC NEWTON

In 1666 a young Cambridge student, Isaac Newton (1643–1727), proved with a simple observation through a prism that white light is a fusion of separate colours. Others had worked on the premise that the prism altered the light. Newton had identified a fact that had eluded colour theorists for centuries. He looked directly at a beam of sunlight through a glass prism, then refracted the light beams, the rays, onto a screen.

To investigate further, Newton set up an experiment. In a dark room he allowed a narrow light beam to enter through a hole in a shutter blind. He then refracted the beam through a prism, a distance of 6.7 m (22 ft). After noting the individual colours, he placed them in order of gradation. He recorded a range of five colours: violet, blue, green, yellow and red. His inclination led him to include two others: indigo and orange, to total seven, which he related to musical notes and seven planets in the celestial sphere. He wrote up his experiment in a student essay entitled 'On Colours'. He later published 'New Theory of Light and Colours' in *Philosophical Transactions of The Royal Society* in London 1671 (No 80, 19 February, 1671/2, 3075-3087). A book expounding his theories, *Opticks: Or a Treatise of the Reflexions, Refractions, Inflexions and Colours of Light*, followed in 1704.

In colour theory Newton created the term 'spectrum' to categorize the progression of the colours. Through experiments in refraction he gauged the length of each 'wave' of light: red being the longest wavelength and violet the shortest. From this natural order of hues, he formulated rules of refraction of colour: the shorter the wave, the greater the refraction and vice versa. He placed the colours' names around the circumference of a segmented circle with white at the centre point, as he considered that all the colours joined at a central point would produce white. The divisions were uneven, based on the length of light-wave. The order, starting with the shortest and most 'fiery' purple-violet hue, circumnavigated the wheel around to red, with colours placed according to wavelengths, to show the relationship of colour in light (not colour pigment).

Drawing of Newton's experiment in which he showed how light from the sun is refracted by prisms.

Newton watches as a prism breaks up a beam of light, leading him to develop his ground-breaking theory.

His success had started, as history has recorded, in the *anni mirabilis* (miraculous years) of 1665 to 1666, while he was staying at home in Woolsthorpe, south of Grantham. In 1666 in absence from Cambridge due to an outbreak of plague, he made his prism discovery. He had been working on his optics theory much earlier and continued to experiment and formulate his hypotheses on colour and light. His theory of colour was revolutionary. It was a method taken forward by Moses Harris in about 1779 and Michel-Eugène Chevreul in 1839. However, in 1810 it was challenged by the German polymath Johann Willhem von Goethe.

Sir Isaac Newton in c. 1726; one of the founding fathers of colour theory.

JOHANN WOLFGANG VON GOETHE

Johann Wolfgang von Goethe (1749–1832) was a German scientist, writer, poet, novelist and extensive traveller. His 1,400-page treatise on colour theory *Zür Farbenlehre (The Colour Theory)* was published in 1810. He expected his treatise to have more permanence and posterity than his poetry.

The treatise was written primarily to help painters but also aimed to disprove Isaac Newton's theories on light refraction. Some of his results were based on his own misinterpretation of Newton's theories. His findings refuted Newton's, whom he was known to dislike intensely. Goethe's attack on Newton led to severe opposition to his own theories.

Goethe divided his 'Doctrine of Colour' into three parts: the first an outline of the theory of colours; the second to examine Newtonian theory; the third to investigate earlier theories and theoreticians. He stated that, 'colours are acts of light; its active and passive modifications'. His colour theory was founded on experiment and observation. He returned to the views of Aristotle (350 BC) and Leonardo da Vinci (c. 1500) and based his theory on the idea that colour emanated from the eye, through rays, rather than Newton's supposition that the eye received colour through light. He did not challenge Newton's scientific calculations, his knowledge was not sufficient; instead he focused on colour harmony; and colour as the instigator of mood and sensation. In the latter, he was a forerunner of Michel-Eugène Chevreul's 'simultaneous contrasts'.

Goethe created a colour wheel and a colour triangle. The two-dimensional wheel illustrated a triad of primaries and a triad of

Goethe in 1818. His views on colour theory angered many at the time.

Impressionist artists such as Claude Monet were influenced by Goethe's views on how shadow affected light and colours.

complementary, secondary colours, at six equidistant points: red opposite green; orange opposite blue; yellow opposite violet. On the triangular illustration he placed primary red, blue and yellow at the corners of the triangle; the secondary colours were triangles linked to the inner sides of the primary triangles and tertiary colours filled triangles of the remaining void. He gave a number value to each hue,

in relation the relative projected luminosity: white, the most luminous received a maximum, 10; yellow, 9; orange, 8; red, 6; green, 6; blue, 4; violet, 3; black, 0.

Artists were receptive to Goethe's ideas. His findings explained how coloured objects were displaced by refraction and that coloured shadows were the result of coloured light creating shadow in its own complementary colour. He discussed proportional colour use. His theories were later acknowledged, to great effect, in paintings by the French Impressionists and Post-Impressionists at the end of the nineteenth century.

Pierre Bonnard was inspired by Goethe's idea that brightness was a determining factor in how colour was perceived, as exemplified here in *Nude in Backlighting* from 1908–09.

MICHEL-EUGÈNE CHEVREUL

In 1824 the French chemist Michel-Eugène Chevreul (1786–1889) was made director of dye-works at Gobelins, the royal tapestry factory outside Paris. It was through his observations and vast experience of working with dyestuffs at the factory that he reached his conclusions on colour theory.

Chevreul researched the uses and composites of primary and secondary colours, to create liquid dyes for the textiles. One of the chief problems was the difficulty of weavers to differentiate between some of the more muted shades: mauve, lilac, grey, black and brown, when used together. An individual colour was readily perceived but not in combination with analogous hues, where the slight gradations of colour tended to blend optically. His experiments to resolve the problem led him to work out a system, which he later described as 'simultaneous contrasts'. In this he was aided by the earlier theoretical study on the properties of light and colours by the British physicist Isaac Newton, first published in 1672 and broadly extended in *Opticks: Or a Treatise of the Reflexions, Refractions, Inflexions and Colours of Light* (1704).

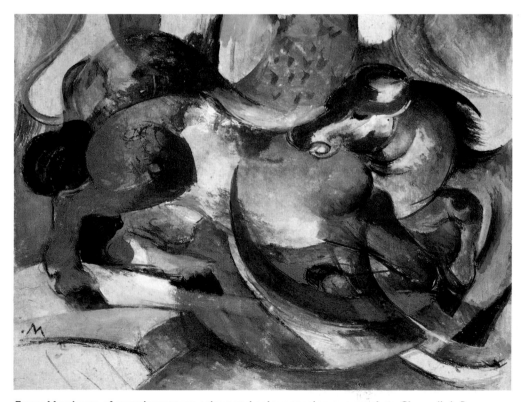

Franz Marc's use of complementary colour and colour spacing owe much to Cheveul's influence.